Scotland's
HERITAGE

Scotland's HERITAGE

a photographic journey

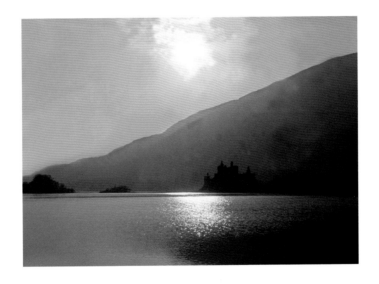

John Hannavy

Whittles Publishing

Published by
Whittles Publishing Ltd.,
Dunbeath,
Caithness, KW6 6EG,
Scotland, UK

www.whittlespublishing.com

Design and concept by John Hannavy

www.johnhannavy.co.uk

ISBN 978-184995-065-7

Printed by Almarose, Slovenia

[below left] Castle Kennedy in Galloway has been a ruin for centuries; its burned-out shell dominating a beautiful country garden.

[below right] An autumn sunset over Loch Lomond, viewed from Ross Priory. Thomas Cook brought his first package tourists to Loch Lomond in the early 19th century – at around the same time that photography was being invented. Photography and tourism have been inseparable ever since, and Loch Lomond remains one of Scotland's most popular tourist attractions.

[opposite] St Martin's Cross, Iona.

following pages,
[left] Meall a'Ghlas Leothaid. The landscape of Wester Ross is wonderfully rugged and barren, but with an austere beauty which brings travellers and climbers back again and again. This truly does epitomise Scott's 'Land of the Mountain and the Flood', the peaty valley floors dotted with small lochans reflecting the craggy hills beyond.

[right] The Cuillins dominate the Skye landscape and define the island's character. Skye is renowned for its fickle weather, and locals readily confirm the island's ability to display four seasons in one day. But every type of weather has a beauty and a drama in a landscape such as this.

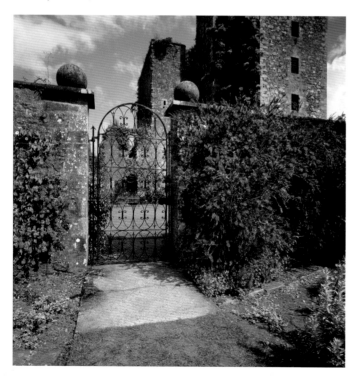

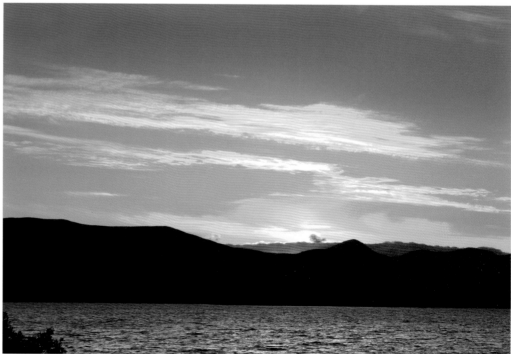

Contents

vi

Introduction

1

The Marks left by Men

27

Land of the Mountain and the Flood

67

Great Houses and Humble Dwellings

87

Churches, Rituals and Monuments

109

The Land of a Thousand Castles

135

One Thousand Years of Industry

163

Living and Working by the Sea

183

Schematic maps

191

Index

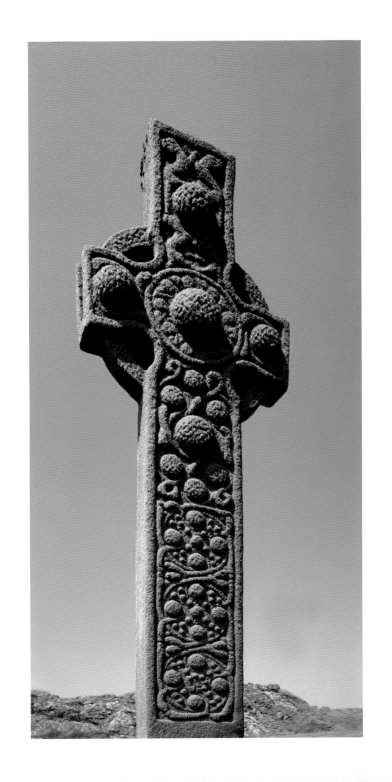

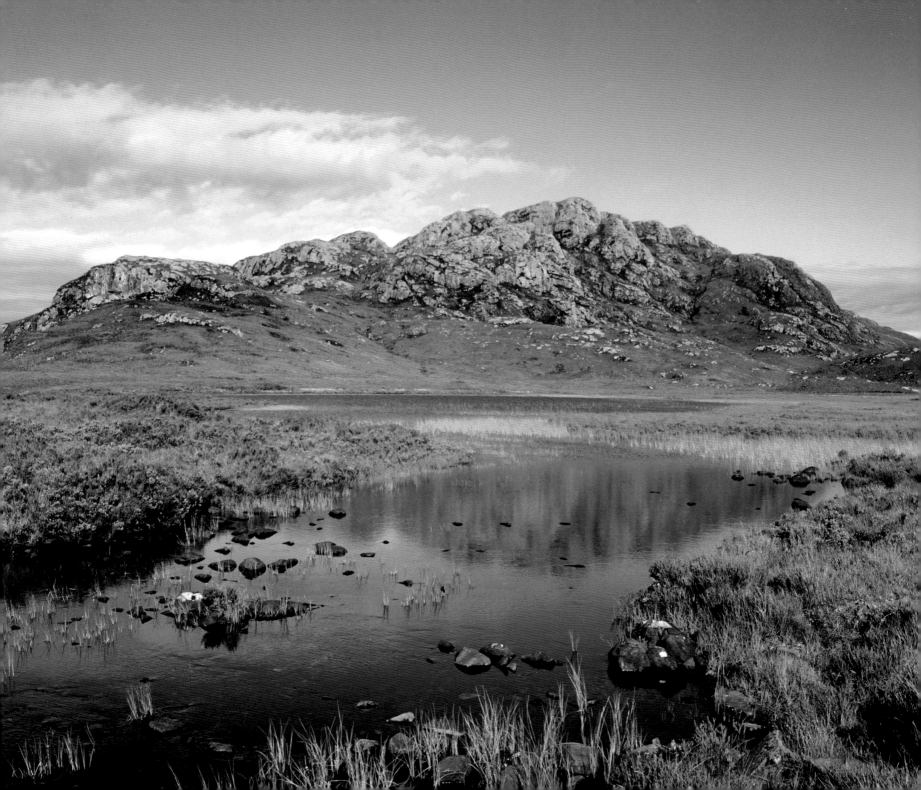

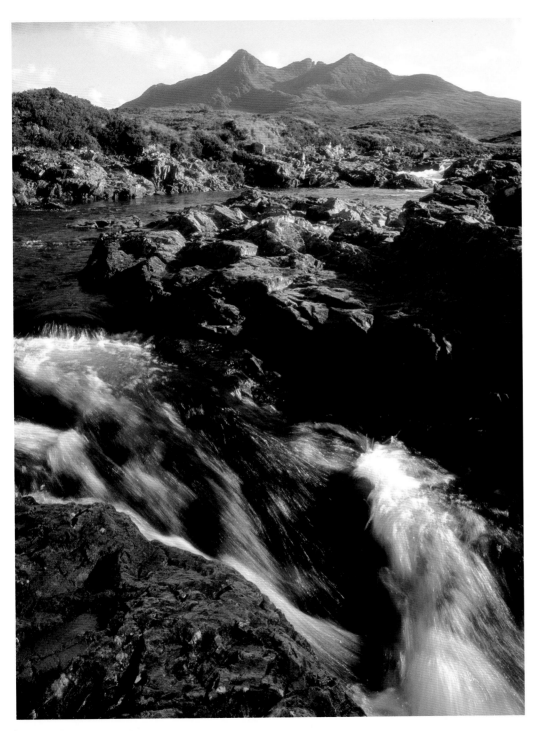

Introduction

Scotland is a country steeped in history and blessed with a rich and varied heritage set in a stunning landscape. When the light is right, it is a photographer's paradise – and that light can change a hundred times a day, each revealing a new aspect of the place. No photographer can ever capture every interplay between light and landscape, and no photographer can ever tell the definitive story of Scotland – but trying to do so is a pleasurable and consuming passion.

Throughout the country can be found the marks left by those who lived here several millennia ago, while today's landscape is dotted with the remains of buildings erected, enjoyed, altered and abandoned over the past twenty centuries.

This book sets out to illustrate some of the country's often-turbulent history by offering a personal view of the places and the buildings where that history was played out.

Of course many great writers have travelled throughout Scotland before me – the first probably being William Camden, whose *Britannia* (first published in Latin in 1586) carries the accolade of being the first guidebook ever produced in Britain. A curious feature of the book is that it celebrated 'Britain' over a century before Britain existed as a nation. Several subsequent editions in English established the book as a major gazetteer and the first of a publishing phenomenon which endures to this day.

Britannia was a systematic county-by-county look at the people, the places, and the histories of Britain – a successful formula which has been replicated many times the world over. Camden did not present his researches in the form of a journey or journeys, preferring instead to deal with each county or geographical area as an individual entity, relating what he believed were the key stories and describing key incidents and important buildings. While in England, Wales, and southern Scotland, his text is clearly written from first-hand experience, but his accounts of Scotland north of the Antonine Wall are patchy. Along the east coast and inland from it, that same personal experience comes across, but of the west coast and most of the Highlands, he left his readers wanting much, much more. In his defence, travelling throughout the whole of the British mainland in the closing years of the 16th

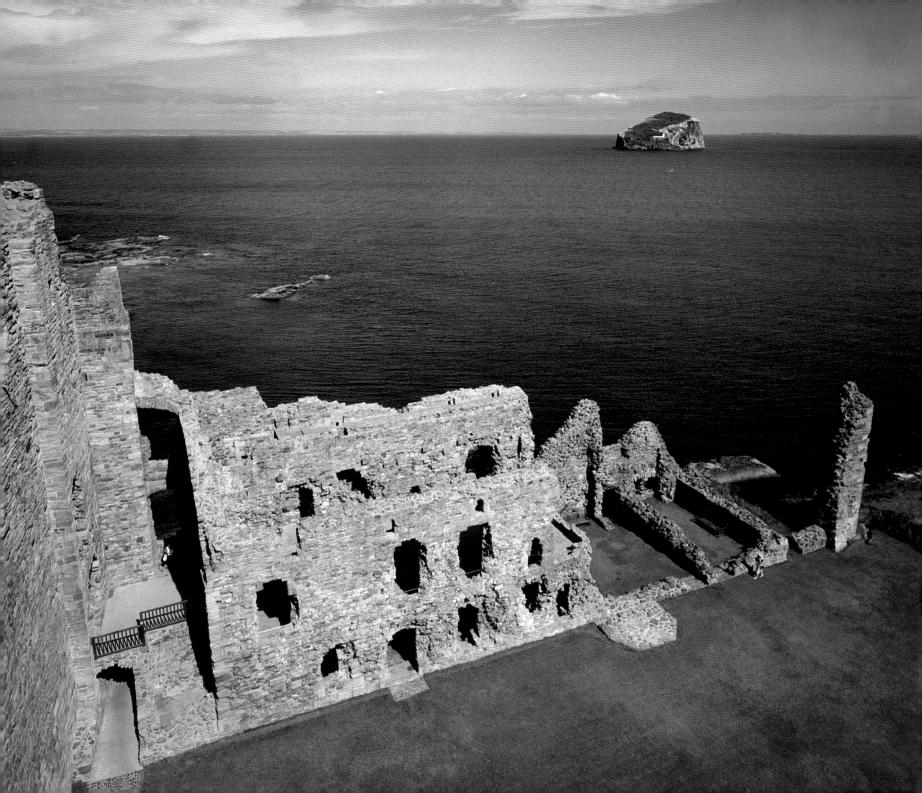

century cannot have been easy! Indeed, some of the places he reported upon are difficult enough to reach with even modern transport. Things cannot have been much easier for those who followed him over a century later.

The 18th-century writers and diarists Thomas Pennant, Daniel Defoe, and James Boswell and Samuel Johnson amongst others, all produced magical travel journals in times when most of Scotland was virtually unknown to the majority of Britons. In the years before photography they had to create word pictures or commission artists to produce (sometimes fanciful) illustrations for their books.

More recently, the incomparable Henry Vollam Morton – 'H. V.' to his readers – published, in the 1930s, his memorable accounts of his travels in two delightful books: *In Search of Scotland*; and *In Scotland Again*. Throughout this book, we will be accompanied by their engaging accounts of Scotland long ago. Many of their observations have stood the test of time.

William Camden can never have imagined the popularity travel, history and heritage books would enjoy today. In presenting this book to you, just over four hundred years after the first English edition of Camden was published, I hope that popularity endures for a few years more!

Part history, part travelogue – and much of it pure indulgence on the part of the photographer and writer – this is, however, not a guidebook in the conventional sense. Rather it is a reflection on the qualities and characteristics that make a country special, illustrated with images I have made during many journeys of exploration across the country of my birth. Scotland is special. Having travelled extensively throughout the world, there is no doubt that being a Scot is an advantage. The Scots' reputation for tenacity, for strength of character and for their love of their own history is worldwide.

Being Scottish can often open doors that would otherwise remain closed. And being Scottish has little to do with where you live – but everything to do with where your roots are, where your soul is, and that strong Celtic heritage which has been passed down undiluted through generations of families now living in every corner of the world.

John Hannavy, 2012

[opposite page] Looking out across the ruins of Tantallon Castle towards the Bass Rock. William Camden included Tantallon in his pioneering gazetteer *Britannia*: 'Above the mouth of this Tine, in the very bending of the shore, standeth Tantallon Castle, from which Archibald Douglasse Earle of Angus wrought James the Fifth, King of Scots, much teen and trouble.'

[left] Lady Stair Close: one of the many wynds, closes and vennels that give Edinburgh's Old Town its character.

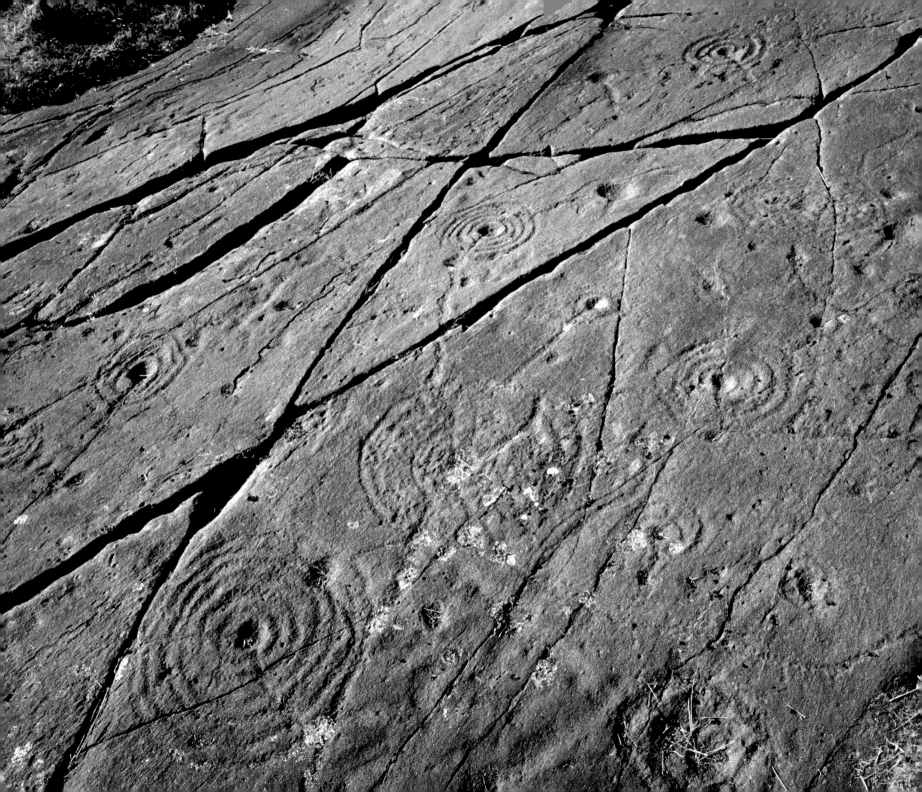

The Marks left by Men

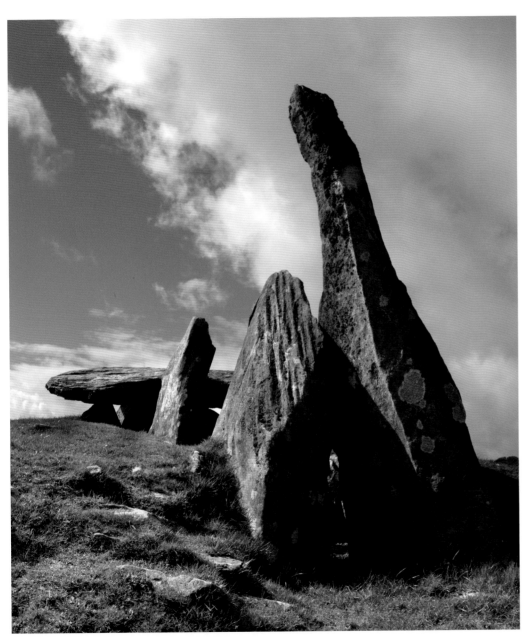

On a hillside near Achnabreck Farm, high above the Crinan Canal at Cairnbaan, is some of the surviving evidence of the ceremonial art of the peoples who inhabited Scotland almost 4,000 years ago.

In Galloway, overlooking Wigtown Bay, predating the Cairnbann cup and ring markings perhaps by centuries, are the remains of two chambered tombs known today as Cairnholy I and Cairnholy II. Long since stripped of their protective covering mounds, they were built overlooking one of the finest views in the area, reminding us that in ancient times the ritual of burial – at least for important members of tribal society – was a significant ceremonial event closely connected to the landscape,

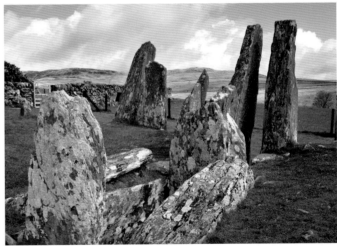

[opposite page] Dating from the 2nd Millennium BC, several of the rocks near Achnabreck Farm, Cairnbaan, carry inscribed cup and ring markings left by ancient civilisations. The exact purpose of these examples of Neolithic and Bronze Age art is uncertain, but their location near tombs, cairns, and other gathering places – often with a panoramic view over the surrounding countryside – would seem to point towards some religious or ritual purpose.

[left and above] Near Gatehouse of Fleet in Galloway, the remains of two ancient chambered tombs – Cairnholy I (above) and Cairnholy II (left) – dating from the 3rd and 2nd Millennium BC, sit on a hillside overlooking the Solway Firth.

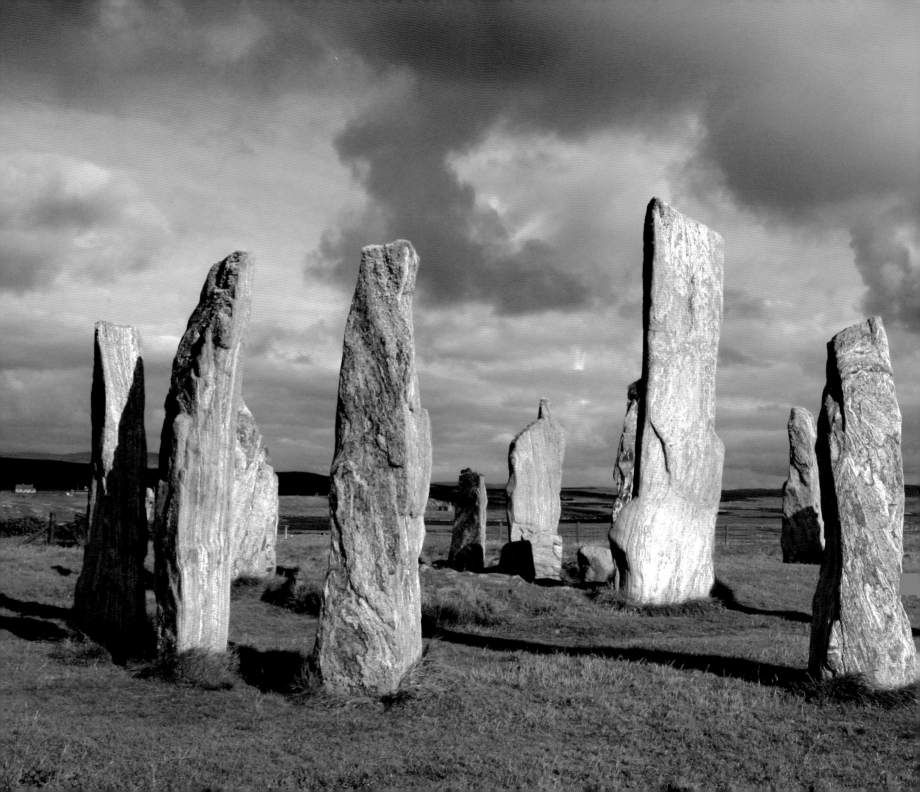

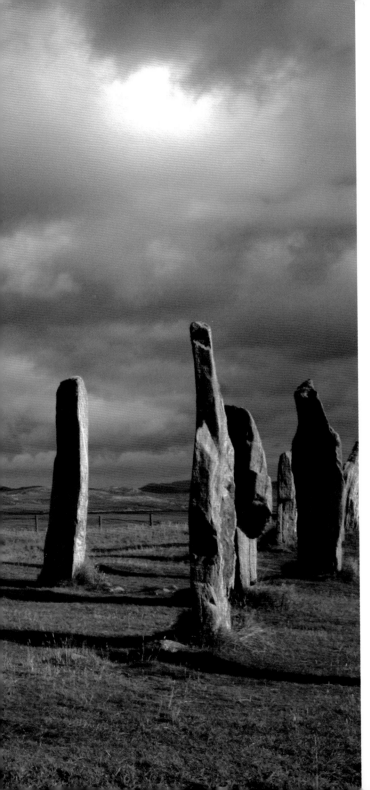

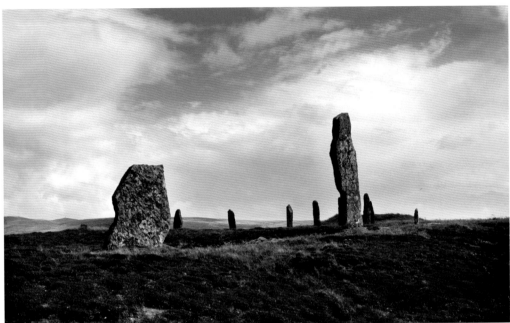

the sun and the sea. When discovered and excavated in the late 1940s, they revealed many tantalising links with these ancient peoples. Amongst the artifacts and tools with which they were entombed, a stone inscribed with cup and ring markings was found within Cairnholy I.

Throughout the country ancient remains abound; some of them dating back to times just after the last Ice Age in which, historians and meteorologists tell us, Scotland was still a very cold and miserable place, and only barely habitable. From Cairnholy in the southwest to Callanish in the northwest and Brodgar and Stenness in the Orkneys, Scotland's great groups of standing stones and ancient burials have a magnetic quality. Perhaps it is because we know comparatively little about them or the people who built them, that we are drawn towards these most tangible reminders of our ancestors. And unlike England's Stonehenge, we can walk freely amongst the stones and explore them up close.

[left] Perhaps the most famous ancient monument in Scotland, the great Callanish stone circle is one of several groups of ancient stones that can be found on the Isle of Lewis. The tall circles and columns of standing stones dominate the bleak empty landscape. Known as 'Callanish I', this is the largest of three stone groupings all within sight of each other.

[above] The Ring of Brodgar is the largest stone circle in the Orkneys, and just one of many ancient sites which are dotted across the islands.

3

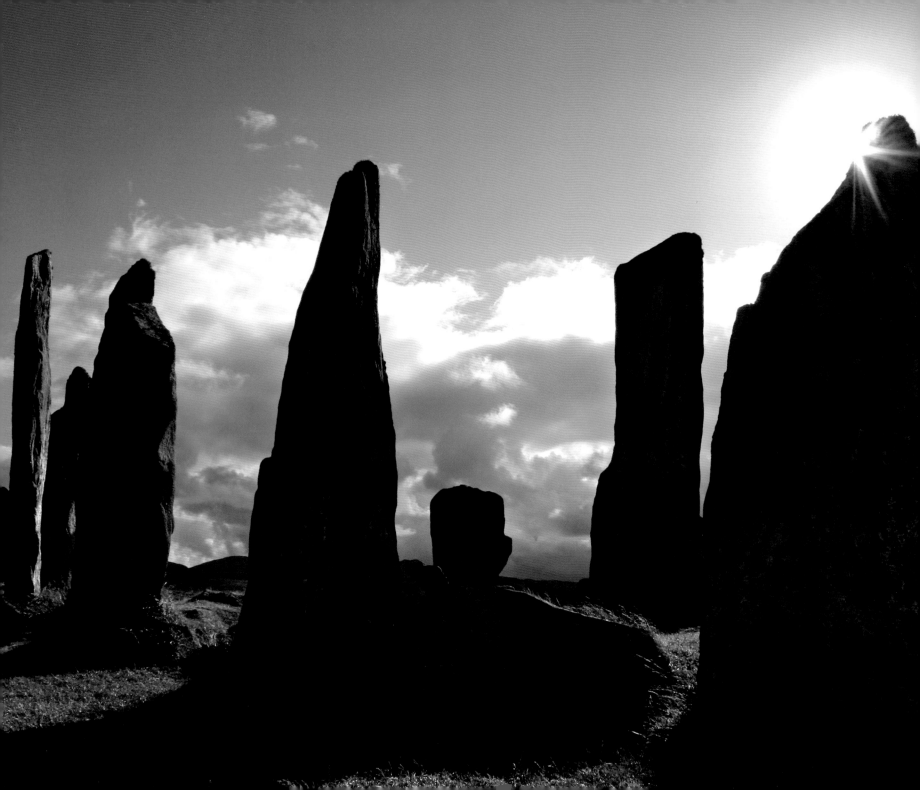

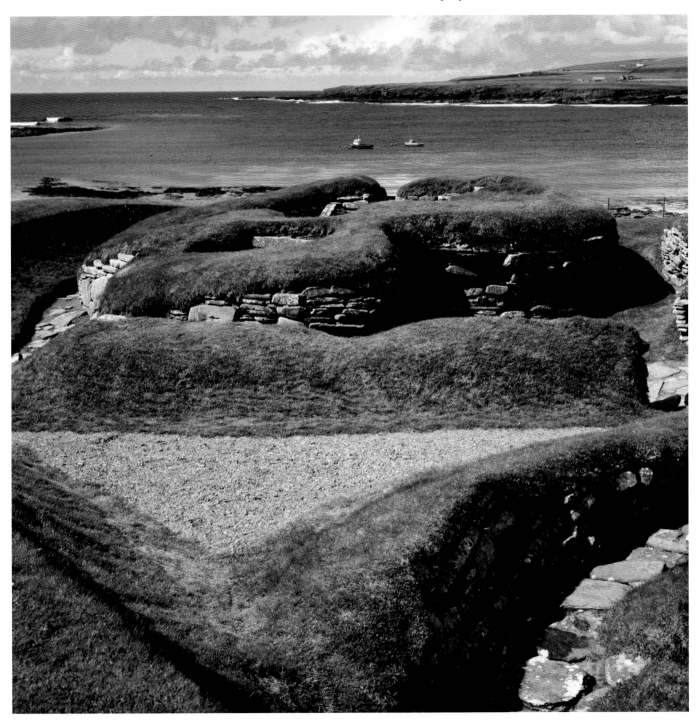

[opposite page] Standing proud against a magnificent sky, the huge monoliths of Callanish I are an awesome sight. They form a circle which is flattened at its western circumference, with evidence of a second circle, and within it there is a chambered cairn, probably of a somewhat younger date.

[left] Looking out across the Bay of Skaill over the remains of the village at Skara Brae, Orkney.

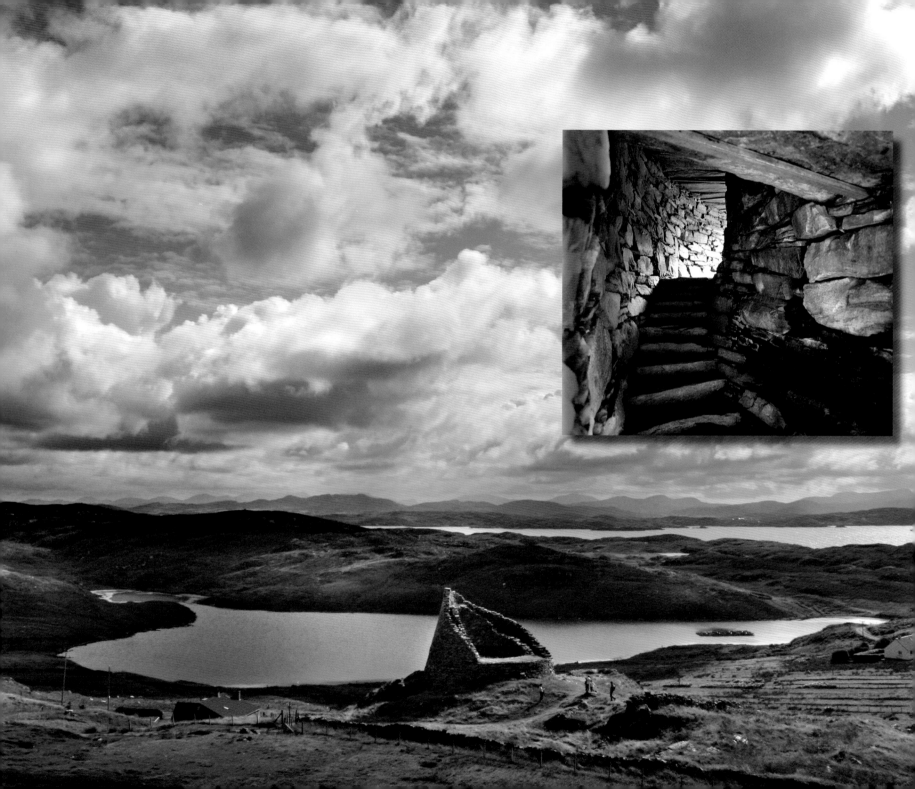

The erection of the stones of Callanish I – the tallest of which stands 4.75 metres high – probably dates from the 3rd or early 2nd Millennium BC. All but the shortest stone stand well above 2.7m high. Three other groupings to the southeast of the main site – Callanish II III and IV – all date from the 2nd Millennium BC.

Even older are parts of the earliest known – and most famous – pre-historic settlement in Scotland: the village of Skara Brae overlooking the Bay of Skaill on Orkney. Archaeologists have dated its construction to a 600-year period of occupation between 3100BC and about 2500BC. Perhaps more than any other site, Skara Brae has told historians a great deal about living conditions in pre-historic Scotland. Now sitting right on the edge of the bay, Skara Brae when built, lay in fertile farmland well back from the water's edge. Erosion over the past 5,000 years has brought destruction ever closer.

Of much more recent date, but every bit as enigmatic, are Scotland's brochs – huge drystone conical fortified structures which when complete probably looked not unlike power station cooling towers. Dating evidence for these structures is patchy in the extreme, and archaeologists admit that a construction date of somewhere between the early 1st century BC, and the 1st century AD is far from certain. They are, therefore, survivals from Scotland's Iron Age, and they can

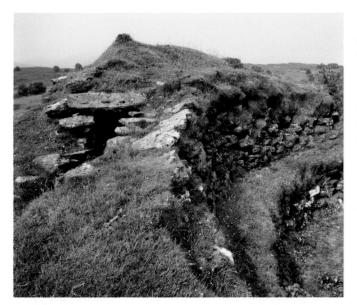

be found in dense groupings throughout the north and west of the country, and in the Western and Northern Isles. Some historians place the earliest broch construction about five centuries earlier, and they remained in use until the end of the 2nd century AD, long after the arrival of the Romans in Scotland (but generally to be found in areas into which the Romans rarely – if ever – ventured).

Brochs are amazing buildings. Their complex design and internal structure, not to mention their height, seems remarkable given that they were constructed entirely without mortar. Some of the more intact survivals – like Mousa in Shetland – still stand over 45 feet tall.

Scotland's brochs have attracted travellers for centuries. When Dr Johnson visited the remains of one of Skye's several brochs in 1773 (he didn't say exactly which) his host – a Mr McQueen – told him that it was a 'Danish Fort', but Johnson was unimpressed. He conceded that there had been some skill and a lot of labour involved in building it, but dismissed its historical importance as probably nothing more than a cattle pen, although he did concede they might have been houses. 'I am inclined to suspect' he wrote, 'that in lawless times, when the inhabitants of every mountain stole the cattle of their neighbour, these enclosures were used to secure the herds and flocks at night.' As to their historical importance or architectural merit, he was scathing in the extreme: 'In *Sky* (sic), as in every other place, there is an ambition of exalting whatever has survived memory, to some important use, and referring it to very remote ages.'

The same Mr McQueen had been host in the previous year to Thomas Pennant, who would also write and publish an account of his Scottish travels. He visited the same broch – the walls of which he described then as 18 feet tall. Pennant accepted McQueen's description of 'a Danish fort' without further comment. However, when Pennant reached the two huge brochs at Dun Telve and Dun Troddan in Glenelg, he felt a lengthier description was called for. Here he included local folklore and an ancient verse which attributed the building of the brochs – *Caisteal Teilbah* in Gaelic – to a mother for her four sons. Locals told him that the other two had been demolished long before. Interestingly, Pennant also quoted from traditional stories which placed the broch-building period 'two hundred and sixty years before the Christian era'.

[opposite page] Set in the stunning Hebridean landscape of the Isle of Lewis, the 2,000-year-old remains of Dun Carloway broch are surprisingly well preserved. It is one of the best preserved of the brochs which dot the west coast, the Hebrides and the Northern Isles. The exact purpose of these remarkable tall and circular dry stone structures remains obscured in the mists of time, but they clearly fulfilled some defensive role. They may also have performed the role later served by castles: to dominate a landscape and therefore impress all-comers. Their name derives from the Norse word 'borg', meaning a fortified place, and the Gaelic prefix 'Dun' implies the same. Most were built between 100BC and about 100AD, and historians believe that they were fitted out with wooden galleries inside, and probably roofed in turf or thatch. The best preserved of all the brochs is the huge Broch of Mousa on Shetland, where the walls stand to a height of nearly 45 feet. Sir Walter Scott, visiting Mousa in August 1814, described it as 'a Pictish fortress, probably the most entire in the world. In form it resembles a dice-box, for the truncated cone is continued only to a certain height, after which it begins to rise perpendicularly.' Despite the considerable distances between brochs and the limited opportunities for communication between broch-builders at the time, that shape is typical of them all.

[inset] The internal staircase within the thickness of the walls of Dun Troddan Broch, one of two brochs in Glenelg.

[left] The overgrown remains of Tirefour Broch on the island of Lismore.

Bearing in mind that even less was known about them or their builders then than now, that seems a pretty accurate estimate. Interestingly, given that early attribution to the Danes, the word 'broch' has Norse roots, while the use of the term 'Dun' in most of the broch names has a Gaelic origin. If currently believed dates are correct, much of the broch-building period in Scotland coincided south of the border with the advance of the Romans.

The Romans had a low opinion of the Scots, but they also had a healthy respect for them – the scale of Hadrian's Wall is testament to that – but it was not always so. Initially the Romans had anticipated quelling the entire island – the Scottish tribes and their lands included – but both the people and the landscape thwarted their plans. They never established towns or villas north of the border, as they did in England, and many of their settlements – primarily military – were built of timber rather than stone. There are exceptions of course, but few of their stone constructions are visible above ground today.

Of their great fort at Trimontium near Melrose, only scant traces remain. South of the Antonine Wall, traces of a bathhouse complex at Bearsden were exposed some years ago. Apart from that, the most tangible proof of Roman occupation consists of fragments of monuments, carved and decorated stonework, pottery and other artifacts, preserved in Scotland's museums. The most visible evidence on the ground is the huge military encampment at Ardoch on the outskirts of the Perthshire village of Braco – by far the most extensive Roman fortifications still visible north of the border.

[right] Dun Telve and Dun Troddan are two well-preserved brochs within a short distance of each other at Corrary near Glenelg, a few miles inland from the Sound of Sleat. Both still contain well-preserved fragments of their internal staircases, constructed within the 15-foot thick walls. This is Dun Telve, where the dry stone wall still rises in places to a height of over 30 feet.

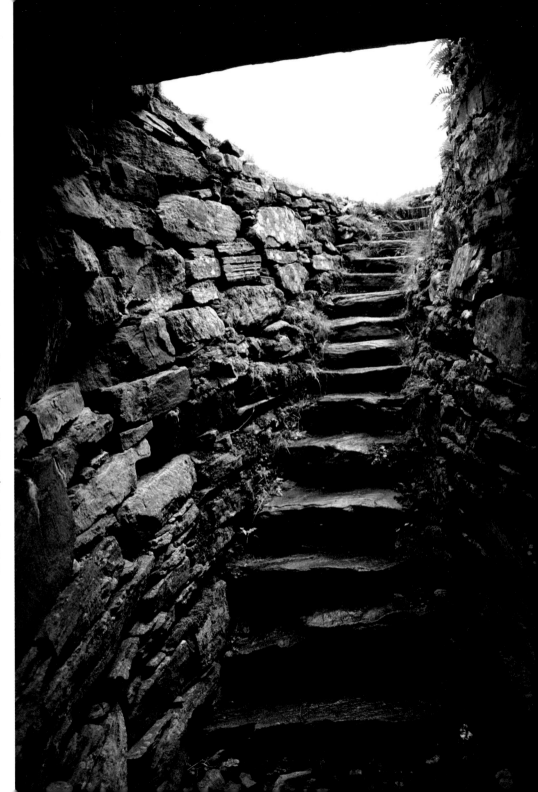

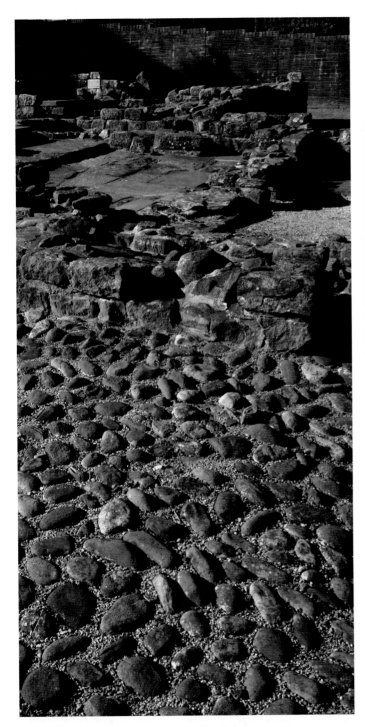

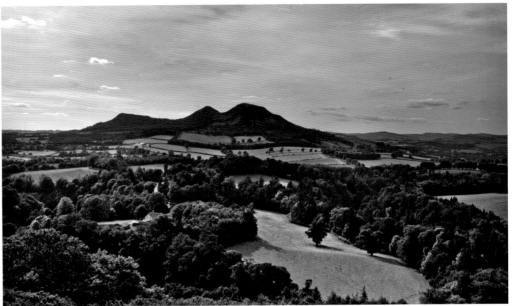

When Thomas Pennant explored the site in 1772, the camp was in a more complete state than today. While a bridge crossed the Knaick at this point (even in his day), it was a narrow pack bridge, the narrow road to which skirted the camps without having caused too much damage. Pennant was impressed. Of Agricola and Ardoch, he wrote: 'As this stationary camp was the most important, so it was secured with greater strength and artifice than any of the rest. No general ever equalled him in the judicious choice of situations; no camp he made was ever taken by storm, or obliged to surrender, or to be deserted. This he fixed on an elevated situation, with one side on the steep bank of the little river of Kneck, and being fortified on that part by nature, he thought fit to give it there the security of only a single fosse. The other three have five, if not six, fosses, of a vast depth, with ramparts of correspondent height between.'

At Comrie and at Strageath (both just a few miles from Ardoch), Pennant visited two smaller camps and gave detailed

[above] Seen here from Scott's View, the three peaks of the Eildon Hills gave their name to the Roman encampment at Trimontium near the border town of Melrose. Romans first occupied the site around 80AD, and over about a century developed it into a large encampment complete with its own military amphitheatre. The site overlooks the 19th-century railway viaduct at Leaderfoot just outside Melrose.

[left] The excavated remains of a Roman bathhouse at Bearsden north of Glasgow. The bathhouse was part of a large fort constructed on the Antonine Wall around the middle of the 2nd century, and housed a detachment of soldiers: part of the wall's garrison.

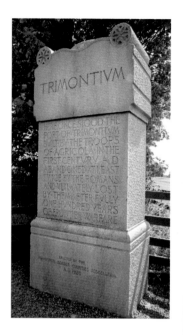

[above] The site of the great fort at Trimontium was marked in 1925 by the erection of an inscribed stone in the shape of a Roman altar.

[above right] The Roman road we know today as Dere Street ran from York (Eboracum) to the Antonine Wall and was the Romans' main supply route north into Scotland. This view was taken on Soutra Hill.

[right] With all traces of its ramparts and ditches ploughed out, Trimontium fort lies beneath this cornfield.

[far right] This shallow bowl above the River Tweed near the Leaderfoot Viaduct is all that remains of the only Roman amphitheatre yet discovered in Scotland.

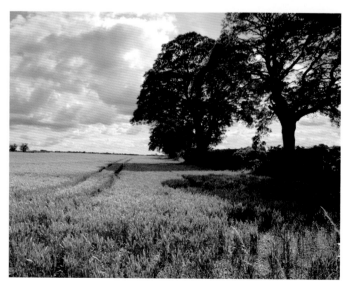

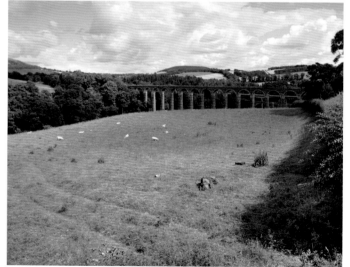

[left] Running through a heavily wooded landscape near Falkirk, this rampart and fosse is a surviving fragment of the Antonine Wall. Under summer foliage the woodland all but hides its 1850-year old treasure. Built in the early 2nd century, the wall ran from Forth to Clyde, and was seen as a new northern frontier after a second Roman incursion into Scotland. The wall and its line of forts were effectively abandoned after just a few years, although the Roman presence in southern Scotland continued into the 4th century. In 2002 a new tunnel was bored under this section of the wall, carrying the restored 18th-century Union Canal to the top of the Falkirk Wheel.

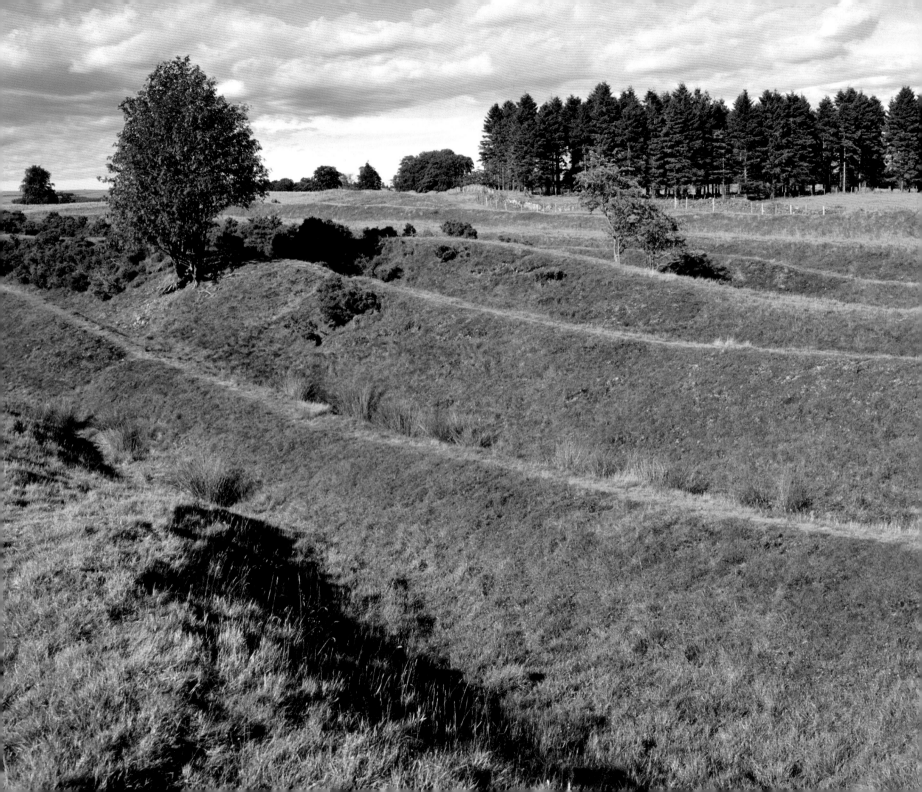

accounts of all three. But Ardoch impressed him the most – every bit as much as it impresses the relatively few people who visit the site today.

Agricola had intended his major military base in Scotland to be at Inchtuthil near Dundee, work on which started in 83AD. Within four years the still incomplete station had been abandoned, and by the early years of the 2nd century the Romans withdrew from Ardoch. A few years later work started on Hadrian's Wall, effectively sealing Scotland off from the south.

The Romans, this time under Antonine, returned in 138AD, and by the early 140s, his great turf and timber wall had been built between the Forth and the Clyde. Abandoned for a period in 150AD or thereabouts, it was re-occupied and then finally abandoned about 165AD.

The Roman experience of trying to tame Scotland was not a good one, and certainly not a successful one. Scotland never really became part of the Roman Empire, unlike the lands south of Hadrian's Wall. To become a recognised part of the empire, military rule usually gave way to civilian governance. In southern Scotland, military rule tenuously prevailed for the entire period of the occupation. Several further attempts were made to quell the tribes north of the Forth and Clyde – and the Romans did advance back up towards Dundee at one stage – but their successes were short-lived. Hadrian's Wall itself held until around 400AD, by which time Roman disenchantment with the north was pretty complete.

Historians still debate just how far north the Romans ventured – with some suggesting they made it at least as far as present-day Aberdeen. The exact extent of their incursion, and indeed the exact locations of their battles, will probably never be known.

Christianity initially came to Scotland from Ireland in the 6th century in the form of the Celtic or Culdee church rather than the Roman church. Many of Scotland's earliest and most revered saints – amongst them Columba, Cuthbert and others – knew little or nothing of the Church of Rome.

Celtic monasticism was unique in that it was based on very simple principles of peace, prayer, good husbandry, and care of the community. That it thrived in the land of the Picts is perhaps surprising, but thrive it did. It introduced order where there had been little, and in addition to religious observance,

historians attribute to it many of the qualities we would today associate with good government.

The Picts are a people much maligned by history. Popular history has cast them as unruly and violent tribesmen – which at times they undoubtedly were – but they were also artists and craftsmen of the highest order. The richness, intricacy and quality of surviving relics of Pictish art show high levels of sophistication in both craftsmanship and creativity.

For a long time chroniclers assumed that the Picts were almost completely wiped out when the Vikings arrived – their civilisation and their culture all but obliterated. However, it is becoming clear that this was not the case. It is also becoming clear that rather than being an isolated and introspective people, the Picts – if Pictish art is a good measure – were influenced by contact with France, Germany, and perhaps even as far afield as modern-day Turkey.

[above & left] On the outskirts of the Perthshire village of Braco lie the extensive remains of the country's largest Roman fort. Ardoch Camp occupies an easily defended position above the River Knaick at the meeting of two valleys, and with commanding views of both – south towards Stirling and north towards Comrie and Crieff. It was partially excavated in the late 19th century, when the layout of the camp's buildings was extensively mapped. Beyond the heavily fortified main camp was a much larger and more lightly protected outer camp, which afforded temporary shelter for several legions at a time.

a battle scene on a carved stone is a great rarity. The stone is believed to have been carved in the early 8th century, and along with Sueno's Stone and others, has been described as the Pictish equivalent of the Bayeux Tapestry.

When Thomas Pennant first toured the country in 1869, he was given the traditional view of the Picts: of a warlike people who spent much of their time fighting the Danes. Penannt was, nonetheless, hugely impressed with what he saw at the village that he believed was called 'Aberlemni'. He drew upon the earlier work of Alexander Gordon, whose 1726 work *Itinerarium Septentrionale* contained a detailed description of the stones.

Referring to the churchyard stone with its battle scene, Pennant wrote: 'Mr Gordon very justly imagines that this was erected in memory of the victory of Loncarty; for in the upper part are horsemen, seemingly fleeing from an enemy; and beneath is another, stopped by three men on foot, armed with rude weapons, probably the peasant Hay and his two sons, putting a stop to the panic of the Scottish army, and animating his countrymen to renew the fight.' This is a very different reading from today's understanding of the sculpted scenes. The Battle of Loncarty or Luncarty, at which 'the peasant Hay' gained fame, is believed to have taken place in 971AD against the Danes, nearly three centuries after Nechtansmere. Pennant also reproduced Mr Gordon's drawings of the stones, but sadly they were just as inaccurate as his assessment of the history, with the figures and animals in a hunting scene depicted on the reverse of another remarkable cross – located just a few hundred yards away by the roadside – bearing little relationship to their positions on the actual stone itself.

Pictish stones can be found in many locations across Scotland, most significantly throughout Angus and Perthshire, and one of the most important can now be found inside St Serf's Church in the little Perthshire village of Dunning.

The 8th-century Dupplin Cross once stood on a hillside between Dunning and Forteviot, and details of its existence were first published by Thomas Pennant. Recent detailed examination of this stone by historians has greatly enhanced understanding of the period during which Pictish art flourished. The Dupplin Cross suggests Pictish art survived much later than previously thought, and that it incorporated influences from all over Europe.

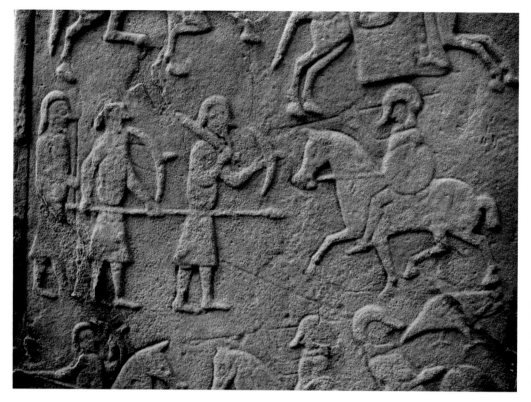

The Aberlemno stones are magnificent survivals of Pictish art. The great cross in the village churchyard has a fine Celtic Cross on one face (opposite far right) and a pictorial representation of the 685AD battle of Nechtansmere on the reverse (above).

By the roadside, a few hundred yards away, another great cross stone depicts a hunting scene on its reverse (right).

The majority of what has survived comprises sculpted tablets and monuments, and epic creations such as Sueno's Stone in Forres, and the great stones of Aberlemno. Sueno's Stone standing nearly 20 feet high is by far the tallest, and with a date of the late 9th or early 10th century, one of the latest. It apparently depicts a battle – believed to have been fought between the Picts and the Scots – and carries rows of intricately carved figures of soldiers.

Much earlier are the stones at Aberlemno, one of which tells the story of the Battle of Nechtansmere in 685AD – just four miles south of Aberlemno in Angus. Here the Pictish forces faced the army of King Ecgfrith of Northumbria. A notable Pictish victory at which Ecgfrith was killed, the depiction of

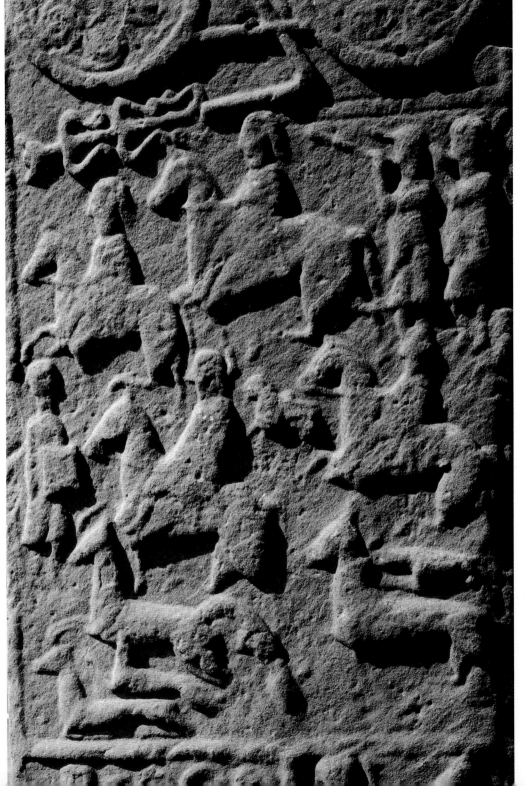

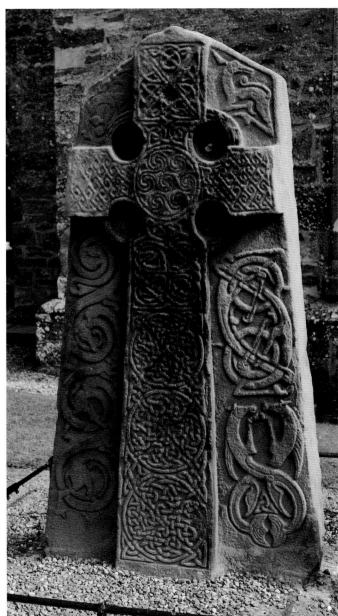

On the other side of the country, the Great Cross of Kildalton stands nearly nine feet (2.6m) high in an Islay churchyard and was carved from a single piece of stone 12 centuries ago.

Many of the finest Pictish monuments date from around the time just before the Vikings invaded Scotland in the late 8th century. But their artistic influences continued to appear in magnificent religious monuments over the following two centuries, albeit within a relatively small area of eastern Scotland. In that time Christianity spread and developed, although the principles of that church were rooted in Columban traditions and rituals rather than Rome. The pagan Vikings never managed to defeat the Celtic (Culdee) church, and many of their leaders eventually converted to Christianity.

When the ascendant Roman church started to gain sway in Scotland in the 11th century, many of the remaining vestiges of Culdee culture and practices were gradually swept aside. Viking influences would, however, continue to dominate many parts of present-day Scotland until well into the 13th century, long after they had ceased to exercise power in Scandanavia. From then onwards, the major marks left by men on the Scottish landscape would for centuries be the great symbols of religion – the abbeys, priories, cathedrals and churches – and the great symbols of power – Scotland's castles and great fortified tower-houses, explored elsewhere in this book.

Amongst the more minor marks which define the past centuries, the gravestones that populate Scottish kirkyards are perhaps the most interesting and enduring. In country graveyards, even relatively humble men are remembered with ornate headstones: monuments which chronicle their lives and achievements. In Aberlemno graveyard (visited predominantly by those wishing to see the Pictish cross) the gravestones of local farmers, men and women all have stories to tell, and all have a place in Scottish history. Glasgow's Necropolis – the huge graveyard which dominates the hill adjacent to the city's medieval cathedral – has that same mix. It is the final destination of both rich and humble, whose graves and tombs are marked by an eclectic mix of monument size, date, style and elaboration. From simple slabs to faux Roman and Greek temples, neo-Gothic mausoleums, marble effigies, and tall granite obelisks, generations of Glaswegian families have let their imaginations run riot when choosing a fitting resting place for the mortal remains of their loved ones. Amongst them is a memorial to the Scots

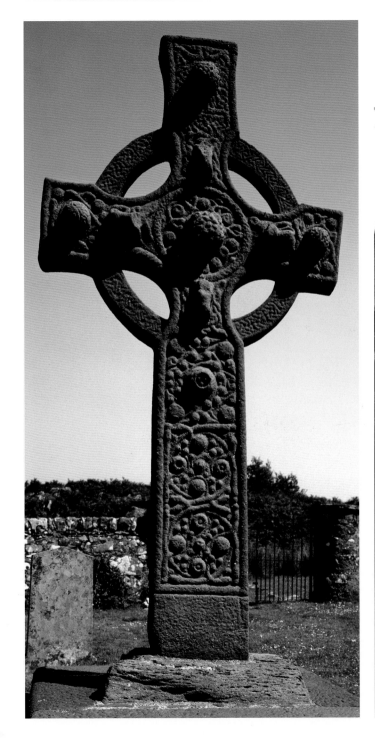

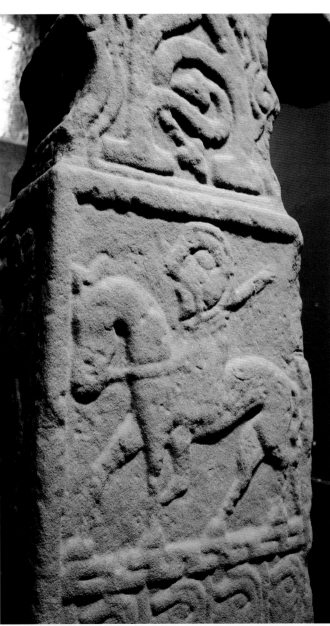

[opposite page] The oldest of the Aberlemno stones is incised with a series of Pictish symbols: a mirror and a comb.

[centre left] The nine-foot-high Great Cross of Kildalton – a giant of a Celtic Cross in the village of the same name a few miles from Port Ellen – is one of the wonders of Islay. How it has survived 1200 years and more is only slightly more surprising than how it was created in the first place. Carved from a single piece of stone, it has a delicacy and intricacy which clearly defies any suggestion that 8th-century man was unsophisticated.

[left] A detail from the Dupplin Cross, now preserved inside St Serf's church in Dunning. While much of the church was rebuilt in the 19th century, the cross is now housed beneath the 12th-century tower.

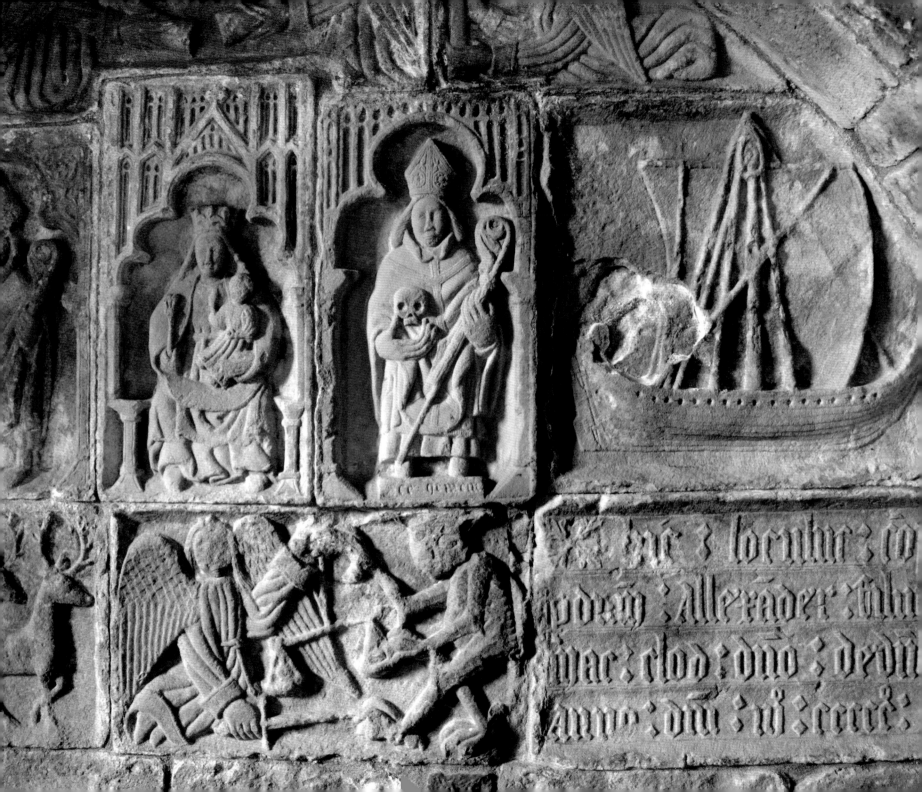

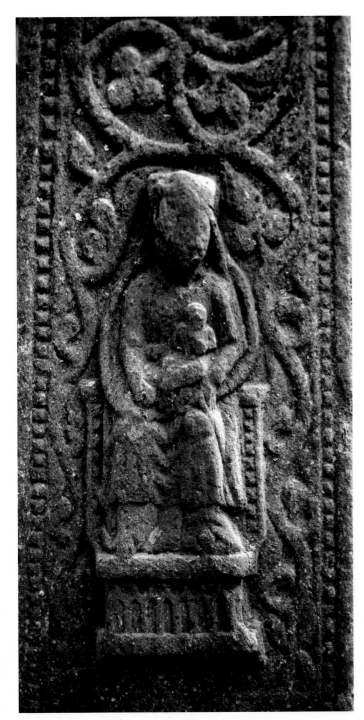

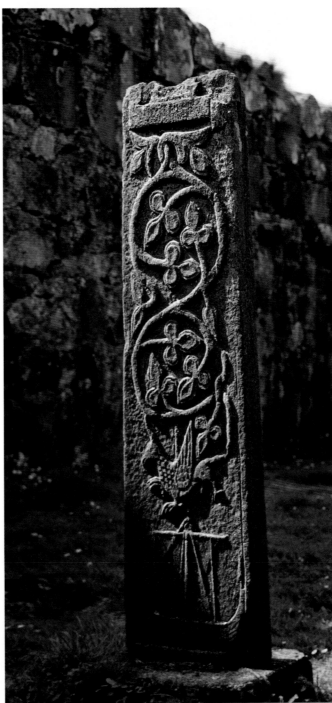

[left] Two views of the cross which stands in the ruined shell of Pennygown Chapel in Salen, Isle of Mull. The chapel itself dates from the 13th century and was apparently abandoned at about the same time as the cross was carved in the early 16th century. One face shows a plant scroll, beneath which is a griffin and a sailing ship. The similarity with the ship on the Rodel tomb (opposite) is unmistakable. Historians believe a crucifix was originally above the scroll. The other face of the 1.3-metre-high sculpture depicts a weathered Madonna and Child, surrounded by the same plant scroll.

[opposite page] St Clement's Church, Rodel, located at the south of Harris, is a curious mixture of the architecturally primitive and the artistically superb. The simple stone church is built directly on to the rock, giving the tower a different floor level to the rest of the building. The simplicity of the exterior gives no hint of the sculptural treasure within: the ornate tomb of Alexander MacLeod. Built in 1528 by and for MacLeod (who was also known as Alasdair Crotach of Dunvegan), the tomb is the finest relic of mediaeval sculpture anywhere in the Hebrides. MacLeod was determined to be buried in style – and determined to enjoy looking at his future resting place, for he had it built two decades before he died.

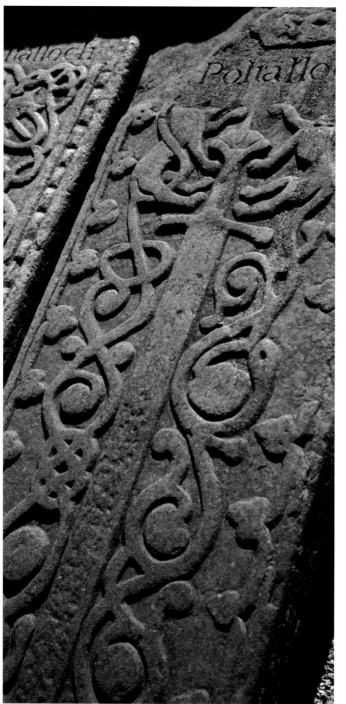

[right] A fine collection of intricately carved stone slabs can be found at Kilmartin, north of Lochgilphead, some of them still in situ in the churchyard, whilst others are preserved in a small building on site. They date from the early 14th through to the 18th centuries.

[below] One of the Kilmodan Sculptured Stones – a group of West Highland graveslabs now preserved in a burial aisle in Kilmodan churchyard – Glendaruel, Argyll. The carving on the stones is typical of local sculptural styles of the 13th–15th centuries.

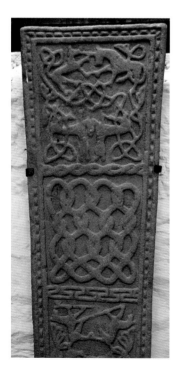

poet William Miller, the 'laureate of the nursery' whose rhyme 'Wee Willie Winkie' (first published in 1841) brought him brief worldwide fame when its words were anglicised and translated – not lasting fame though, for he died destitute in 1872.

Elsewhere, other great Scots are remembered in statues and monuments: Sir Walter Scott on Edinburgh's Princes Street; William Wallace on the monument on the Abbey Craig at Causewayhead; and Alexander Selkirk – the original Robinson Crusoe – whose statue stands recessed in the wall of a house in Lower Largo, Fife. And in memory of a great canine Scot, the bronze statue of Greyfriars Bobby – the faithful dog who stood for years by his dead master's grave – is one of Edinburgh's most photographed monuments, despite repeated attempts to debunk the story.

Some other marks left by men are a little more surprising – not least of them the Dunmore Pineapple, which celebrates the first successful growing of that fruit in Scotland in 1761. Up in the Orkneys on the island of Lamb Holm stands The Italian Chapel, built by prisoners of war in 1943 – a stark and moving reminder of the fact that the British treated their prisoners much more humanely than the Axis powers. Domenico Chiocchetti, a prisoner from Moena, created the beautiful interior murals, and returned regularly after the war along with fellow ex-prisoners to maintain and preserve the building. No other trace of their camp now remains – just their beautiful chapel in a converted Nissen hut.

Another reminder of World War II can be found on a hilltop near the village of Spean Bridge: an area used extensively for the training of British commando units and American Special Forces during the war. Funds were raised very quickly for Scott Sutherland's magnificent bronze group, and it was unveiled only seven years after the war ended.

Not all monuments were funded with such ease or speed. On Edinburgh's Calton Hill, the never-completed National Monument stands like an unfinished Parthenon, in remembrance of the Scots who lost their lives in the Napoleonic Wars. Conceived as a grand and fitting tribute in 1816 – the year after Napoleon's defeat at Waterloo – work started on the huge edifice in 1822, but the funds were never forthcoming and just a fragment of Edinburgh architect William Playfair's Athenian monument was ever built.

Travel anywhere in Scotland, and the marks left by men are all around you. Some are on a grand scale; others are small, poignant and personal. They all add up to the history of a nation.

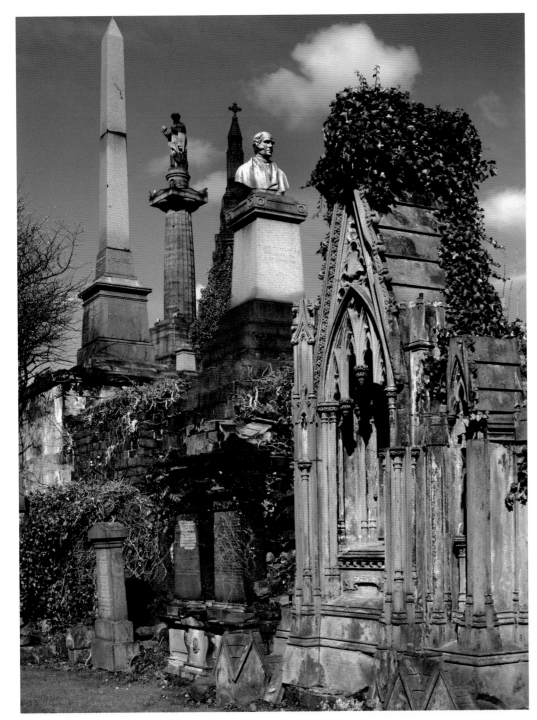

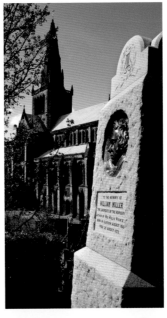

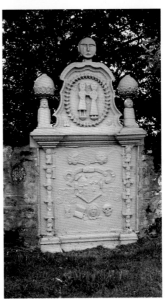

[main picture] The eclectic mix of architectural styles is one of the fascinations of Glasgow's Necropolis.

[left] The memorial to William Miller, poet and author of 'Wee Willie Winkie', seen here with Glasgow's cathedral behind it.

[below left] John Faichney's 18th-century monument to his wife Joanna, who died in 1707, and ten of their children, photographed some years ago in its original position built into a boundary wall in Innerpeffray churchyard. It has now been conserved and relocated inside the church. John Faichney was a local sculptor, devastated by the loss of his wife and the ten of their children who predeceased her. The monument stands nearly 2.5 metres tall, and when photographed had been heavily over-painted after an early attempt at restoration.

[right and below right] The Italian Chapel on Lamb Holm, Orkney, built in a converted Nissen hut overlooking Scapa Flow by Italian prisoners of war in 1943. These photographs were taken before the chapel underwent a major restoration. It is still used regularly for services, and attracts almost 100,000 visitors each year, many of them descendants of the prisoners who built it.

[far right] The marble statue of Sir Walter Scott sits beneath the Scott Monument on Edinburgh's Princes Street.

[below] The Churchill Barriers were created to block off entrances to Scapa Flow at the height of World War II. They carry the roadway which links the line of islands that form one side of the huge natural harbour. They link the Orkney Mainland in the north with the islands of South Ronaldsay, Burray, Lamb Holm and Glimps Holm. Work on them began in 1940, a direct response to the German sinking of HMS *Royal Oak*. Construction took over four years, and the causeway was officially opened in May 1945, just after the war in Europe ended. Over a quarter of a million tons of rock and 66,000 five and ten-ton concrete blocks were used in their construction. Much of the labour was undertaken by the Italian prisoners, with the project designated as roadworks so as not to breach the Geneva Convention.

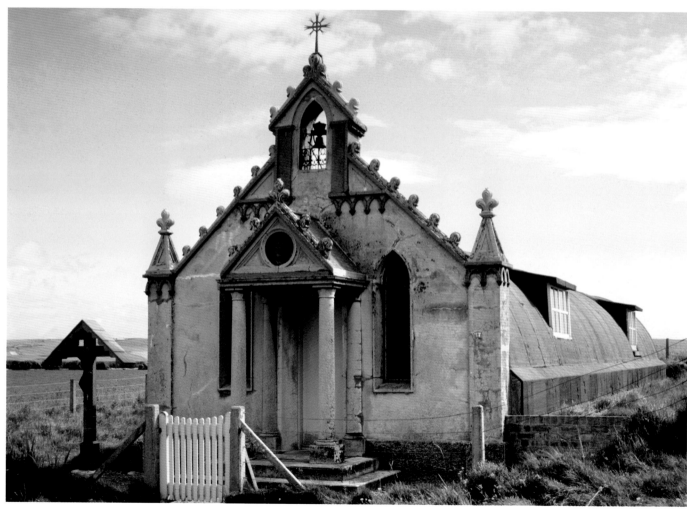

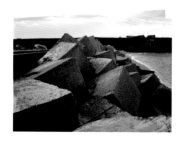

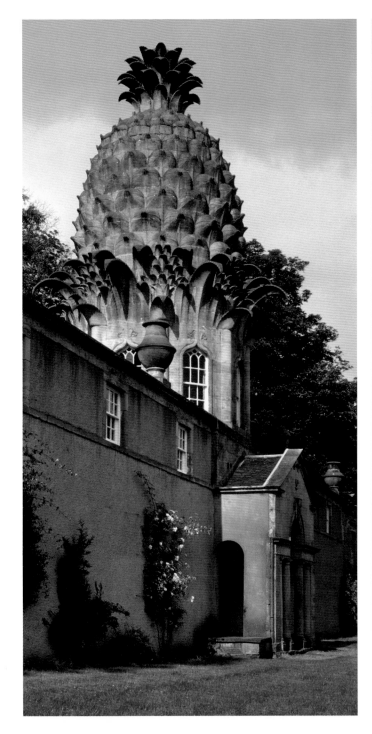

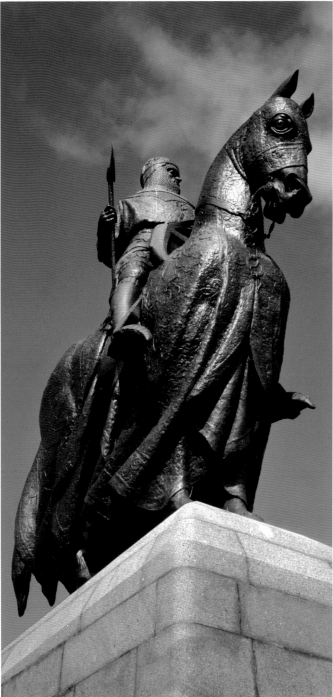

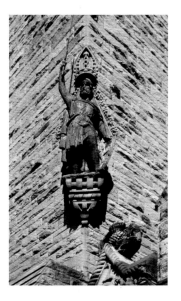

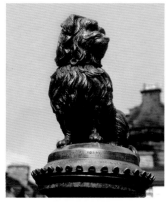

[far left] The Dunmore Pineapple.

[left] Robert the Bruce at Bannockburn.

[top] William Wallace's statue on the Wallace Monument.

[above] Greyfriars Bobby, Edinburgh.

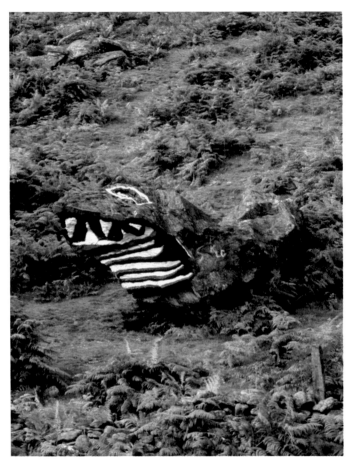

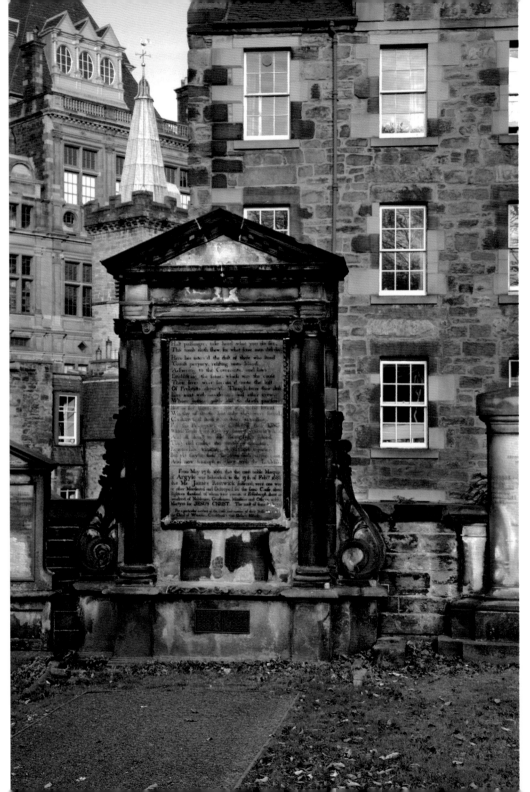

[above] The Crocodile Rock, St Fillans, Perthshire. Nobody knows just when locals started painting this stone to look like a crocodile. The railway line which once ran alongside it was abandoned long ago.

[right] The Martyrs' Monument in Greyfriars Churchyard. Many of those who had signed the Scottish National Covenant in that same churchyard in 1638, repudiating the Episcopacy and confirming their Presbyterian freedoms, were later persecuted under Charles II. Several of them were executed and some lie buried beneath this 'Martyrs' Monument'. Ironically, Judge Sir George MacKenzie, the King's Advocate who sentenced them, is buried elsewhere in the same graveyard.

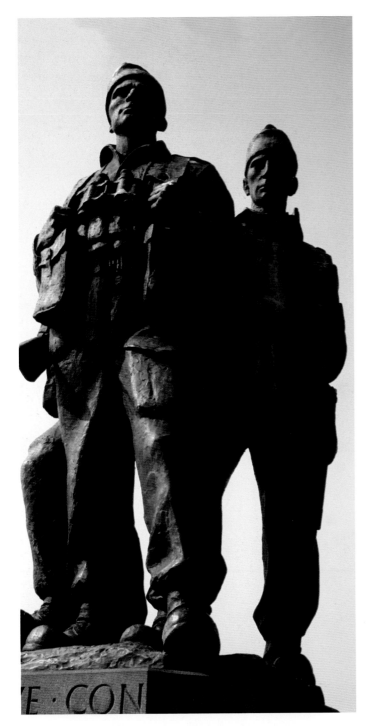

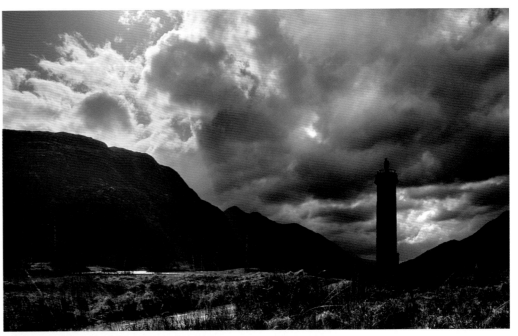

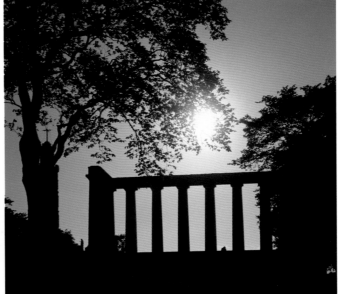

[above] An early spring storm passes over the Glenfinnan Monument, erected in 1815 to mark the spot where Bonnie Prince Charlie set foot on Scottish soil at the beginning of the ill-fated 1745 Jacobite uprising.

[left] The Commando Memorial at Spean Bridge. Cast from a sculpture by Scott Sutherland, the bronze monument was sited on its imposing hilltop position in 1952 to commemorate the many commando units who trained in the area during World War II.

[right] The National Monument on Edinburgh's Calton Hill, work on which started in 1822 and never progressed beyond this small fragment, despite the directors of the trust fund petitioning King and Parliament for funds over the following 20 years.

Land of the Mountain and the Flood

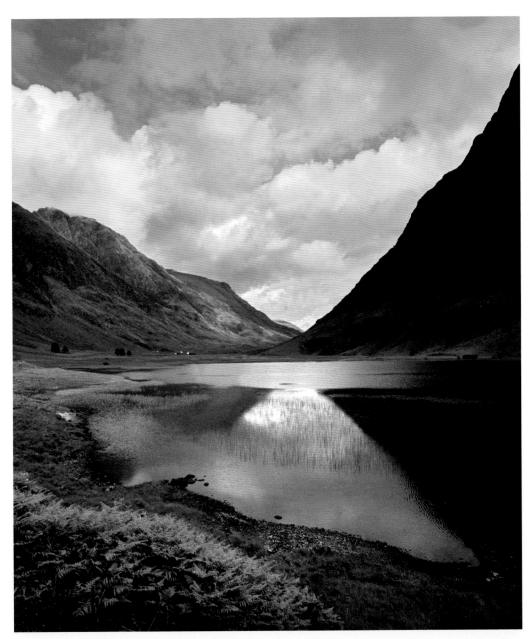

Sir Walter Scott coined the phrase 'land of the mountain and the flood' to describe Scotland in his epic 1845 poem *The Lay of the Last Minstrel*. It was also the inspiration for Hamish MacCunn's 1887 orchestral overture of the same name – his musical interpretation of Scotland's landscape was applauded as being just as evocative as Scott's poetry. As George Bernard Shaw said after hearing the overture's first performance at London's Crystal Palace, it 'carries you over the hills and far away'.

MacCunn was a precocious talent, writing his romantic *tour de force* at the age of only 18. He went on to compose much more music inspired by Scott – a piece entitled *Lay of the Last Minstrel*, and what has been described as the finest late-Victorian opera, *Jeannie Deans*, with the eponymous figure from Scott's *Heart of Midlothian* as the central character. Many composers have sought to interpret Scotland's dramatic landscape in music – Mendelssohn perhaps being the best known with his *Scottish Symphony* and of course his *Hebridean Overture*, also known as *Fingal's Cave*, which was inspired by a turbulent sea crossing to Staffa – but MacCunn could claim to be the only one to have been born and brought up amongst the hills he celebrated in music.

The richness of Scotland's scenery, and the infinite variety of her light is certainly magical and entrancing, but that rugged beauty was formed, accidentally, by the most violent of beginnings.

It is hard to imagine the forces of nature which formed Scotland's rugged landscape, although geologists can tell us that the rocks which form the great mountains are at least one billion years old, and many of them three times that age. Over those three thousand million years, the movement of tectonic plates has assembled rocks from many different parts of the earth's surface

The face which Glencoe shows to the traveller depends entirely on the weather. It can change in moments from one of benign beauty to threatening turbulence. The heavy clouds which roll in over the hills bringing cold and storms have caught out many a traveller. They robe the landscape in a cloak of bleak monochrome which has an austere beauty all its own. Writing in 1773, Samuel Johnson made it clear that he was less than impressed by the weather or the scenery.

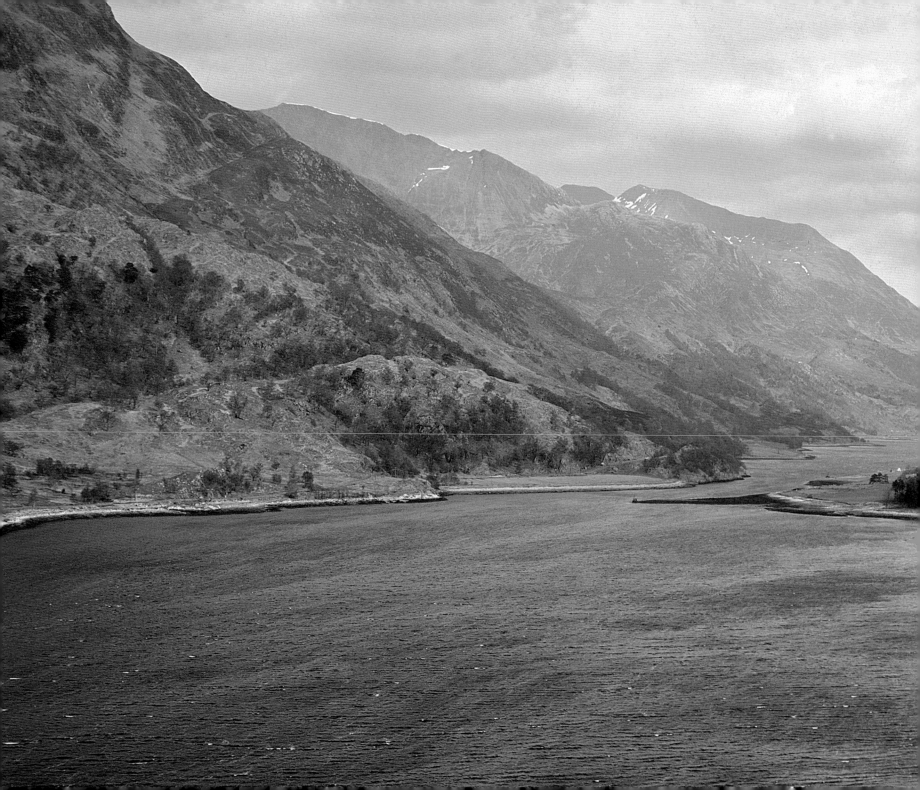

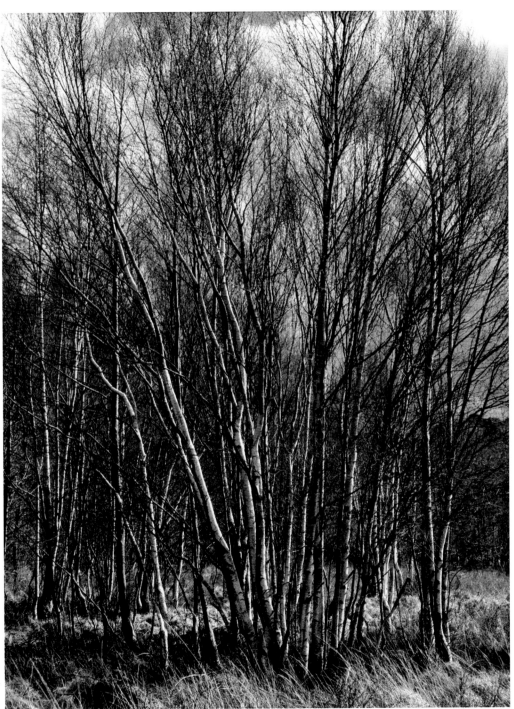

in what we now call Scotland, forcing some of them thousands of feet up into the air, and in so doing, creating the turbulent air movements which give the country its infinitely variable weather patterns. Scientists also tell us that 600 million years ago, the land mass that we call Scotland was actually south of the Equator.

As the continental plates moved and ground against each other, features we recognise today – such as the Great Glen – were created as fault lines, giant cracks in the surface. Elsewhere there were volcanoes, the rims of which still survive, creating the ideal locations, millennia later, for some of the country's most impressive castles.

Through successive Ice Ages – the last of which ended only about 10,000 years ago – glaciers scarred and shaped the landscape, at one point covering the country with ice up to a mile deep. As the glaciers moved and the ice slowly melted and took accumulated sediment with it, water filled the hollows left behind, forming the lochs and river valleys which define the landscape today. While parts of the landscape seem to have been perpetually barren, other areas developed as huge forests, becoming home to a rich variety of fauna and flora and man himself – although man's 8,000-year presence is a mere blink of an eye when considered against the age of the landscape and its rocks.

And for less than 500 of those 8,000 years – since the *Hystory and Croniklis of Scotland* was published in 1541 – man has been writing about the country, its history and its people. For even fewer years have writers tried to express in words their reaction to this dramatic landscape. Published accounts of the country are a fascinating source of information about the land, its appearance, the people who lived there, the work they undertook, and often also about their relationship with the fickle and changing Scottish climate.

The Perth poet William Soutar was one 20th-century writer who understood the Scottish psyche, writing: 'It was a glorious October day; the light had that angelic radiance of a Scottish autumn and its tingling freshness, so welcome to people who enjoy feeling cold, as the Scots often do.' The light in both spring and autumn often does indeed have a clarity and radiance that truly brings the landscape to life.

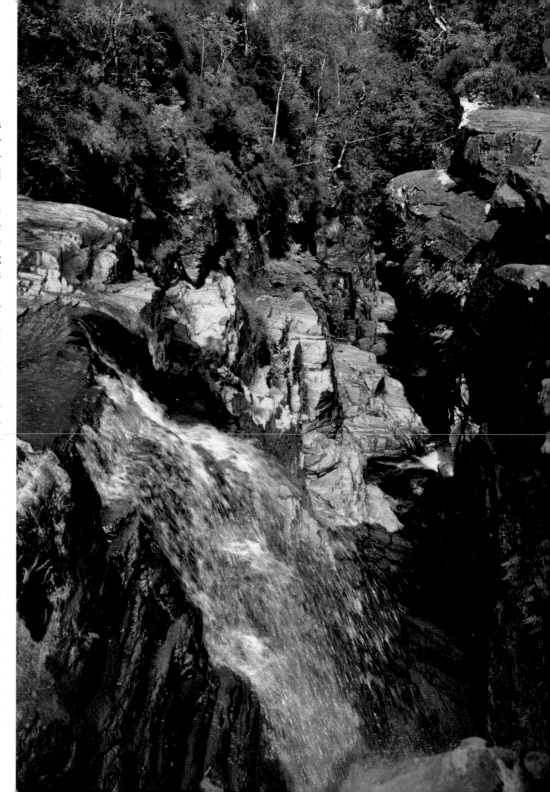

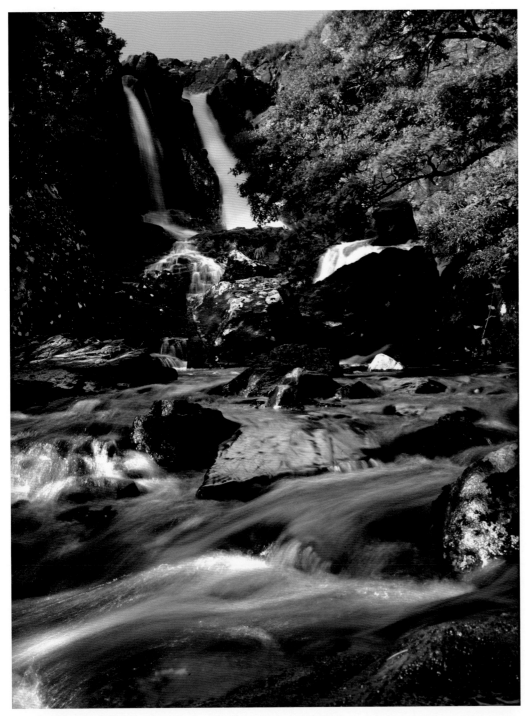

The language of Thomas Pennant's 1772 *Tour in Scotland* may be archaic in places, and his opinions somewhat slewed by the comfort – or lack of it – experienced during his sea voyages and coach journeys, but his account is fascinating; genuinely being a 'first look' at the Highland landscape. Today, we are inundated with photographs from childhood, preconditioning our expectations of what we are likely to encounter on any journey of discovery, so we rarely look at any landscape with truly 'fresh' eyes. But when Pennant disembarked from his ship at Dundonnell and set off on a the long walk to Loch Maree in Wester Ross – telling the captain he would meet the vessel again at Gairloch – he recorded his reaction to the experience in his diary, capturing both the sights and sounds in the words of a true explorer.

This is one of the great descriptions of a landscape, written over 250 years ago – long before today's highly developed appreciation of natural beauty:

'We found ourselves seated in spot equalized by few in picturesque and magnificent scenery. The banks of the river that rushes by the house is fringed by trees; and the course often interrupted by cascades. At a small distance, the ground begins to rise; as we mount, the eye is entertained with new objects, the river rolling beneath the dark shade of alders, an extent of plain composed of fields bounded by groves; and as the walk advances, appears a deep and tremendous hollow, shagged with trees, and winding far amidst the hills. We are alarmed with the roar of invisible cataracts, long before their

[previous page left] Loch Leven, Argyll, from above Ballachulish, with the last of the winter snow still clinging to the mountain tops.

[previous page right] Silver birch trees, winter, near the Glenfinnan Monument.

[far left] Like so many others, Ahbain Culeig Waterfall near Ullapool cascades over numerous rocks and rushes through deep gorges – just like those described with such eloquence by Thomas Pennant in his 1772 travelogue.

[left] Eas Fors Waterfall, on the west coast of Mull rushes under the roadway and over a near-vertical cliff before cascading on to the beach below. It has a curious name: 'Eas' means waterfall in Gaelic, and 'Fors' means waterfall in Norse. So, literally translated, this is Waterfall Waterfall Waterfall! About a mile towards Ulva Ferry a track leads down to the beach and the foot of the falls. From where the road crosses the river, a precarious path zigzags down the cliff and is not for the faint-hearted.

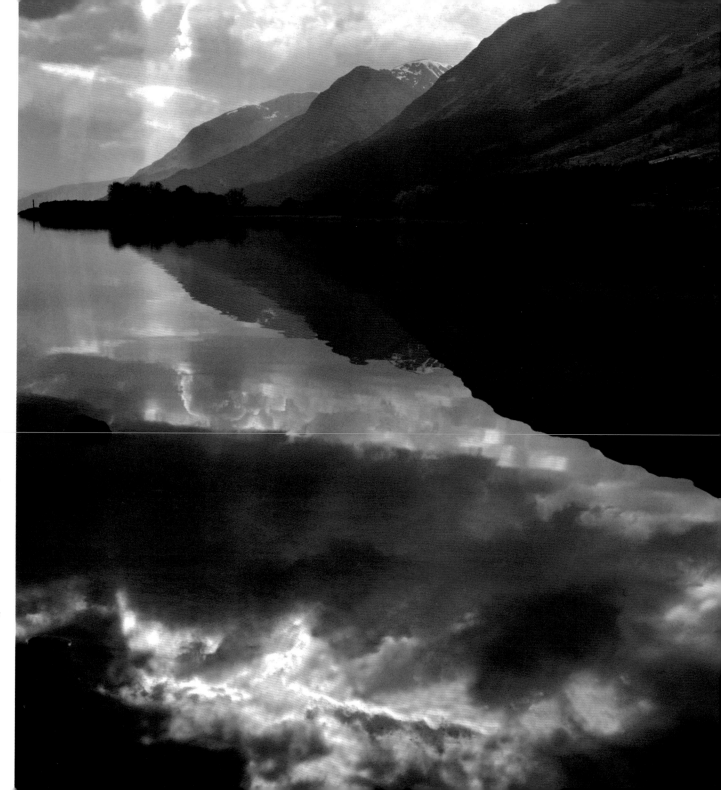

[right] Loch Lochy on a still day in late winter, the mountains still topped with snow reflected in the deep waters. Since the early years of the 19th century, Loch Lochy has been an integral part of the great Caledonian Canal, engineered by Thomas Telford. The huge canal project was conceived as part of a bold plan to revitalise the Scottish Highlands, while at the same time giving naval and merchant ships a short cut across Scotland, avoiding the treacherous waters off the north coast. It was thought by many that nature had already half completed the canal: the four lochs which lie end-to-end along the great Glen – Loch Lochy, Loch Ouch, Loch Ness and Loch Dochfour – really only needed to be linked to complete the job. Telford proposed the plan to Government, and was rewarded with both approval and the post of Director of Works for the project. The project was never a commercial success as it was too shallow, and by the time it was deepened in 1847, merchant ships were already too large to fit through its locks. Today it is used by pleasure craft and the occasional fishing boat.

[far right] From Mingary Castle near Kilchoan, the hills of Mull rise above the horizon across the Sound of Mull. A ferry service from Tobermory to Kilchoan connects the island with Ardnamurchan.

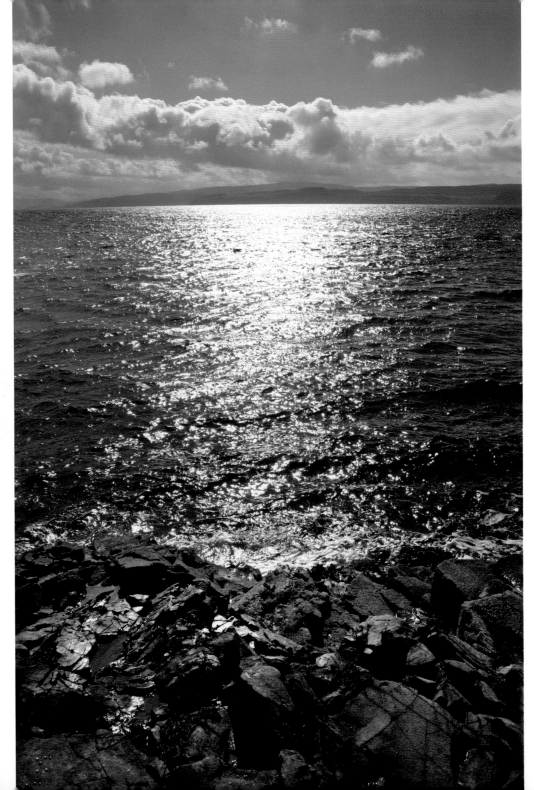

place is discovered; and find them precipitating themselves down narrow chasms of stupendous depths, so narrow at the top, that Highlanders in the eagerness of the chase will fearlessly spring over these barathra. They meander for miles amidst the mountains, and are the age-worn work of water, branch off into every glen, hid with trees of various species. Torrents roll over their bottoms often darting down precipices of a thousand forms, losing themselves beneath the undermined rocks, and appearing again white with the violence of the fall. Besides these darksome waters, multitudes of others precipitate themselves in full view down the steep sides of the adjacent hills; and create for several hundreds of feet a series of magnificent falls. Above rises a magnificent hill, which as far as the sight can reach is clothed with birch and pines, the shelter of stags, roes and black game.'

Just by reading that description, we are there, climbing with Pennant and sharing his total engagement with his environs.

Daniel Defoe, writing of the Highlands in 1727 in his *Tour Through the Whole Island of Great Britain* offered a much more factual account of the countryside through which he travelled, only occasionally offering an insight into the differences between the climate in Scotland's far north and that with which his largely English readership would be more familiar. 'From hence to the west point of the passage to Orkney' he wrote of his journey west from what he called 'John o'Grot's' house, 'is near twenty miles, being what may be call'd the end of the island of Britain'. Of this far corner of Scotland he continued:

'and this part faces directly to the North Pole; the land, as it were, looking forward just against the Pole Star, and the Pole so elevated, that the tail of the Ursa Major, or the Great Bear, is seen just in the zenith, or over your head; and the day is said to be eighteen hours long, that is to say, the sun is so long above the horizon: But the rest of the light is so far beyond a twilight, by reason of the smallness of the arch of that circle, which the sun makes beneath the horizon, that it is clear and perfect day almost all the time; not forgetting withal, that the dark nights take their turn with them in their season, and it is just as long night in the winter.

Yet it is observable here, that they have more temperate winters here generally speaking, than we have to the most southerly part of the island, and particularly the water in some

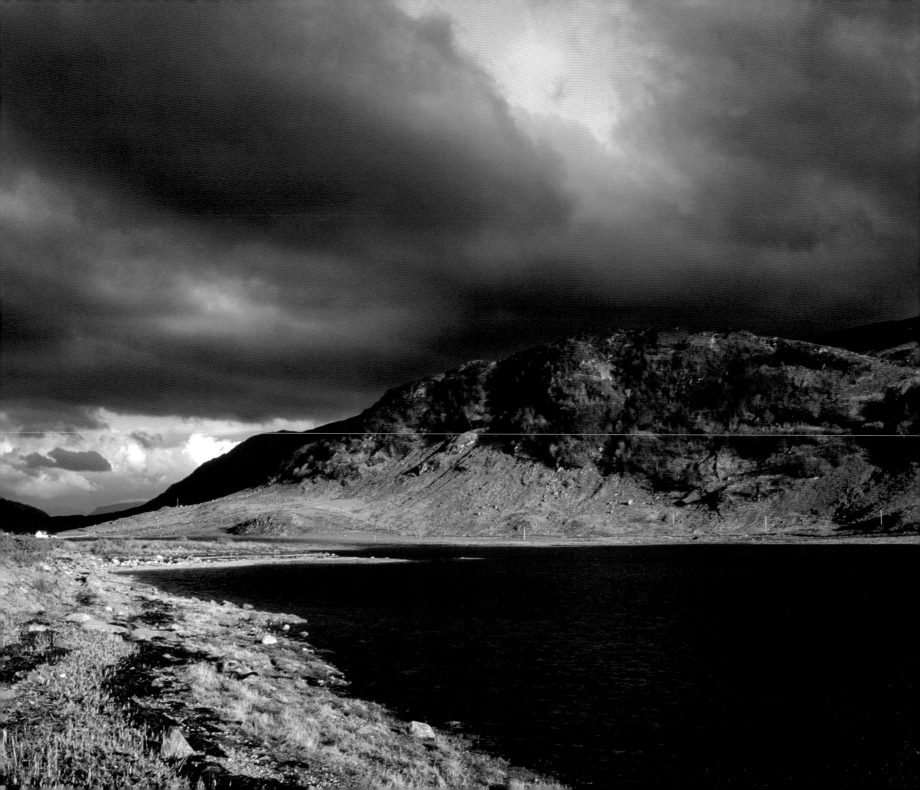

of the rivers as in the Ness, for example, never freezes, nor are their frosts ordinarily so lasting as they are in the most southerly climates, which is accounted for from the nearness of the sea, which filling the air with moist vapours, thickens the fluids and causes that they are not so easily penetrated by the severity of the cold. On this account the snows also are not so deep, neither do they lie so long up on the ground, as in other places, except it be on some of the high hills, in the upper and innermost part of the country, where the tops, or summits of the hills are continually cover'd with snow, and perhaps have been so for many ages, so that here if in any place of the world they may justly add to the description of their country

> – vast wat'ry lakes, which spread below, and
> mountains cover'd with eternal snow.'

It is fascinating to read two contrasting approaches to describing the experience of travelling through Scotland in the first half of the 18th century: Pennant creating a real sense of 'being there' while Defoe, the novelist, largely restricts himself to descriptions of the places he visited and the people he met.

Defoe did, on occasions, come up with more than just simple descriptions. In his poem *Caledonia*, written in honour of Scotland, and published in 1706, he wittily summed up the relationship between the Scots and their climate:

> 'First Younger Sister to the Frozen Zone,
> Battered by Parent Nature's constant Frown,
> Adept to Hardships, and cut out for Toil;
> The best worst Climate and the worst best Soil.'

[opposite page] Glas Bheinn near the head of Loch Suinart glows in late afternoon sunlight, with the dark shape of Creach Bheinn beyond, after the passing of an April storm.

[left] Poppies bloom at the edge of a recently harvested cornfield near the ancient Preston Mill at East Linton, Lothian.

[overleaf left] A winter wonderland. Heavy frost hangs from the trees near Drymen on the edge of the Loch Lomond & Trossachs National Park.

[overleaf right] Rocky outcrops at the edge of Loch Moidart; a sea loch to the north of the Ardnamurchan peninsula.

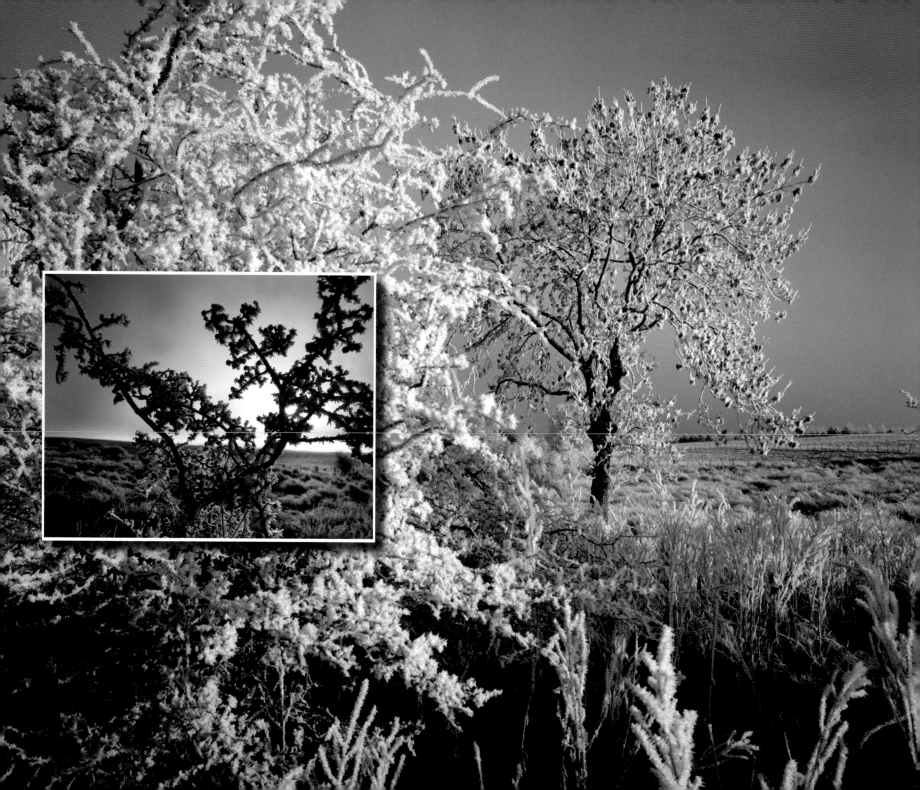

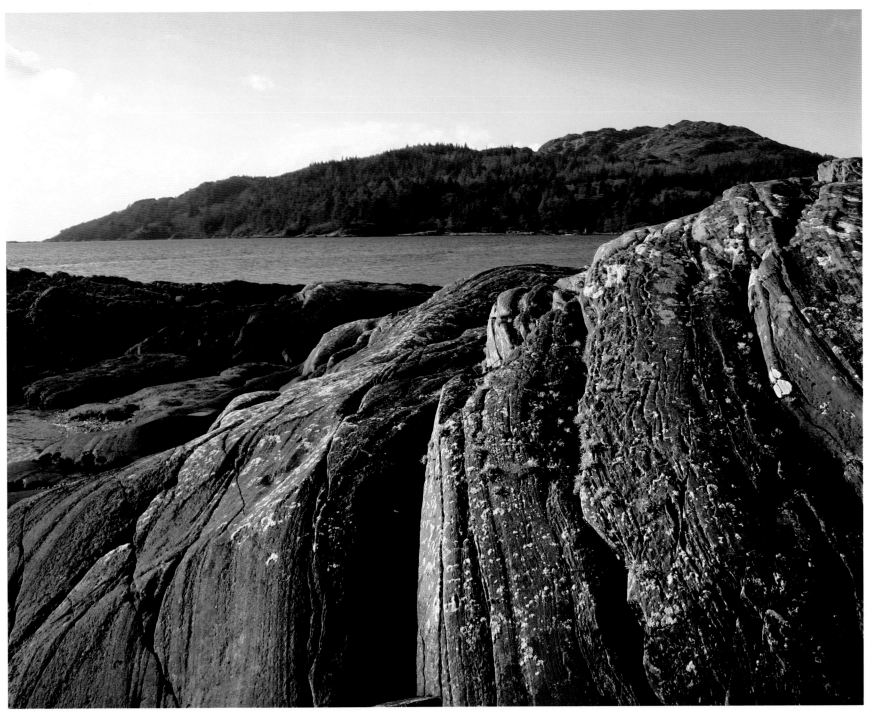

Pennant and Defoe are just two in a long line of chroniclers of Scotland – the lochs and mountains have drawn writers and artists for centuries – and for the past 170 years, photographers as well.

By a coincidence of history, photography and the package holiday are about the same age. It was in 1846 that Thomas Cook organised his first tour to Scotland – taking a group of

[below] Grasses on a winter beach, early morning, Calgary Bay, Isle of Mull.

[right] Silver birch trees in Burnfoot Woods near Gatehouse of Fleet grow amidst a springtime bed of bluebells and wild garlic.

[opposite] Low tide at the head of Loch Scridian on the Isle of Mull, with the barren winter slopes of Bein na Srèine disappearing up into the low cloud.

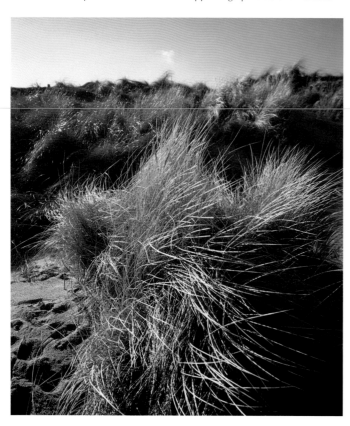

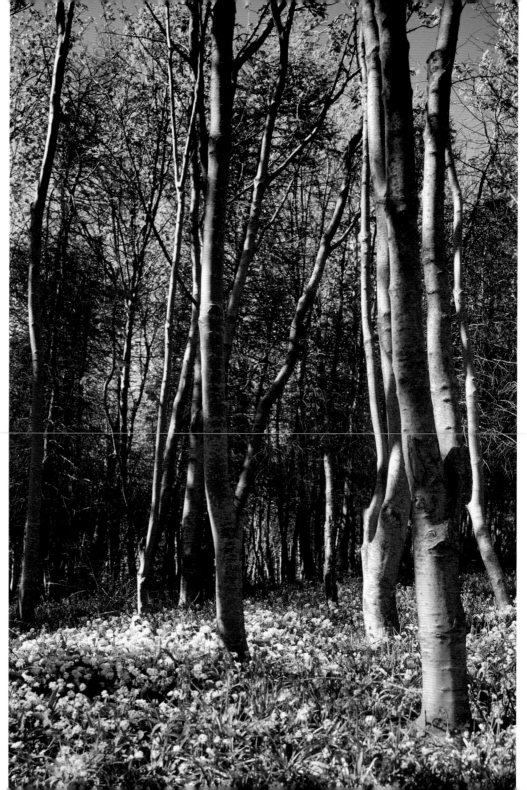

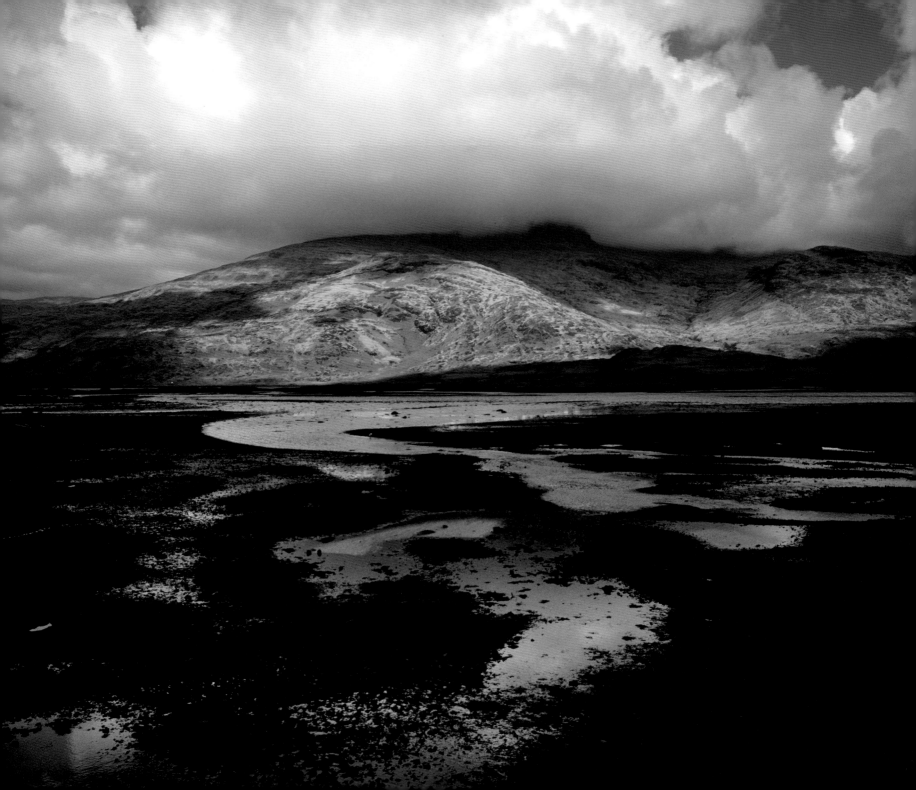

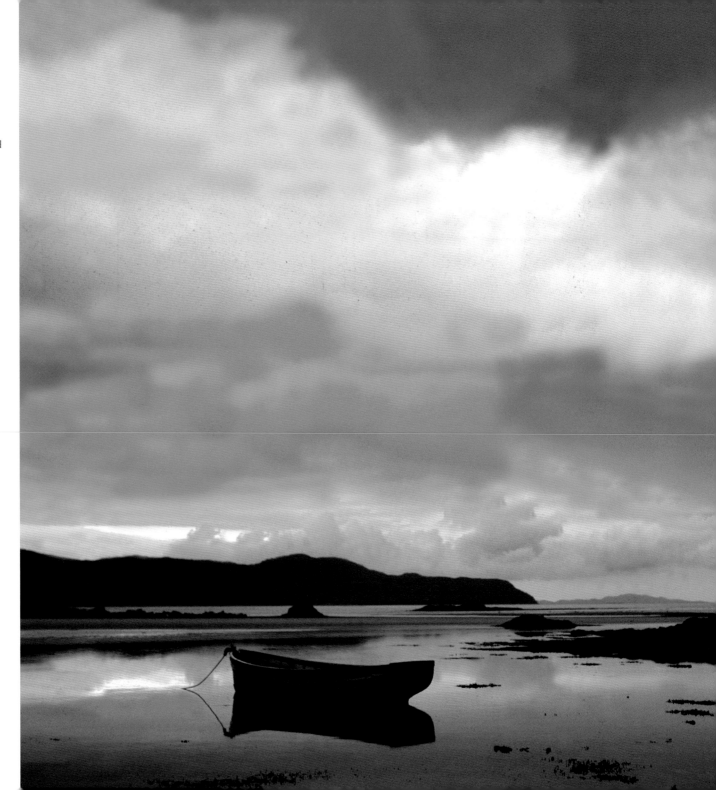

[right] On a cloudy but completely placid summer's evening, Broadford Bay on the Isle of Skye has been drained of almost all of its colour – yet still retains a striking beauty. Beyond this quiet corner to the north lie the islands of Scalpay, Longay and Pabay, and in the distance, the mountains of the Applecross peninsula in Wester Ross.

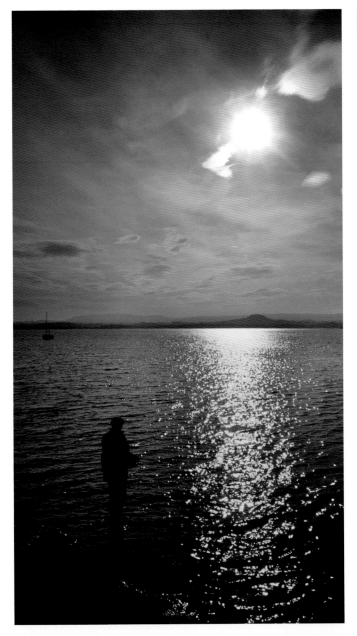

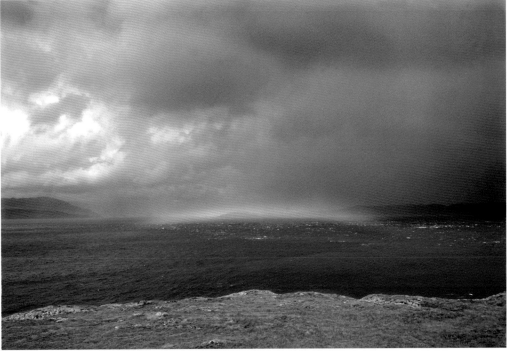

holidaymakers on a tour of the Trossachs, and the many of Borders locations associated with the life and work of Sir Walter Scott. In that same year William Henry Fox Talbot, inventor of the world's first photographic process which produced a negative from which countless prints could be made, visited Scotland to take the photographs for *Sun Pictures in Scotland*: a bound portfolio of photographs – the first Scottish 'coffee-table book' – also celebrating Scott's life and work. Other photographers would follow in his footsteps so that by the 1870s there were photographs available for purchase of just about every scenic view in the country.

Hampered by long exposure times and limited to only sepia, these early photographs offered a very flat and static view of Scotland. Their monochrome negatives were sensitive only to blue light, distorting the tonal relationships within the

[left] A fisherman stands immobile in the waters of Millarochy Bay, Loch Lomond.

[above] Looking up Loch Linnhe from Duart Point – the Mull headland on which stands Duart Castle. A break in the clouds as a storm rolls over the long narrow island of Lismore creates a dramatic rainbow just above the waters of the loch.

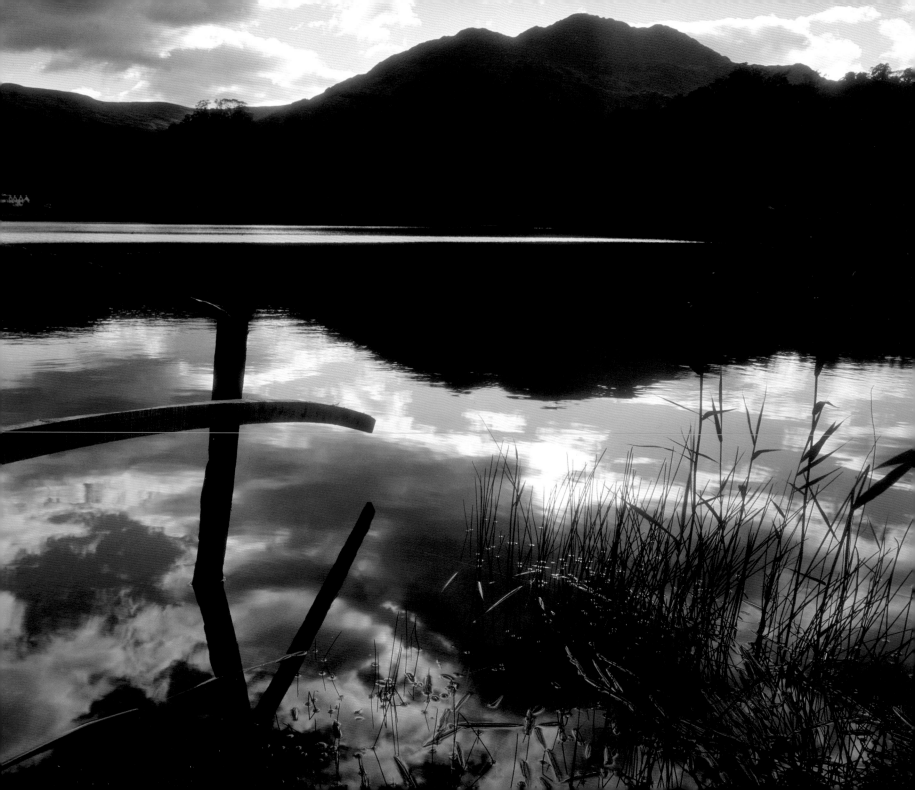

[opposite page] The black silhouettes of the Trossachs mountains reflected in still waters of Loch Achray.

[left] The island of Hoy seen across the Pentland Firth from the deck of the Orkney ferry as it makes its way north from Scrabster.

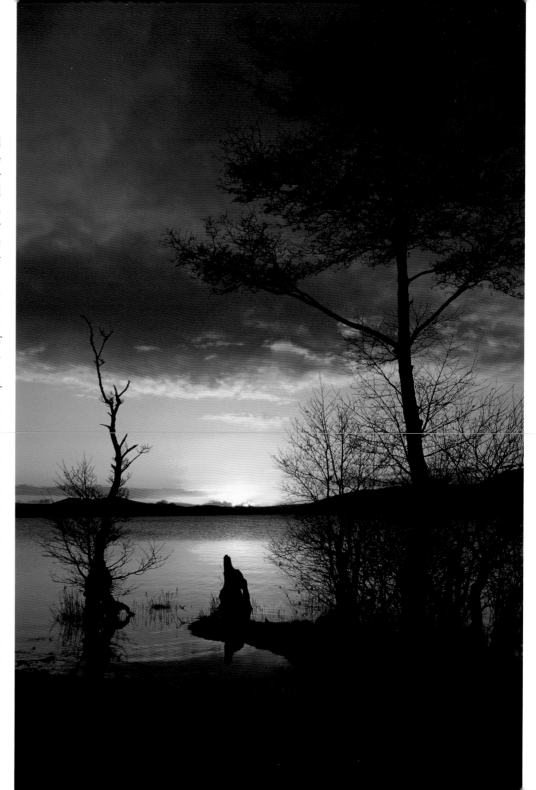

landscape, and the length of the exposure necessary to record detail in the rich browns and purples of the moors and the trees invariably created bland plain skies. But despite their limitations they opened the country up to tourism as more and more people wished to experience the places they had seen in pictures. But this was not easy. As the Victorian photographer George Washington Wilson noted when walking in the same remote corner as Pennant had done 150 years earlier, poor weather effective rendered photography impossible:

'After breakfast Gellie and I took a walk up a footpath which leads to the Corrie of Ben Eay. Saw on our way down a capital view looking down a gullie towards Craig Roy. Went on to the end of the footpath about 3 miles and had a splendid view of Ben Eay. After going a little further over the quartz rocks, saw down the glen by the back of Ben Luigeach and Ben Alligan. We then went up a hill to the right some distance and saw a peep of Loch Maree and had a fine view of Ben Slioch, Craig Roy and the mountain beyond. Came on to rain. We got a soaking before reaching the inn at Kinlochewe.'

He tried again the following day, but the Scottish weather foiled him again: 'The morning looked promising, we started off for the Corrie of Ben Eay the coachman carrying the basket and camera up the hill. It got dark before we reached the first corrie... rain before we got down.'

Even a light wind would blur the trees during an exposure often of several seconds – especially in dull weather. So, still days and good light were essential – not characteristics the Scottish weather can be counted on to display.

In taking his travellers to the Trossachs, Thomas Cook introduced them to the most accessible glimpses of the Scottish Highlands – for within the Trossachs is Highland Scotland in microcosm. There, only a relatively short drive from the flat

[right] A dramatic Christmas Day sunset looking west across Loch Lomond from Mullarochy Bay.

[opposite page] Looking west from a high vantage point by the roadside, Loch Garry seems to take on the familiar shape of a map of Scotland.

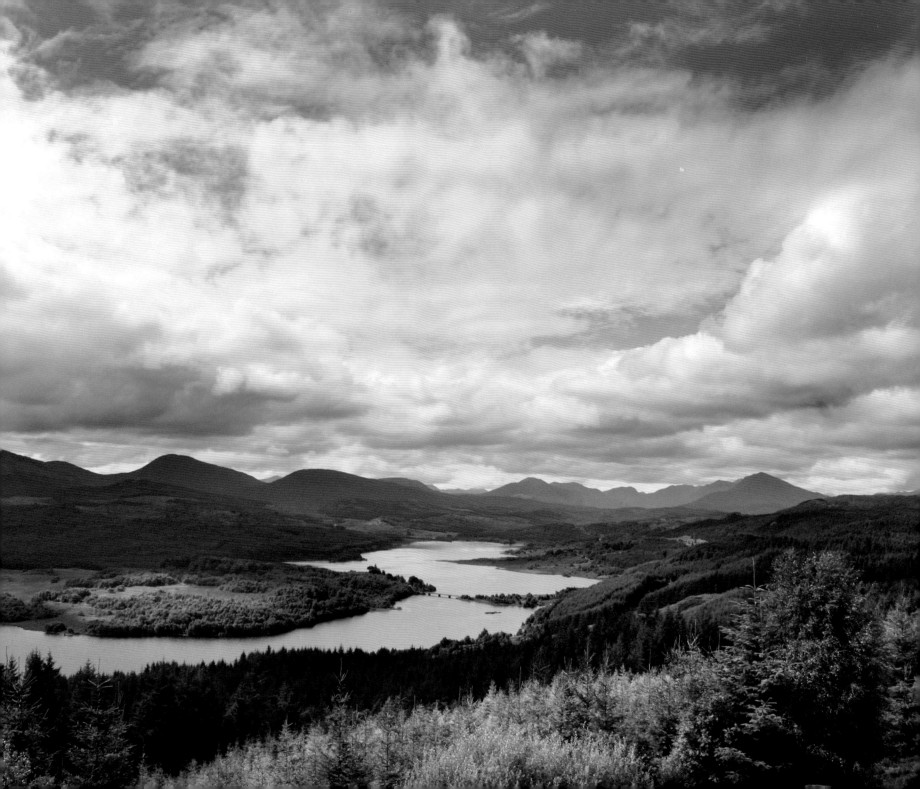

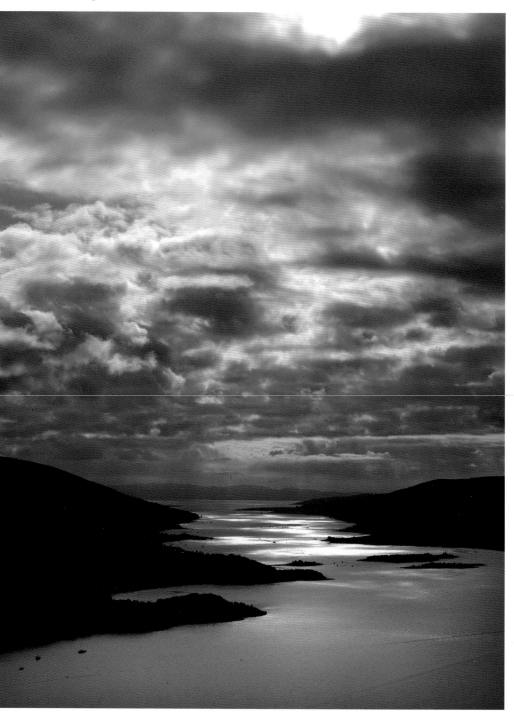

[top] Rowan berries on the shores of Loch Katrine, the jewel of the Trossachs.

[above] A still day at Otter Ferry on the shores of Loch Fyne, Cowal.

[right] A dramatic morning view looking south down the Kyles of Bute.

[opposite page] The first tints of autumn in the Queen Elizabeth Forest Park, Trossachs, with Loch Achray and Ben Vane in the distance.

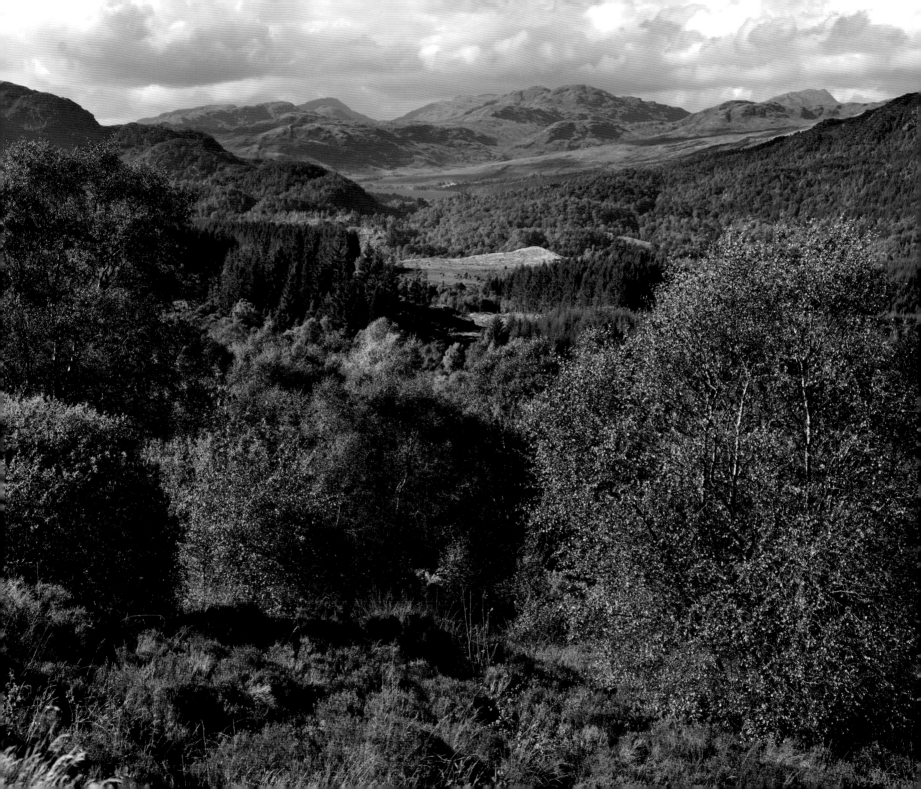

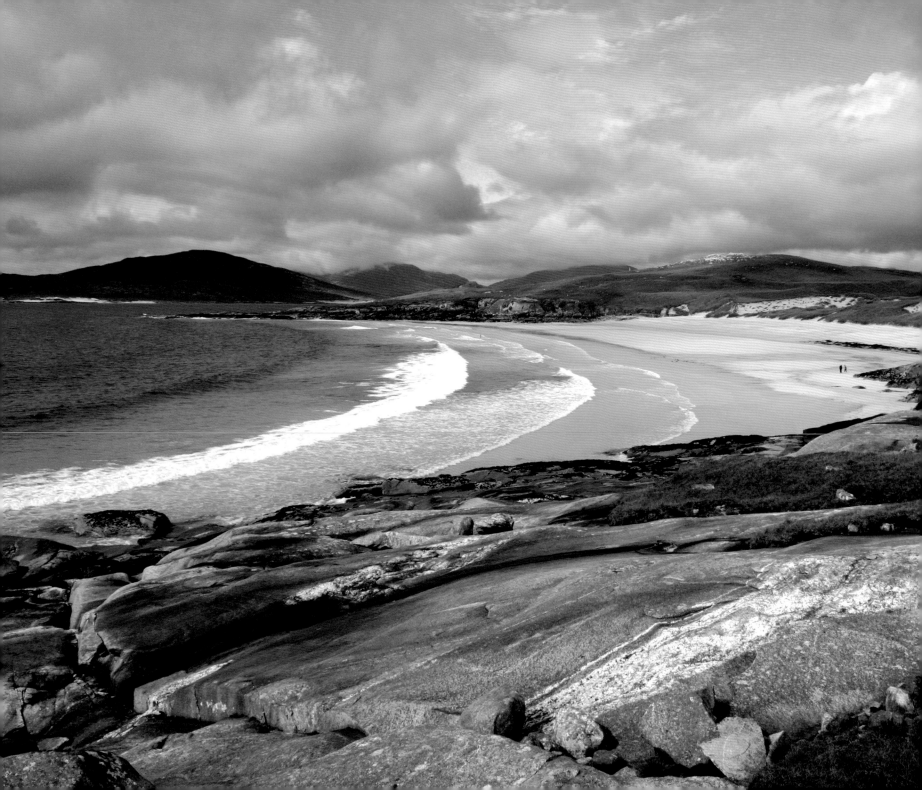

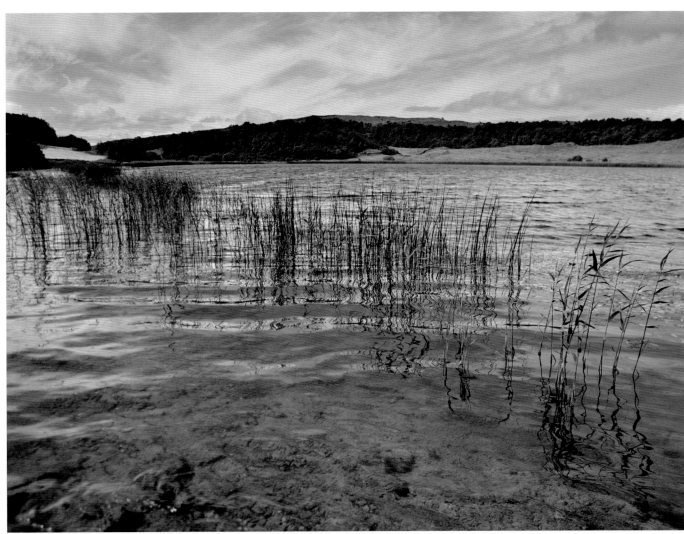

[left] Two people walk along the otherwise deserted sands of the beautiful na Buirgh beach on Harris. Like so many places on and off Scotland's west coast, it is the emptiness and complete tranquility of such places which is their perpetual attraction.

[above] Kilcheran Loch, a small stretch of water on the island of Lismore. The ruins of crofts abandoned during the Highland Clearances can still be seen by the loch side. Port Kilcheran nearby once bustled with activity, with lime kilns and a busy harbour. Today this quiet corner of south eastern Lismore is virtually deserted.

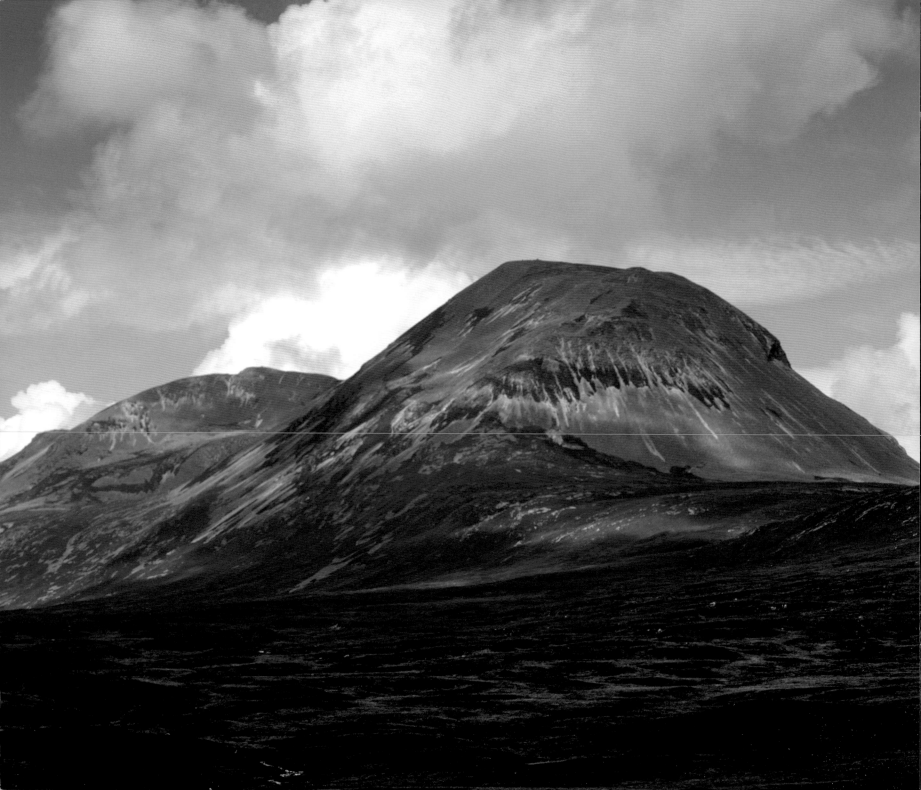

carse of Stirling, the traveller is suddenly and dramatically confronted by steep mountains, long deep lochs, and lush forests.

While the Trossachs remains a tourist magnet to this day, few venture further north where, for the next two hundred miles – with beautiful and infinite variations – the drama unfolds repeatedly.

In the centuries since Pennant, Boswell, Johnson and others wrote their pioneering accounts, many others have written of their experiences travelling in Scotland: amongst those in the 20th century, Henry Vollam Morton stands out. Born in Lancashire, H. V. Morton rose to international fame as the journalist who accompanied Howard Carter into the tomb of

[left] The bleak scree-covered slopes of the Paps of Jura dominate the island, and the skyline for miles around.

[above:] Rich colours adorn the hillsides in Glen Nevis.

51

Tutankhamun, but really established his enduring renown as a travel writer. Morton's humour, his ability to paint word-pictures and above all, his sheer love of Britain, mark his books out as delightful reading. In the second of his two seminal Scottish travelogues *In Scotland Again* – published in 1933 and probably one of the most readable accounts of a Scottish journey ever published – he wrote of his last few days on Mull:

'Rain fell with the nagging persistence of toothache. There were moments when it would torment with a pretence at ending, only to resume with renewed vigour. The sky fell. The earth gushed water. Boulders shone like brown glass. Mists hung out of heaven to wrap the world in a grey wetness. Burns spouted. Rivers rose to the bridges. Pools overflowed. New and unexpected streams were born out of a responsive earth. The wind joined in, hurling the rain upwards in sudden mad gusts, so that in the magnificent sincerity of the storm, the very laws of gravity were defied and, in other words, it was made perfectly clear why Scotland invented whisky.'

Whether he was on Scotland's west coast or deep in the English Lake District, Morton saw the dramatic changes the weather wrought on the landscape as one of the delights of travelling. A good job, for as any traveller in Britain knows only too well, the idea of 'four seasons in one day' is not entirely fanciful. 'Scotland is two absolutely different countries' wrote Morton: 'Scotland in sunlight and Scotland in rain. One is the most beautiful country in the world and the other is the most awesome.' He went on to suggest that 'it is to these grey fearful days that one can trace the moody, poetic, sensitive temperament of the Gael'.

Not everyone shared his summary of the Gaelic temperament – in print at least there were notable dissenters. Samuel Johnson, writing in 1733, believed that until the Act of Union earlier that century had brought civilization in the form of what he described as 'English manners' to the Highlands, 'the culture of their lands was unskillful, and their domestic life uninformed, their tables were coarse as the feasts of Eskimeaux, and their houses as filthy as Hottentots'.

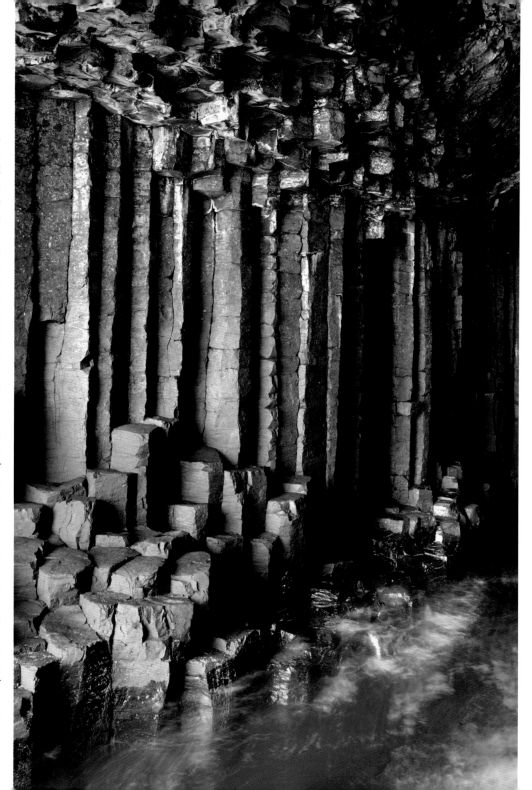

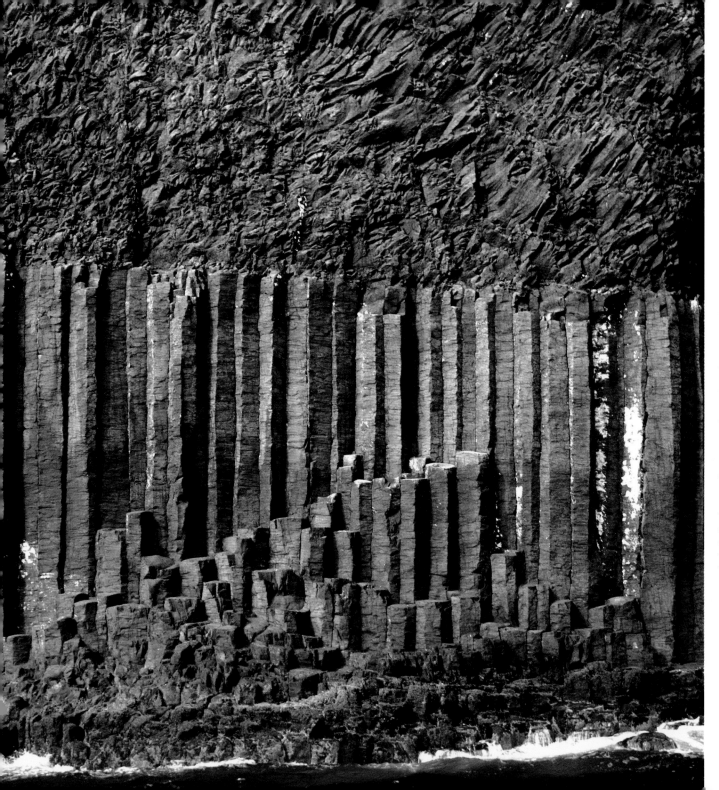

The spectacular island of Staffa has long been a magnet for artists, writers, composers and photographers – but getting there can be a memorable experience. Mendelssohn, Boswell, Johnson and many others have all taken to boats, large and small, to marvel at its spectacular coastline.

[far left] The interior of Fingal's Cave.

[left] Some of the basalt columns which rise up out of the sea. Those columns most famously seen both on Staffa and at the Giant's Causeway in Ulster also reveal themselves on the west coast of Mull. The 18th-century traveller Thomas Pennant noted in his 1772 account of his tour of Scotland: that Staffa was 'a new Giant's Causeway, rising amidst the waves; but with columns of double the height of that in Ireland'. A heavy swell, and the reluctance of his boatman to go closer in to shore, precluded Pennant landing, much to his chagrin. In the centuries since, many others have shared his disappointment, as the seas around the rocky island are notoriously fickle.

[right] Meall Lochan a Chleirich, near Gairloch is typical of the wild landscape of Wester Ross – bleak and in winter, very cold – yet due to a quirk of global air and water currents, at Poolewe only a few miles away on the coast there is a tropical garden where palm trees and a host of other exotic flora grow.

[opposite page] Lochan na h'Achlaise on Rannoch Moor is one of many small lochans which are dotted across the peaty moorland. While here too the weather can be bleak and forbidding, under an evening sun it is a beautiful place.

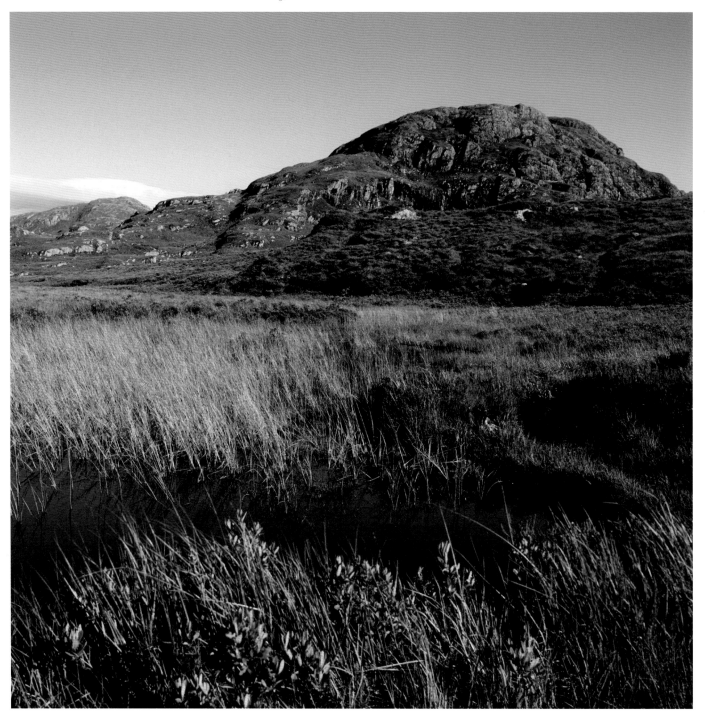

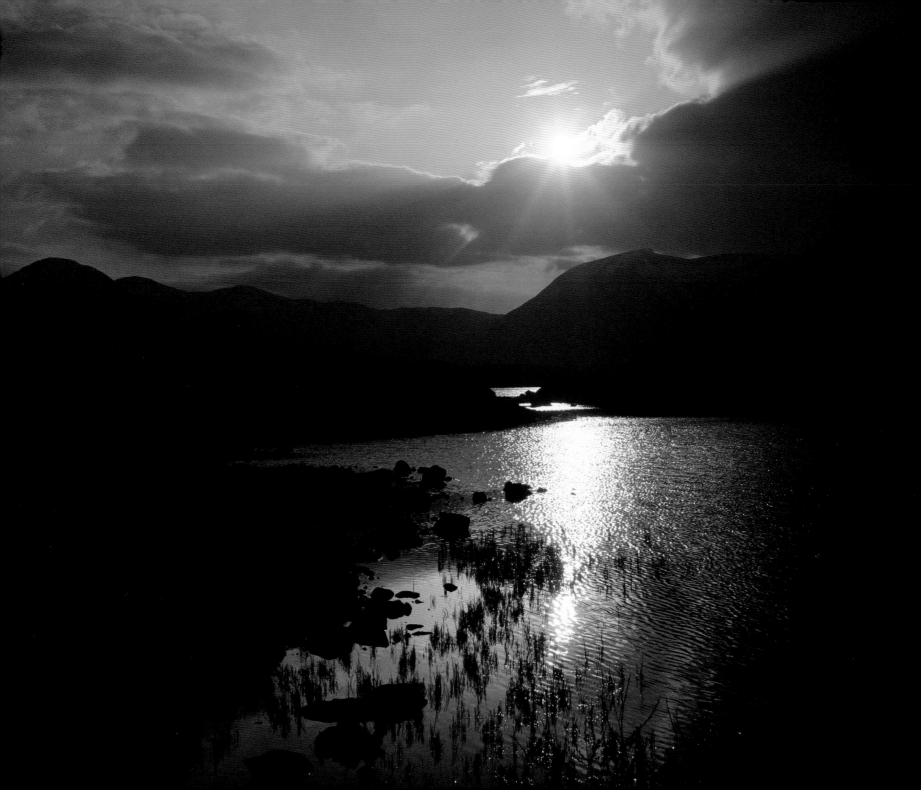

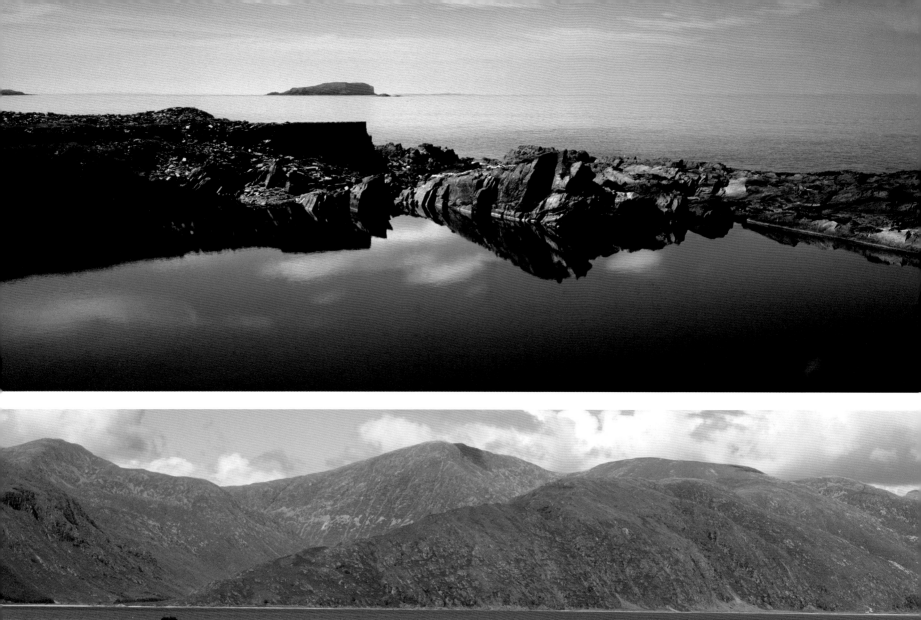
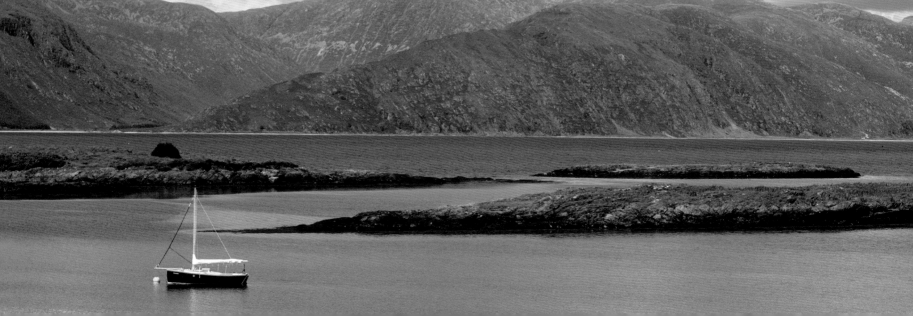

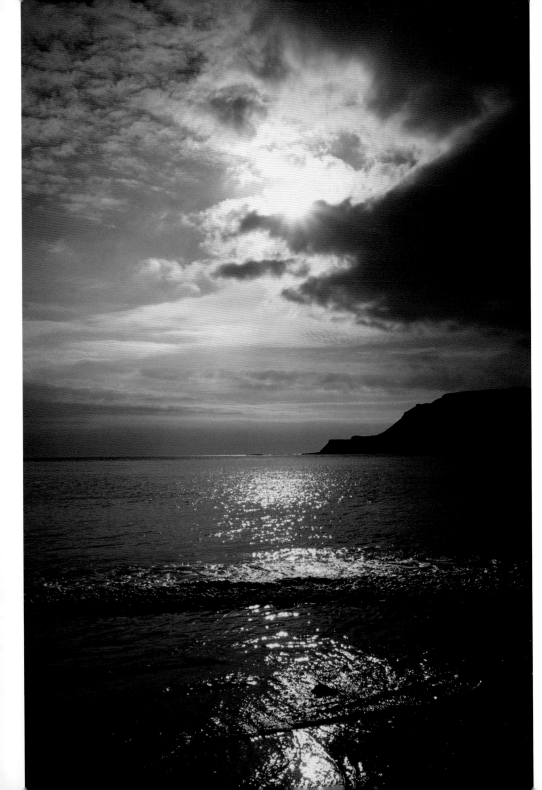

The Scottish-born naturalist John Muir – who would become an important influence within the nature conservation movement in late-19th-century America – writing of his Scottish childhood in East Lothian, paid homage to the landscape, the climate and, above all, the light: 'How our young wondering eyes reveled in the sunny, breezy, glories of the hills and the sky, every particle of us thrilling and tingling with the bees and the glad birds and glad streams.' Later, he got it right when he said: 'Storms are never counted amongst the resources of a country, yet how far they go towards making brave people.'

The 16th-century writer Sir Thomas Craig, observed that, despite the unpredictability of its climate, 'there is no land in which a man may live more pleasantly and delicately than in

[opposite page top] The still waters of one of the lagoons created when the Easdale slate quarries flooded. This lagoon is now used as the setting for the World Stone Skimming Championships.

[opposite page bottom] Beinn na Cille and Creach Bheinn viewed across Loch Linnhe from near Port Ramsay on the island of Lismore.

[left and above] Two views of Calgary Bay on Mull, taken within just a few minutes of each other, reflect how quickly the light and the weather can change.

Scotland'. Generations of Scots developed a deeply held love of their country's rugged beauty, and it is, perhaps, not surprising that when driven overseas to earn their livelihood or seek their fortune, they chose similar landscapes in Canada, New Zealand and elsewhere.

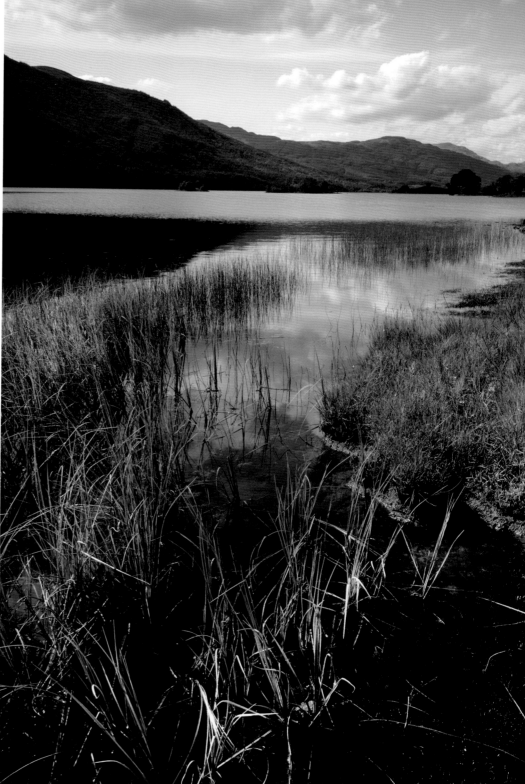

[above] The rocky beach at Southernness on the Solway. Rock shapes like these remind us of the forces of nature which moved these rock shelves millennia ago.

[right] Reeds at the edge of Loch Chon, one of the many small lochs in the Trossachs.

[far right] The white sands of the beach at Fionnphort are edged with magnificent rocks. Just a few yards away is the slipway for the short ferry crossing to Iona.

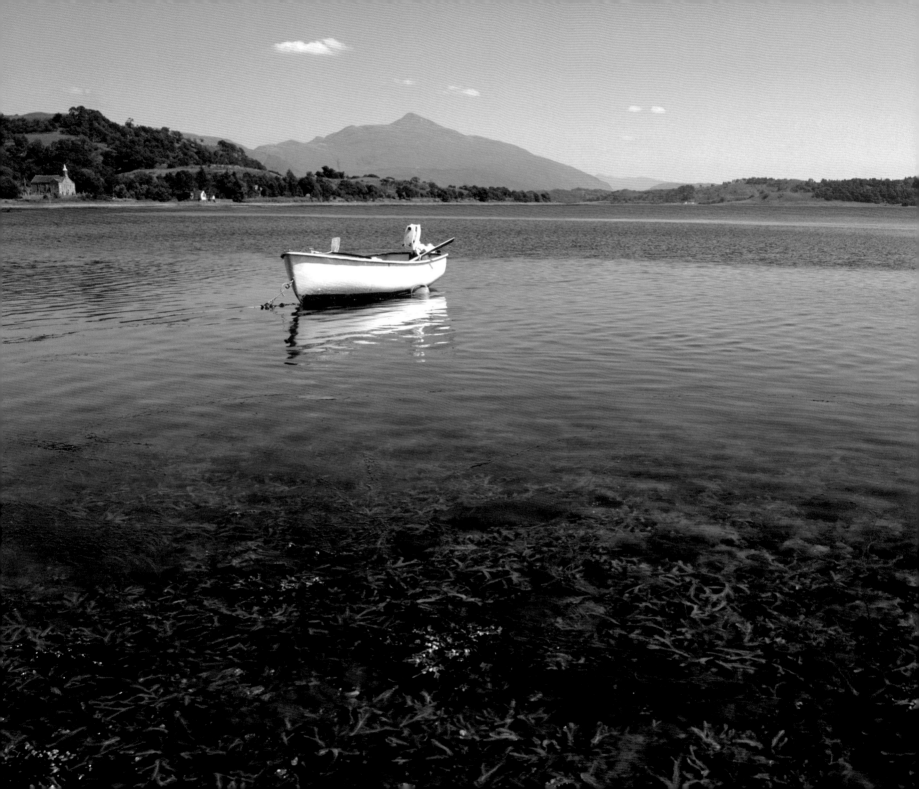

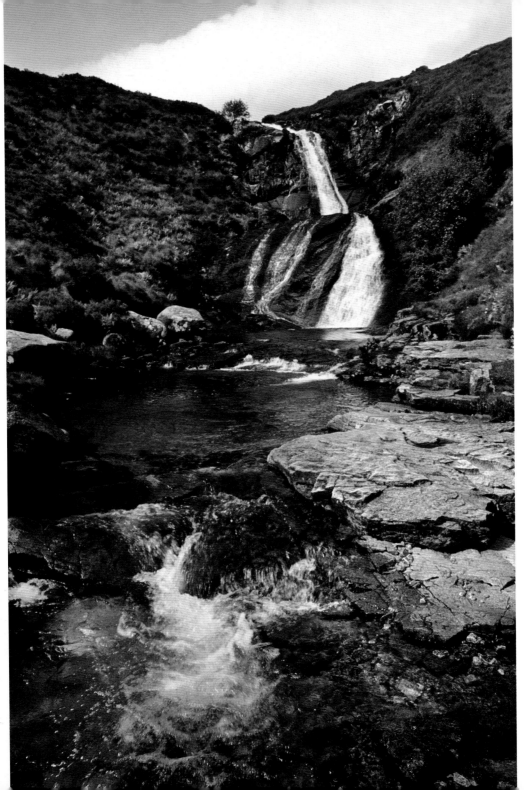

[far left] A still day on Loch Etive. In mediaeval times, the loch was a rich source of food for the monks of nearby Ardchattan Priory. In later years, it became one of the Highland's centres for iron smelting – the preserved remains of Bonawe Iron Furnace are open to the public. Once served by steamers from Oban – the loch enters the sea at Connell – Loch Etive is now a beautiful backwater.

[left] Waterfall, Loch Ainort, Isle of Skye.

[above] Patterns in the sand left by a receding tide, Iona. The island is blessed with beautiful stretches of sand, but most visitors hardly notice the shoreline as they step from the ferry and stride off towards the ancient religious sites which have brought them to the island.

[right] Reeds by the shores of Loch Scridian near Derevich, with the mountains of Mull behind them. In centuries gone by, crops like this would have provided valuable roofing material for the croft and other buildings which once dotted this landscape.

[opposite page] Auchendowie, near Lundin Links, Fife after the harvest, early morning.

[opposite page] Loch Lomond's still waters on a cold winter's morning.

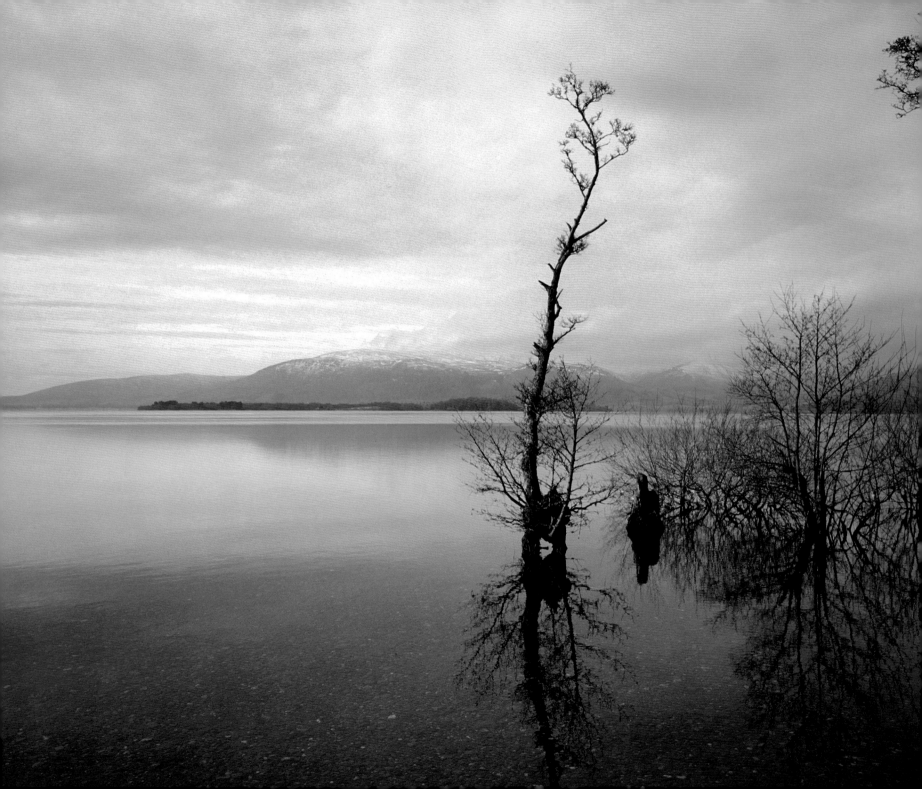

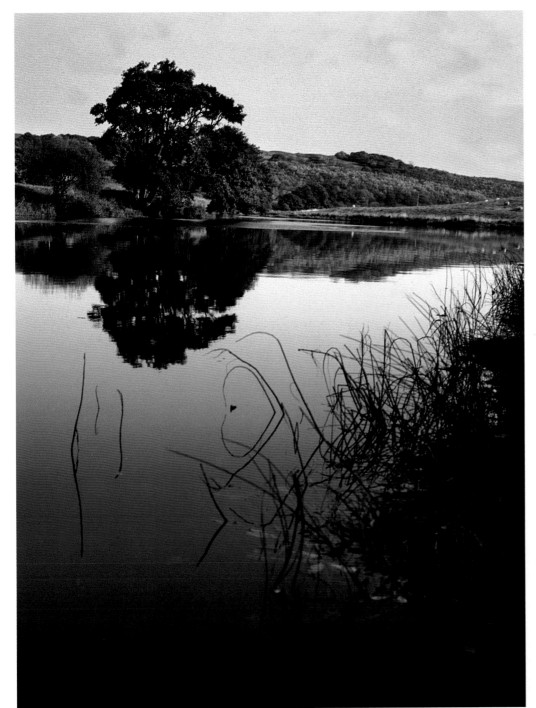

[main picture left] The still waters of the River Cree in Galloway on an autumn evening.

[above] A Galloway farmhouse nestles amidst autumn foliage.

[left] Bog cotton blowing in the wind at Quanterness in Orkney.

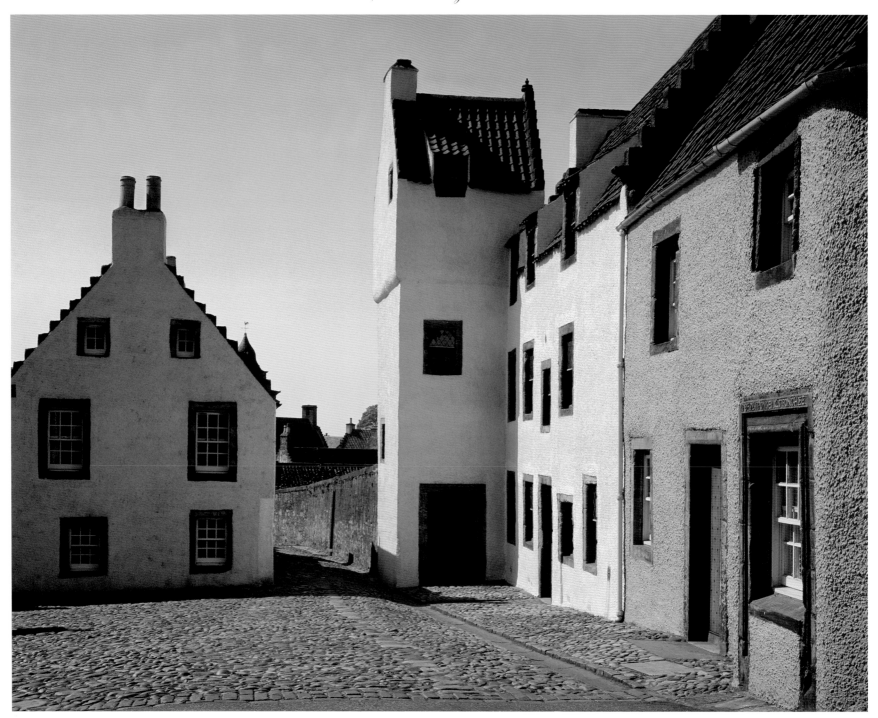

Great Houses and Humble Dwellings

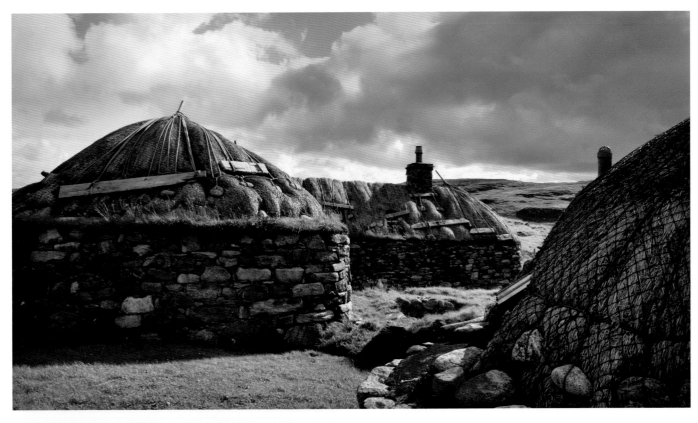

[opposite page] The Fife village of Culross retains much of the charater of an 18th-century coastal village. The owners of Culross made their money out of coal and salt, exporting their produce to many ports in northern Europe from mediaeval times. As ballast, ships returning empty from Holland and the other Low Countries brought pantiles, and introduced a roofing material which has defined the domestic architecture of Scotland's east coast ever since.

[left] The blackhouses of Gearrannan on the island of Lewis are roofed in a style little-altered for over two millennia.

[bottom left] Roof detail from a reconstructed Iron-Age house on the island of Great Bernera. The foundations of a close-knit group of iron-age houses – the predecessor of the Scottish blackhouse – were revealed just above the beach after a storm in the 1990s. Apart from the chicken-wire, the roofing style is believed to be appropriate for the period.

In a remote location on the west coast of Lewis, a group of blackhouses – traditional dry stone buildings covered with turf or thatched roofs – recall a time when living conditions such as these were the norm in the Scottish islands. Similar examples can be found throughout the Western Isles, some preserved as museums but many others, as at Gearrannan, are traditional only on the outside. Despite their primitive and basic external appearance, a surprise awaits inside. Some of the cottages have been refurbished as high-quality holiday lets, with all the comfort and equipment a 21st-century holidaymaker would expect. A far cry from the harsh existence of the islanders for whom houses like these were built centuries ago.

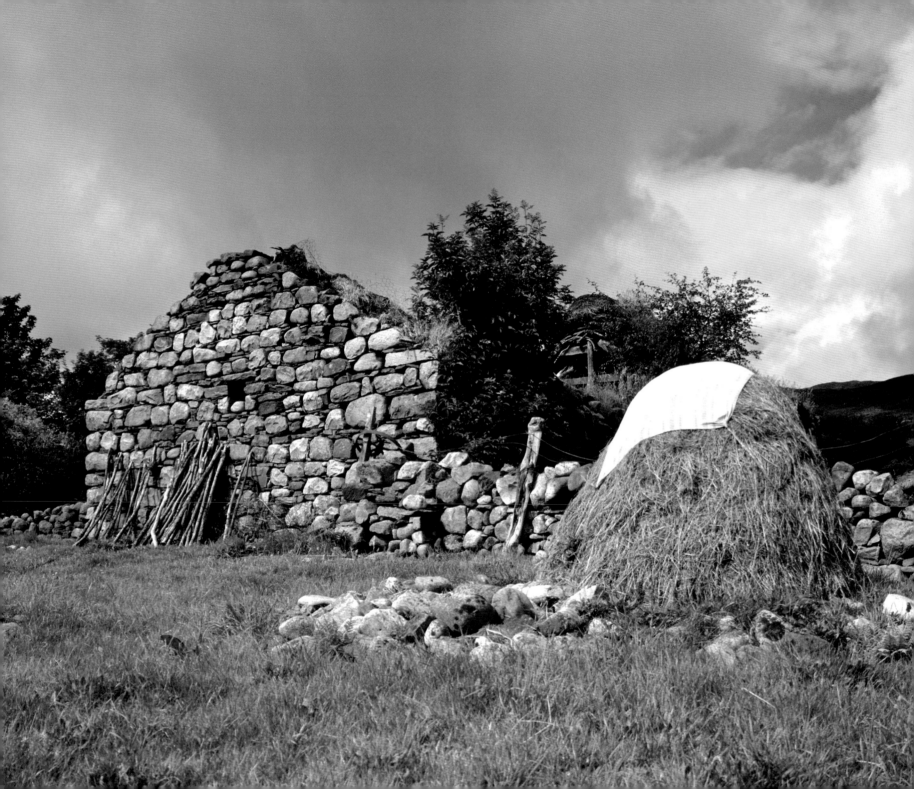

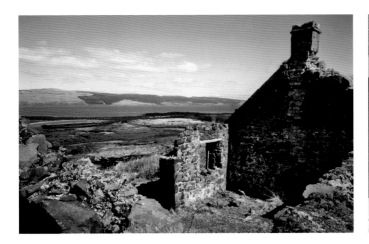

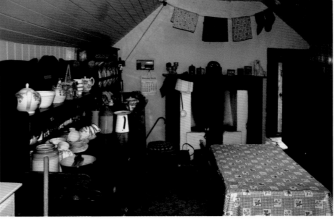

[far left] An abandoned croft by the roadside near Salen, Mull, still gives a sense of the unforgiving environment in which the crofters lived and worked.

[left] The calendar on the wall says August 1955 – one of the rooms in the Gearrannan museum has been laid out as the interior of a blackhouse on Lewis might have looked just over half a century ago. In a lamp niche above the calendar, the bible was always close at hand.

[below] Many of the crofts at Keils are slowly collapsing, revealing their cruck-frame construction.

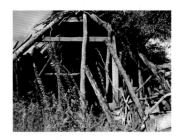

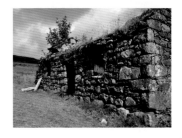

Living in the many exposed areas of Scotland would never have been either easy or comfortable, and houses were invariably built of whatever materials were locally available. For crofters there was little chance of them being able to afford to bring materials to wherever they planned to build – so no slates for roofs, or dressed stone for walls. For many, the roof was living turf, for others it was grass and straw – the by-products of crofting itself.

But time has taken its toll on so many of the rural communities of which such houses were a part. The Highland Clearances left so many crofts empty and abandoned, and the economics of farming marginal lands has condemned so many others to ruin over the past century and a half. The highlands and islands are dotted with the roofless shells of houses which once sheltered tens of thousands of families.

Keils on the island of Jura is an unusual survival of a 19th-century farming community – unusual in that it has not been completely abandoned, nor has it been manicured for today's tourist who wishes to satisfy his curiosity without being confronted with the harsh reality which invariably accompanied the picturesque. While some of the buildings are still inhabited, more are slowly succumbing to the effects of the Jura climate. Remarkable cruck-framed dry stone buildings lie open to the elements, the wooden cattle stalls bleaching and rotting a little more each winter.

The traditional croft – which evolved in several different forms throughout the Highlands – was home for the family and their livestock. At one end of the building, two, or exceptionally three, rooms would house the family, while the byre at the other end – often accessible without having to brave the elements – offered some shelter for the animals during the long dark winters. Having a separate cattle shed was a significant improvement on the earlier design of long house, where people and animals essentially lived together.

The contrast between Keils and Gearrannan is marked and poignant. While the restored group of houses at Gearrannan – one of which is a splendid museum – do evoke a sense of what a small crofting or fishing community looked like, it is at Keils that one gets a real sense of the marginal nature of the crofter's lifestyle. The ease and relative speed with which nature is able to reclaim the buildings and absorb them back into the landscape is a stark reminder of the precarious balance between success and failure, and the harsh challenge of trying to eke out a living in such an exposed and unforgiving landscape. Keils is the much more eloquent reminder of man's ultimate defeat by the elements.

Samuel Johnson recounted his first visit to such a cottage, near Fort Augustus, in 1773. 'This was the first Highland

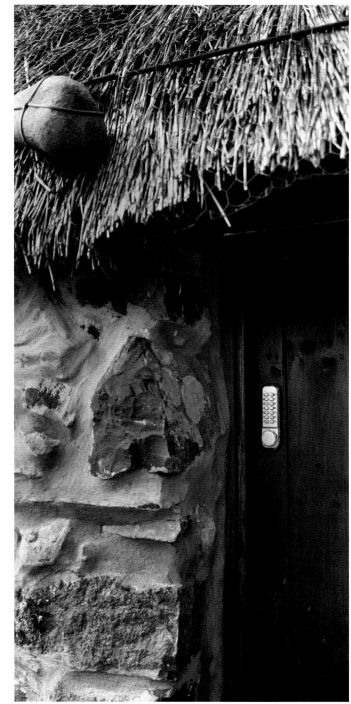

[right] An open bible, and an oil lamp in the window: strict religious observance and a warm welcome were two of the most important features of life in rural Scotland.

[far right] This picture says a great deal about today's world – the restored Sheila's Cottage on the island of Ulva has been fitted with a digital door lock. When houses like these were the norm, nobody ever felt the need to lock their doors.

[opposite page] Sheila's Cottage celebrates one of Ulva's more colourful characters, and the humble dwelling which was her home.

[inset] The interior of a Skye blackhouse in Victorian times, as recreated in the Museum of Island Life on Skye. Established nearly 40 years ago as the Skye Blackhouse Museum, this once-typical group of buildings has been developed into a highly evocative celebration of the hardships of life in the remote corners of Scotland's west coast and islands.

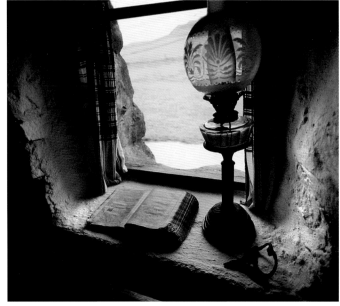

Hut I had seen' he wrote: 'and as our business was with life and manners, we were willing to visit it. To enter a habitation without leave, seems to be not considered here as rudeness or intrusion. The old laws of hospitality still give this licence to a stranger.' He continued:

'A hut is constructed with loose stones, ranged for the most part with some tendency to circularity. It must be placed where the wind cannot act upon it with violence, because it has no cement; and where the water will run easily away, because it has no floor but the naked ground. The wall, which is commonly about six feet high, declines from the perpendicular a little inward. Such rafters as can be procured are then raised for a roof, and covered with heath, which makes a strong and warm thatch, kept from flying off by ropes of twisted heath, of which the ends, reaching from the centre of the thatch to the top of the wall, are held firm by the weight of a large stone.'

Previously, he had visited some of Scotland's finest mansions, so was moved to remark that: 'Such is the general structure

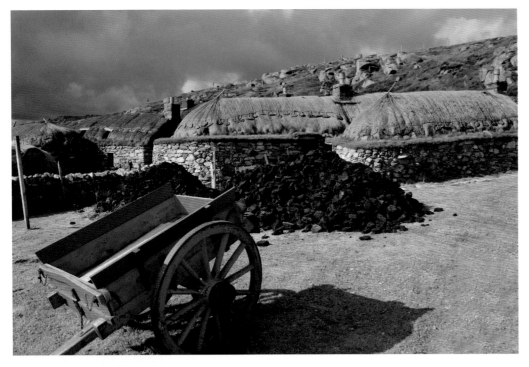

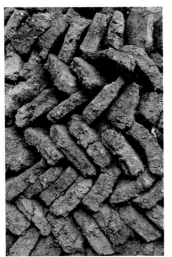

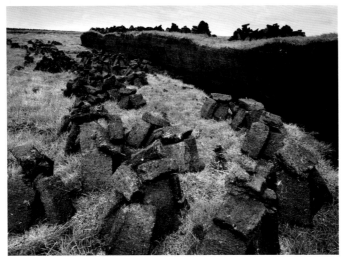

of the houses in which one of the nations of this opulent and powerful island has been hitherto content to live.' Of course such a broad generalisation would not have stood up to close scrutiny even in Boswell and Johnson's day, but it clearly added to his general thesis that rural Scots were a primitive people!

Elsewhere in the country, as his other essays make clear, the quality of housing was higher – ranging from the sophisticated and modern, to the congested and unsanitary tenements of the cities. Boswell and Johnson had enjoyed the hospitality of some of Scotland's leading landowners in their fine castles and houses, so the contrast between the living conditions of country landlord and tenant farmer must have been unavoidable.

Like their country cousins, the wealthier strata of Scottish urban society were reasonably comfortable – many fine houses were constructed during the 18th century – but for the working classes life was hard, invariably crowded and uncomfortable. Into the middle of the 19th century, living conditions for the tens of thousands of workers who swelled the numbers in Scotland's growing cities were starkly medieval in character.

While Edinburgh was building its fine New Town in the 18th century, overcrowding and lack of sanitation in the tenements and wynds on the other side of the Nor Loch made such places a breeding ground for disease. Life expectancy in the old town was markedly shorter than in the new. Working class living conditions in Victorian times were also shameful – and in Glasgow so bad that widespread demolition and replacement was called for in the 1860s. When the Glasgow City Improvement Act was passed in 1866, the city's slums were amongst the most densely populated places in Europe. In the areas along the River Clyde, housing stock had changed little in centuries. The introduction to the act of parliament read:

'Portions of the City of Glasgow are so built, and the buildings thereon are so densely inhabited, as to be highly injurious to the moral and physical welfare of the inhabitants, and many of the thoroughfares are narrow, circuitous, and inconvenient, and it would be of public and local advantage if various houses and buildings were taken down, and portions of the said city reconstituted.'

The housing that replaced the medieval tenements lasted a century, until in the 1960s another clearance on a massive scale was necessary.

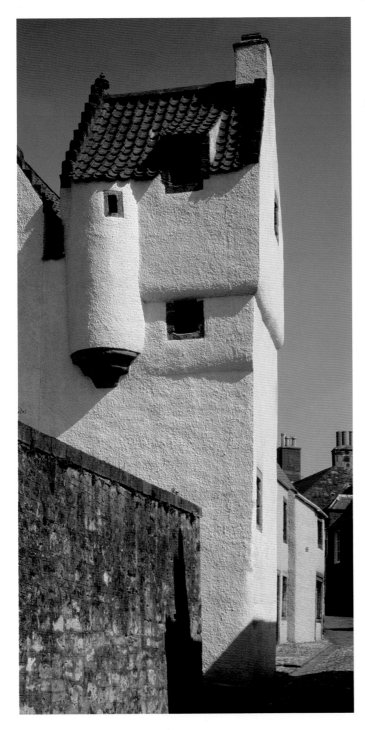

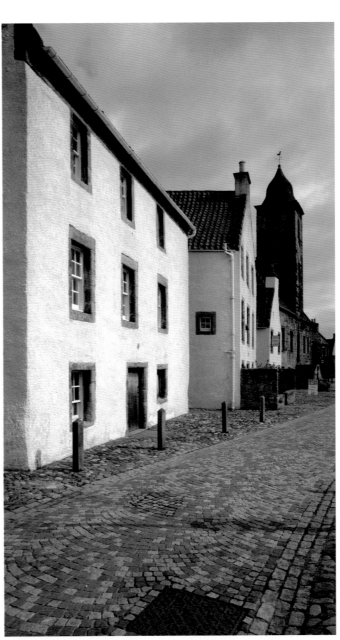

[opposite page top] The roofs of the houses at Gearrannan are held in place by weighted ropes, just as described by Johnson, albeit using modern ropes rather than twisted heath.

[opposite page bottom] Peat – the fuel burned by crofters – was in plentiful supply. These pictures show peat stacked outside a house on Harris (left) and being cut on the moors of Skye (right).

[far left] The Study at Culross, viewed from Mid Causeway: one of the many fine 17th-century buildings in the little Fife village which developed in support of the local coal and salt industries.

[left] Looking towards the Town House just a few yards from the shore at Culross. The Town House, or Tolbooth, built in 1625, was an early sign of the village's relative affluence.

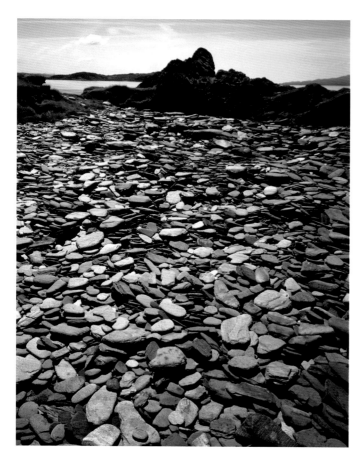

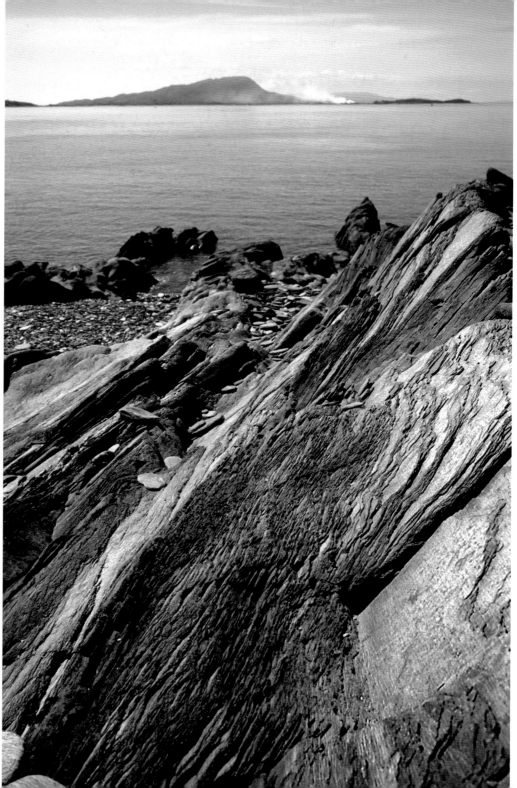

[above and right] Until the workings were inundated during a storm, the tiny island of Easdale was a centre of the Scottish slate industry, creating the small warm-coloured slates which roof many of the country's finest 18th and 19th-century houses. Easdale Island lies to the west of the island of Seil, south of Oban. The beaches around the island are littered with the debris of centuries of slate quarrying and cutting, while in places the layering of the stone which made it ideal for slates can still be seen. Today the flooded slate workings form several deep still lagoons, one of which is used for the World Stone Skimming Championships (the trophy for which is often on display in the Puffer Bar).

[opposite page] The whitewashed cottages of Easdale village once housed fishermen and slate quarry workers. The roofs are covered with local slate. Today people who run a wide range of small businesses populate the village.

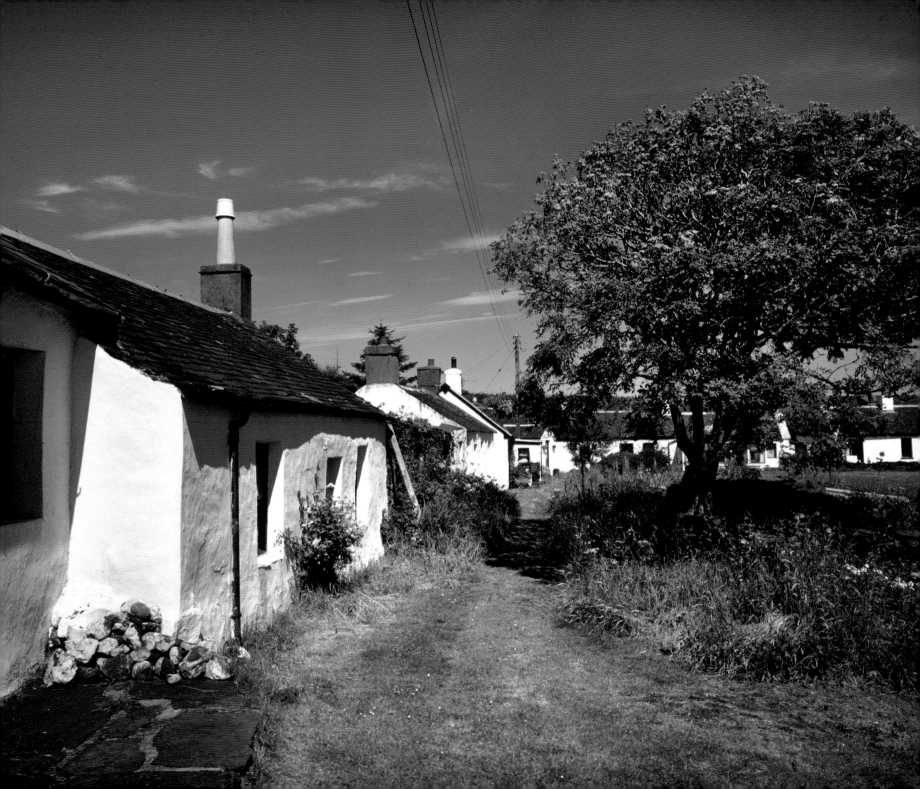

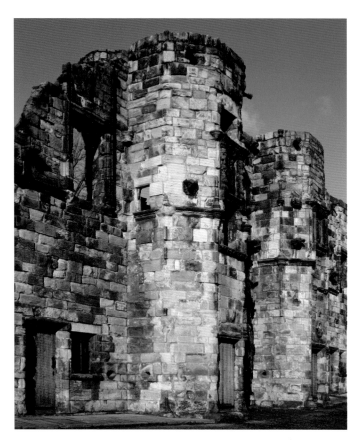

[above] Mar's Wark in Stirling is the remains of a great renaissance-style town-house built in the 1570s by the Earl of Mar on the hill below Stirling Castle. Mar dismantled much of the Augustinian Cambuskenneth Abbey and had the stone transported up from the riverside to construct his house. Mar – for a time the most powerful man in the land – combined the roles of guardian to the infant King James VI, Regent of Scotland and Governor of Stirling Castle.

[right] Visiting the borders in 1724, Daniel Defoe talked about the construction of Traquair House by 'the late Earl of Traquair' as if he had died only recently. The house, in fact, was already several centuries old when Defoe visited. So its construction was hardly recent, despite the fact that Defoe is talking to us from nearly three centuries ago. Traquair is claimed to be the oldest continuously inhabited house in Scotland, with the present building tracing its origins back to the 14th century when it was built on the site of a much earlier structure.

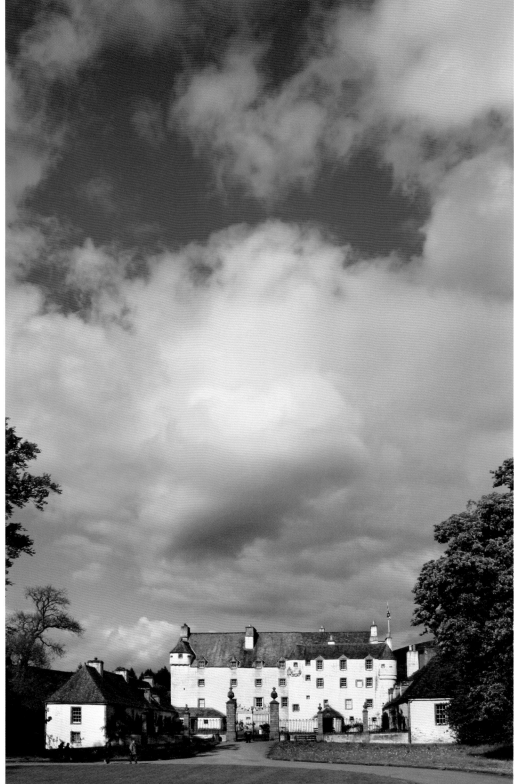

There is an interesting comparison to be made by visiting the Glasgow Tenement House – a restoration of a 19th-century tenement flat – and No.7 Charlotte Square in Edinburgh, Robert Adam's magnificently restored 18th-century town-house; both under the custodianship of the National Trust for Scotland. It is an irony of the tourist culture in which we live that we go in our tens of thousands to visit preserved crofts, museums of farming life and island life, yet with the exception of Glasgow's Tenement House, there are no surviving examples of the conditions under which Victorian working class city dwellers lived. But we visit properties more to be entertained than educated, so the attraction of preserved castles and houses, and restored gardens is easily understood. And while Scotland's history may have affected everyone, irrespective of where and how they lived, it was largely driven by those whose power and wealth created the magnificent stately homes we all enjoy exploring.

To create their magnificent homes, the landed gentry of the 18th century employed some of the finest architects and designers of their times. The money that was lavished on this

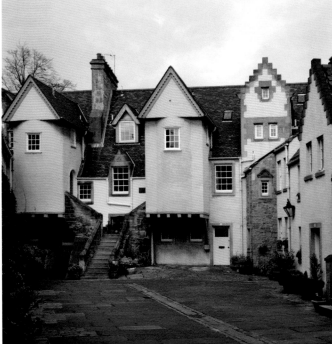

[left] Inveresk Lodge was just two decades old when Daniel Defoe visited the town in 1724. The house was completed in 1700 and the first owner was Sir Richard Colt, Solicitor-General to King Charles II. Defoe noted: 'At that part of the town call'd Inner-Esk are some handsome country houses with gardens, and the citizens of Edinburgh come out in the summer and take lodgings here for the air, as they do from London at Kensington Gravel-Pits, or at Hampstead and Highgate.' The gardens are today under the guardianship of the National Trust for Scotland.

[far left] Edinburgh's Charlotte Square is one of Robert Adam's finest creations. Adam never lived to see the completion of this beautiful and elegant square. No.7 Charlotte Square, restored to Adam's original decor, is now open to the public.

[left] Whitehorse Close towards the foot of the Royal Mile in Edinburgh's Old Town was carefully restored in the 1960s and preserves much of the character of the late 17th century. The white horse after which the close was named was the favourite mount of Mary, Queen of Scots.

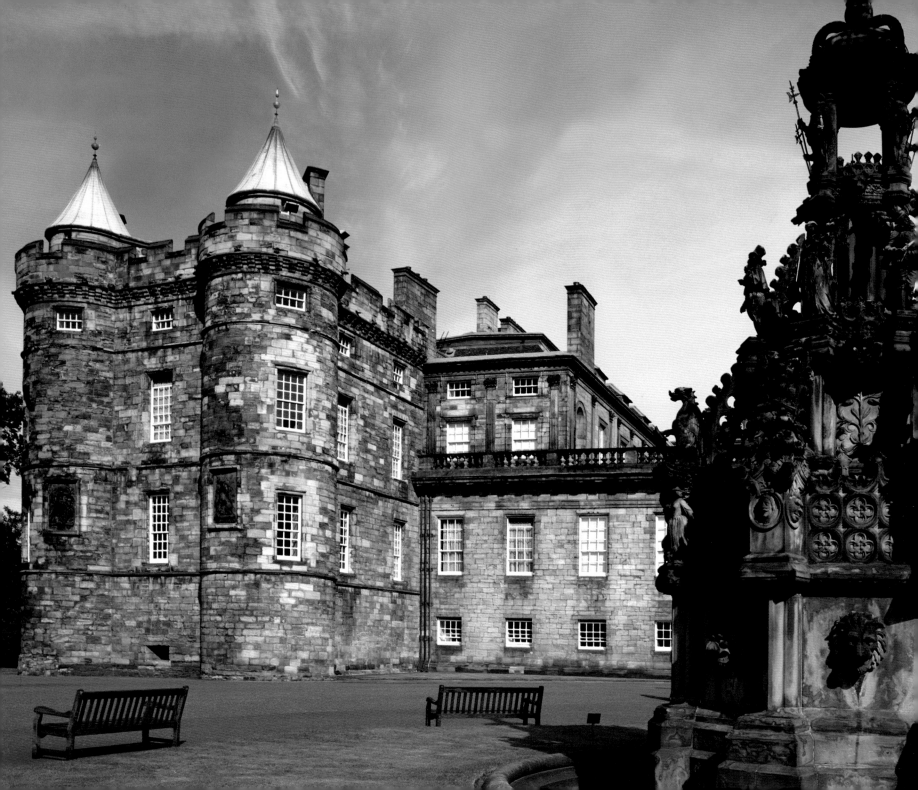

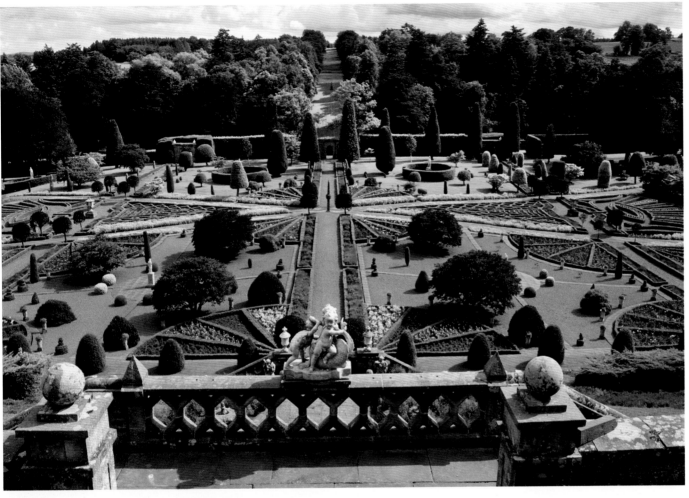

[opposite] The Palace of Holyroodhouse, the official residence of the Queen in Scotland, is a mixture of several architectural styles and periods. It was built on part of the site of the ancient Augustinian Abbey of Holyrood, which was abandoned and largely demolished at the time of the Scottish Reformation. Despite its grand appearance, it could never have been a very comfortable place for Scottish monarchs to live.

[this page] Drummond Castle near Crieff in Perthshire is well hidden, despite sitting at the edge of a sheer volcanic escarpment. The view through the small entrance gate in the curtain is spectacular. There, spread out on the flat plain below the rock, is an Italianate parterre based on the Scottish saltire. The gardens were originally created in the mid 17th century, and the present layout introduced in the 1830s, complete with classical statures and obelisks – one of which is an elaborate sundial which reputedly allows the time of day to be calculated for most of the capital cities of Europe. The original tower-house dates from the closing years of the 15th century, but was in ruins after Cromwell's army attacked it in 1641. It has been burned and rebuilt twice more since them. The adjacent mansion house dates from the late 17th century. Thomas Pennant, in 1772, described Drummond as 'both mean and small'.

new age of country houses was enormous, but then so was the wealth of those who commissioned their construction.

Head and shoulders above several eminent others, Robert Adam was responsible for completing his father's work at Mellerstain, as well as the creation of the magnificent Culzean Castle in Ayrshire. In Edinburgh, his masterpiece, Charlotte Square, is the finest group of buildings in the New Town. Designed by Adam in 1792, it was also his swansong, as he died the following year. Robert, together with his father William and brother John, left a magnificent legacy of Scottish architecture – and left their indelible marks on the House of Dun, Floors Castle, Hopetoun House, Dumfries House and many others.

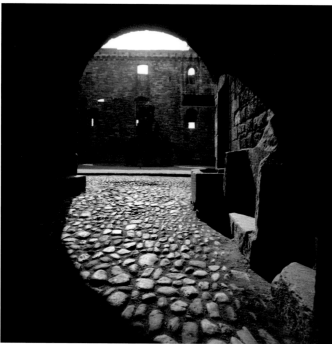

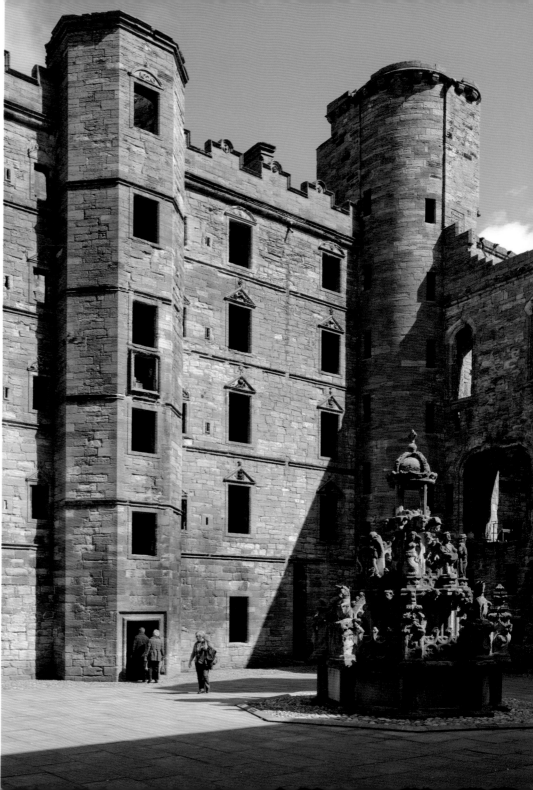

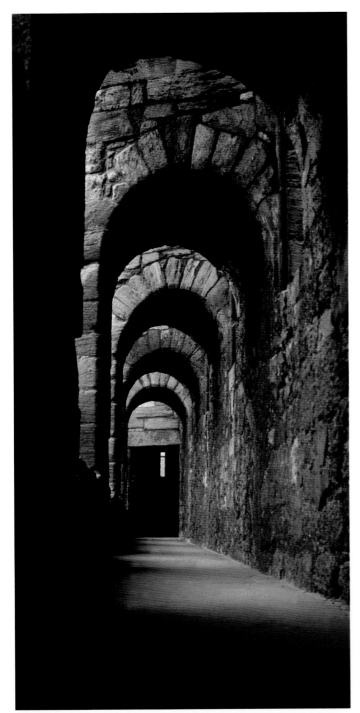

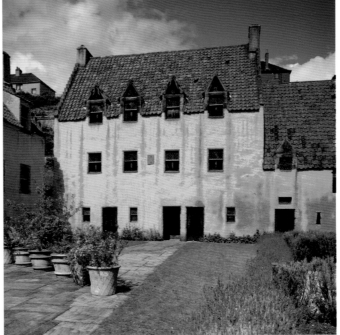

[opposite page & far left] It was in Linlithgow Palace that Mary Stuart, the future Mary Queen of Scots, was born on 8 December 1542. She became Queen less than a week later, and was crowned in September 1543 – although as a child she was Queen only in name; the power being wielded by her mother, Mary of Guise, and a group of powerful Scottish and French nobles. She returned to the palace periodically throughout her life in Scotland. The palace sits at the edge of a small loch on the outskirts of the town of the same name, James I initiated the creation of this great building in 1425 and work on the construction over the following 90 years created the huge structure we see today. Further alterations, improvements and embellishments continued until 1624, just short of two centuries after work started. The great quadrangle around which the palace is built remains largely as Mary would have known it. In the centre stands an ornate early-16th-century fountain installed by James V. The north face was extensively remodelled in the first quarter of the 17th century during the reign of James VI.

[above left] Culross Palace, the late-16th-century home of Sir George Bruce, was built from the proceeds of his coal mine, which ran deep under the Firth of Forth.

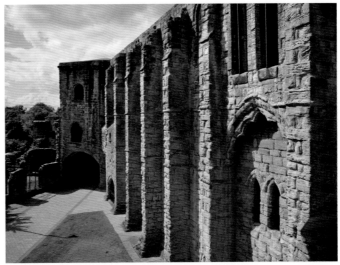

[left] The imposing facade of the 16th-century Royal Palace at Dunfermline, built by King James V1 after the Reformation. It stands adjacent to the medieval abbey church. King Charles I was born here in 1600.

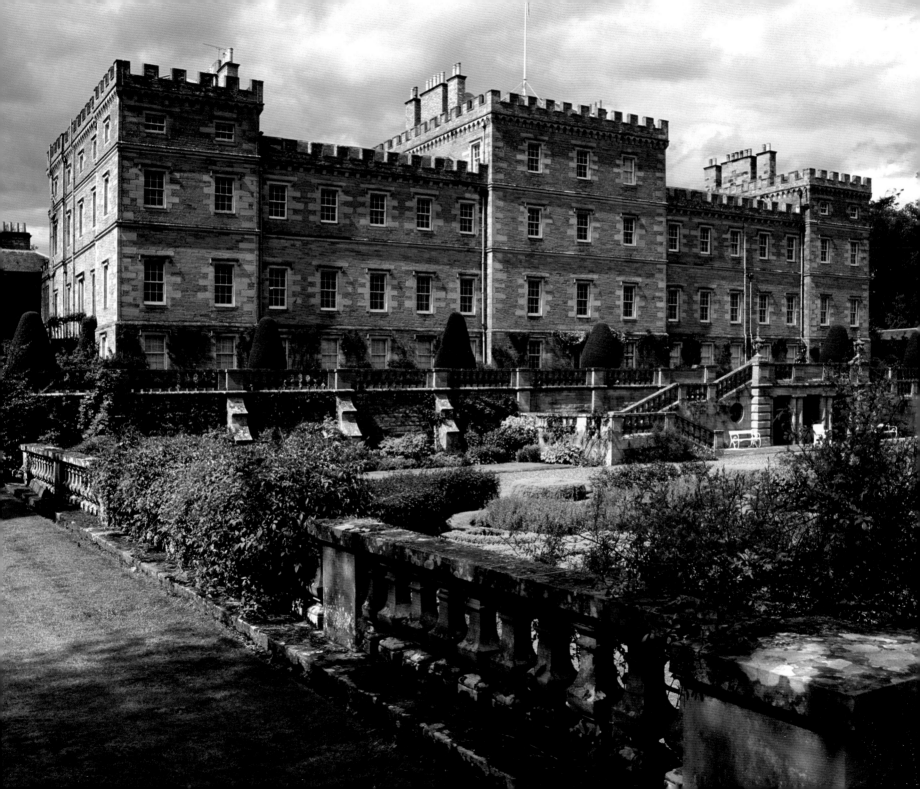

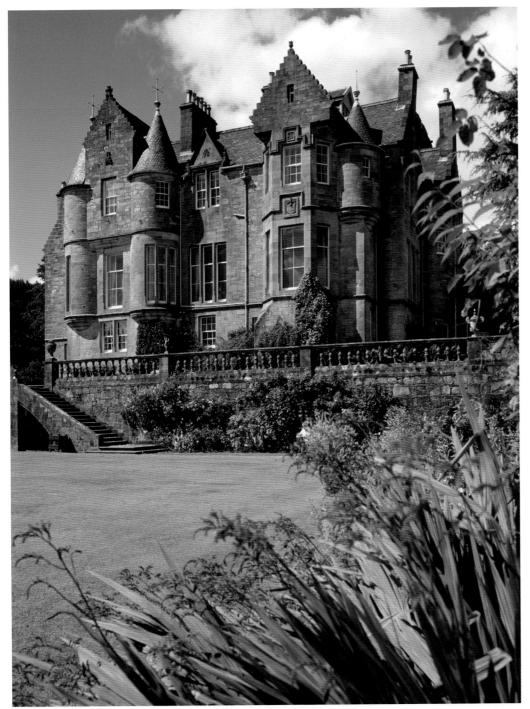

[left] Torosay Castle on the Isle of Mull is a mid-19th-century baronial mansion, designed by eminent Victorian architect David Bryce for John Campbell of Possil. It was completed in 1858. Campbell only kept the house until 1865, when he sold it to a wealthy London businessman as a holiday retreat. David Bryce was also responsible for the design of the Bank of Scotland headquarters building on the Mound in Edinburgh, and also for the city's Fettes College.

[above] One of the ornately planted parterres at Pitmedden, near Ellon in Aberdeenshire. The gardens were first laid out on the instructions of Sir Alexander Seton in 1675. The Seton family had acquired Pitmedden in 1603, the year of the Union of the Crowns, and they were staunch royalists. So it is perhaps not surprising that, with the fashion for formal gardens gaining appeal amongst landowners, Seton should adopt a parterre design for his gardens, not unlike the gardens then laid out at Holyroodhouse. The gardens as laid out today are a recreation of the originals, which have disappeared over the centuries.

[opposite page] The magnificent garden front at Mellerstain in Berwickshire. George Baillie of Jerviswood commissioned William Adam to design his new house at Mellerstain in 1725, but when only the wings of the house had been completed, the money ran out. In 1770 his son, Robert, was commissioned to complete the project and had to create a design for the main house which linked the two extant wings. His signature colour schemes and plasterwork are amongst the house's major attractions.

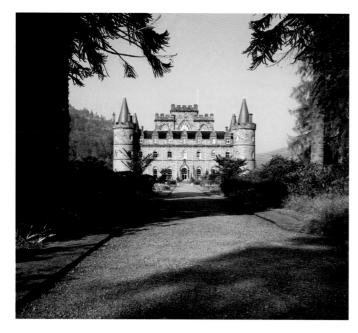

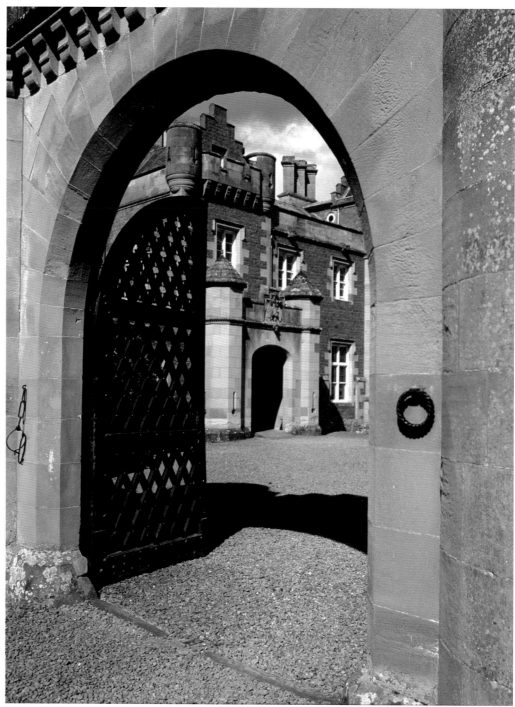

[above] Inveraray Castle, built for the second Duke of Argyll is the result of input by many of the leading architects of the 18th century. In 1720 the first drawings were prepared by Sir John Vanbrugh, the architect of Blenheim Palace and Castle Howard. Vanbrugh died before work started on the building and his design was developed by Roger Morris in 1746, working with William Adam. Both Morris and Adam died in 1748 before building work got underway and it was Adam's sons, John and Robert, who completed the castle in 1789.

[right] Sir Walter Scott, Scotland's most successful Victorian writer, developed Abbotsford from a small farmstead in 1812 into his magnificent home on the banks of the Tweed. The house, designed by London architect William Atkinson, was constructed in two phases, with work completed in 1825. The castle epitomised Scott's idea of a noble baronial Scotland – the same Scotland imagined in his Waverley novels and his epic poetry – a Scotland somewhat removed from the 19th-century reality of what was disparagingly referred to as 'North Britain'.

[opposite page] The roofs of many of the 18th and 19th-century houses in Haddington, East Lothian, are covered with Scottish slates, while others use imported pantiles. This view was taken on a summer's evening, looking across the River North Tyne.

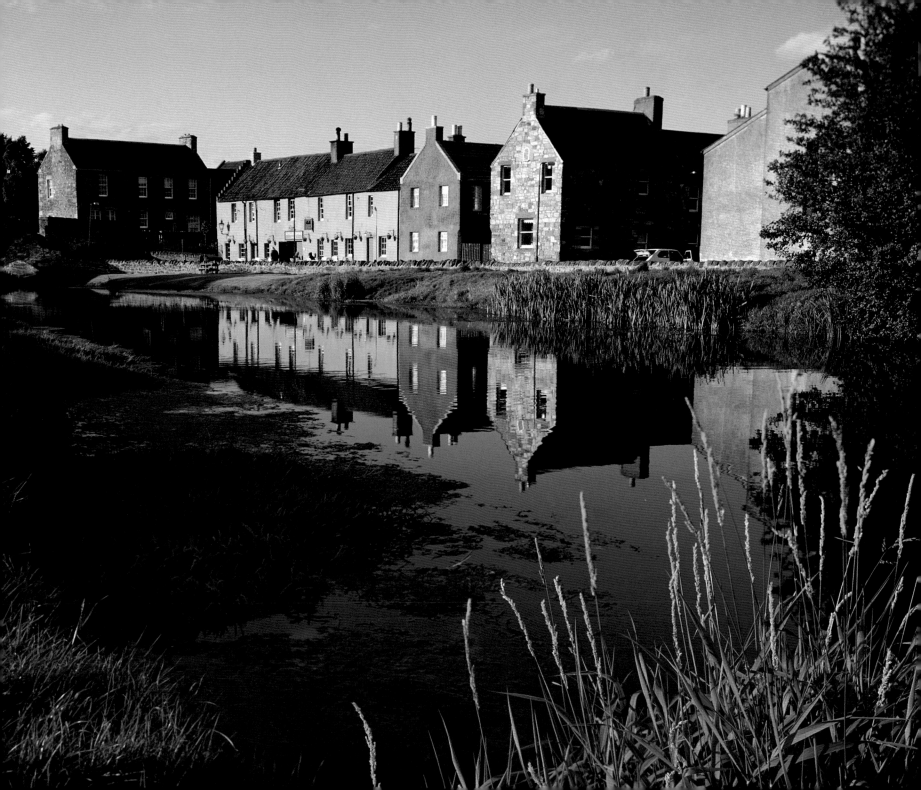

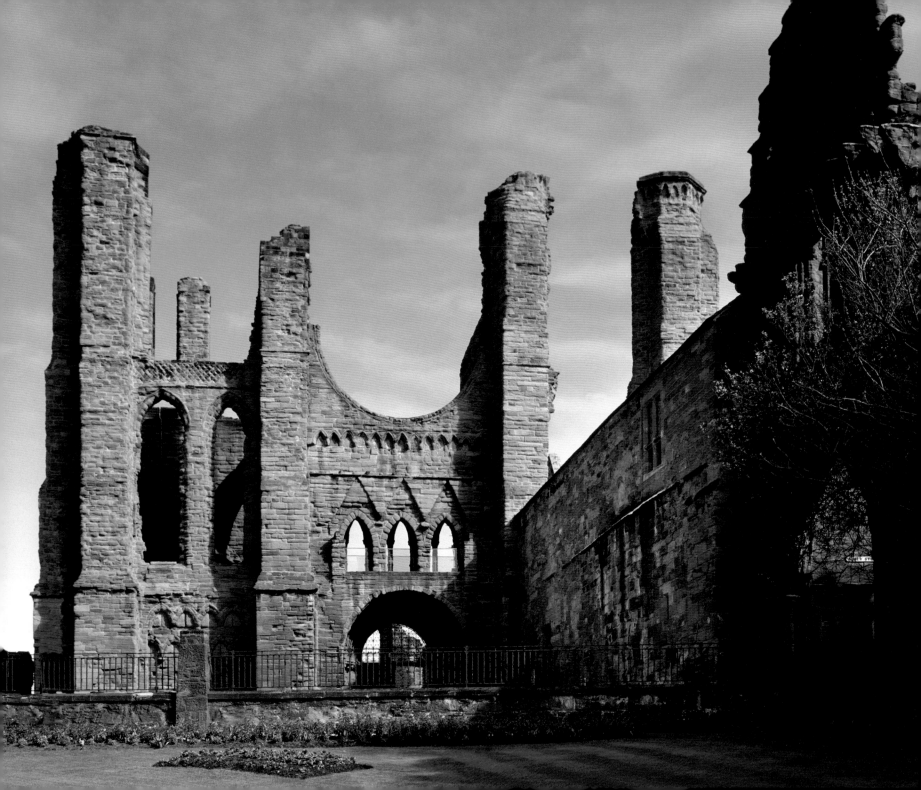

Churches, Rituals & Monuments

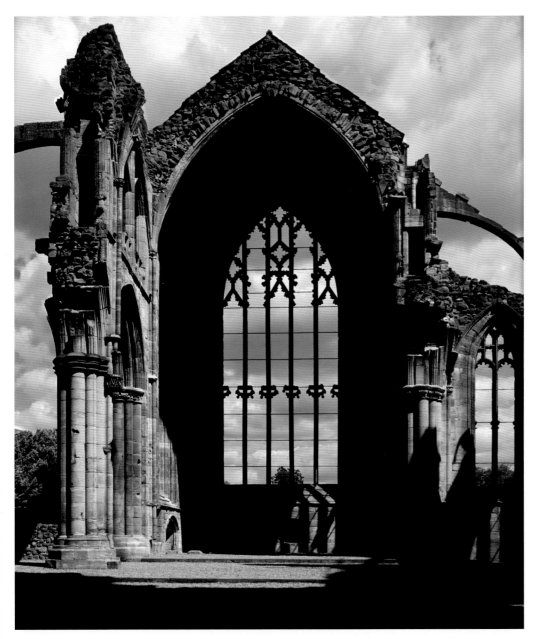

Arbroath Abbey has a very special place in Scottish history. It was within the abbey precinct that the Scottish nobles met on 6 April 1320 to sign the Scottish Declaration of Independence. The anonymous writer who prepared the Declaration – held to be the most important document in Scottish history and one of the most eloquently worded statements of freedom and defiance ever written – is thought by many to have been Arbroath's Abbot Bernard, who was at the time also Chancellor of Scotland. In the Declaration, signed by over 50 of Scotland's senior noblemen, Scotland asked the Pope to use his influence and intervene between the Scots and the English.

The wars with England had been going on for generations, but had reached a crisis point with the violence of the attacks by the troops of King Edward I. 'The deeds of cruelty, massacre, violence, pillage, arson, imprisoning prelates, burning down monasteries, robbing and killing monks and nuns, and yet other outrages without number which he committed against our people, sparing neither age nor sex, religion nor rank,' said the Declaration, 'no one could describe nor fully imagine unless he had seen them with his own eyes.'

The abbey itself had been founded 142 years earlier in 1178 by King William the Lion for a chapter of monks of the Order of Tiron: the Tironensians. Their abbey was the first ever to bear the dedication to St Thomas á Becket the Martyr – the Archbishop of Canterbury who had been murdered on the altar steps of his cathedral only eight years earlier in 1170.

Like so many of Scotland's other great abbeys, what survives in Arbroath today is a mere fragment of the magnificent sight it must have been. The Reformation in the middle of the 16th century was an often-violent affair, and the three centuries that immediately followed it are not marked by the care and attention lavished on these early architectural gems.

[opposite page] The surviving fragment of the west end of Arbroath Abbey church.

[left] Melrose Abbey's great church remained in use long after the Reformation.

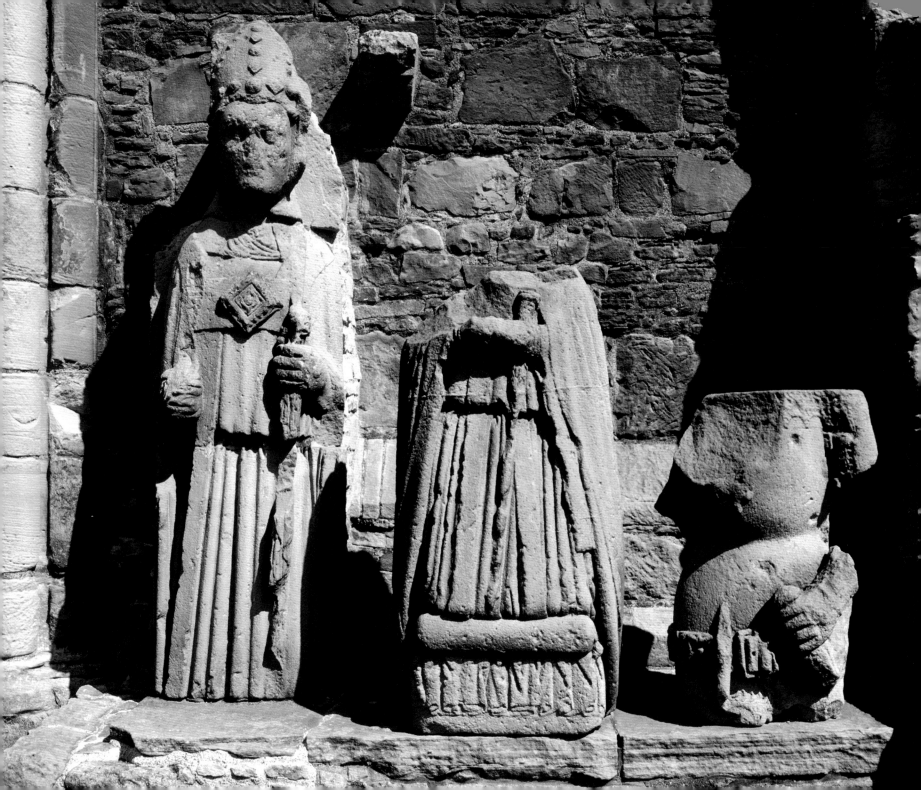

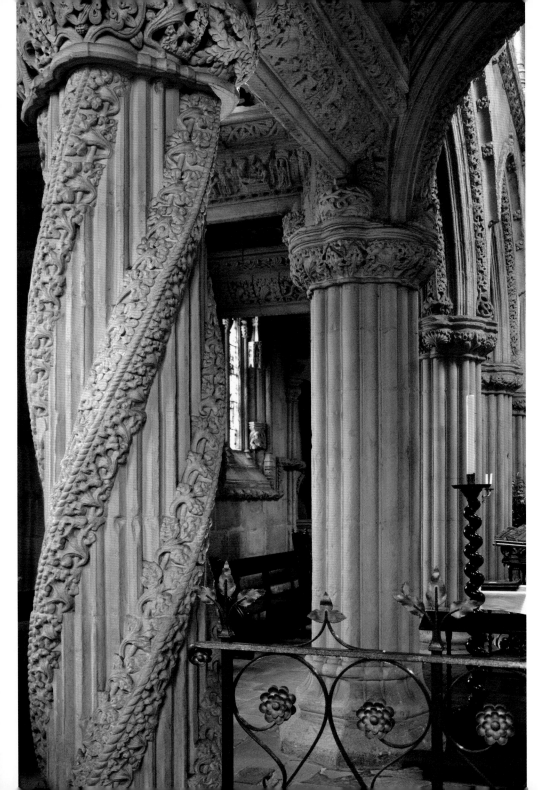

They became quarries, the stones being re-used in hundreds of other buildings – some of which are also now ruins. Yet some remarkable buildings have survived and are now, rightly, treasured.

Could Dan Brown have had any idea of the effect his brief mention of Rosslyn Chapel in his bestseller *The da Vinci Code* would have on the little church a few miles south of Edinburgh? In the months following the publication of the book, the number of visitors making their way to the 15th- century building grew from a few hundred each summer month to many thousands. The days when a visitor could often enjoy the peace and quiet of the exquisite building alone were, for a time at least, a thing of the past. Brown's assertion that Rosslyn Chapel was 'built by the Knights Templar in 1446' is a key tenet of his book, but is completely without substance. The Templars as an order had been suppressed in Scotland over a century earlier, and St Matthew's Church Roslin (as it is more correctly known) was built as a secular college, or collegiate church. However flimsy Brown's claim, it has brought this remarkable and unique building to the attention of many thousands of people who might otherwise never have heard of it.

One of the most richly decorated of Scotland's mediaeval buildings, Rosslyn's most stunning feature is the 'Prentice Pillar': an ornate masterpiece of stone carving, which according to the stuff of legend, was created by an apprentice while the master mason was away. Well, the master would have had to have been away for a very long time, as this amazing pillar must have taken many months to create. It is however, just one of the many remarkable treasures which can be found in Scotland's old churches, abbeys and priories, some of them immediately recognisable, others much less well known.

In that latter category one would have to include the little collegiate church of Fowlis Easter in Angus – a simple rectangular building with a singularly unimpressive exterior, but inside survives the significant remains of a late-15th-

[opposite page] Statues, Elgin Cathedral. The church would once have been richly decorated with statues of saints. Today only the damaged remnants of a few remain.

[left] The 'Prentice Pillar', Rosslyn Chapel. One of the finest examples of mediaeval stone carving anywhere in Scotland. Founded in 1447, the church was never completed with only the choir being built.

[right] Crucifixion Painting, Fowlis Easter Church. Also known as the 'Doom' painting these painted panels inside Fowlis church are a rare survival from the late 15th century.

[below] Fowlis Easter Collegiate Church. The plane rectangular barn-like exterior of Fowlis church conceals the mediaeval treasures inside.

[bottom] It was a requirement that all able-bodied men practiced their archery skills every week, and these markings beneath one of the consecration crosses on the wall of Crail parish church in Fife are reputed to be incisions made by the repeated sharpening of arrow heads as the men prepared for archery practice after Sunday Mass.

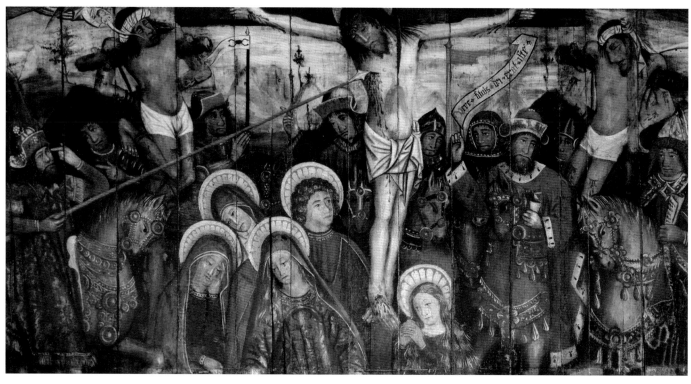

century Crucifixion painting, over 4m long by almost 2m high. Painted in tempera on oak panels, it is a remarkable survival. It reminds us that the interiors of mediaeval churches would originally have been a blaze of colour.

Many of the Scotland's finest churches are in ruins, and were for centuries quarried for their stone. Thus, on the tiny island of Inchcolm in the Firth of Forth, amongst the ruins of the remote Abbey of Augustinian Canons there is little left of the church. While the domestic buildings continued to be used as living quarters after the Reformation in 1560 – and so remain in a remarkably good and complete state of preservation today – there was little need for a church once the abbey had been abandoned. Now under the care of Historic Scotland, Inchcolm is reached by a short boat trip which leaves from the former

ferry slipway at South Queensferry. Others – like Iona Abbey – were ruins before their inspired reconstructions.

To visit Iona today, it is hard to imagine the scene that greeted visitors until much less than a century ago – most of the abbey buildings little more than foundations, and the church roofless and abandoned as it had been for centuries. The Augustinian Nunnery – which is passed on the way to the abbey – was perhaps the saddest sight of them all. Thomas Pennant described its condition in his account of his 1772 tour of Scotland:

'The church was fifty-eight feet by twenty; the roof of the east end is entire, is a pretty vault made of very thin stones, bound together by four ribs meeting at the centre. The floor is covered some feet thick with cow-dung; this place being at present the common shelter for the cattle; and the islanders are

too lazy to remove this fine manure, the collection of a century, to enrich their grounds.

With much difficulty, by virtue of fair words, and a bribe, prevail on one of these listless fellows to remove a great quantity of this dunghill; and by that means once more expose to light the tomb of the last prioress. Her figure is cut on the face of the stone; an angel on each side supports her head; and above them is a little plate and a comb.'

It is only a century ago that the plan to rebuild the abbey was first mooted, and the restored religious centre that greets visitors today is a testament to a wonderful vision, and a great deal of hard work.

But that restoration did not please everybody: 'The cathedral has been almost too lovingly restored', wrote H. V. Morton in his second Scottish travelogue, *In Scotland Again* (published in 1933), adding: 'It is for an older Iona – an Iona of which not one visible trace remains – that the mind hungers.'

Morton never visited Dunblane Cathedral in Perthshire, so we don't know what he thought of it, but it too had greeted Victorian visitors as a partially roofless shell – only the mediaeval choir had been retained as the parish church, the nave having been allowed to decay into ruin. The beautifully restored cathedral today, with over eight centuries of history to its name, is one of Scotland's most surprising buildings – a rare flowering of Gothic architecture in a country not usually known for architectural exuberance.

Only a few miles away, in Scotland's newest city, Stirling, stands the only surviving coronation church in the country. It was at the Church of the Holy Rude, only a few yards from Stirling's imposing castle, that the infant James VI, son of Mary Queen of Scots, was carried into the building by the Earl of Mar and crowned King in 1567.

Despite the widespread destruction which took place at the time of the Reformation in the middle of the 16th century, Scotland's surviving mediaeval cathedrals, churches, abbeys, priories and friaries number several hundreds, and many offer us wonderful glimpses of their former richness and beauty. The

[left] The east gable of the great cathedral-priory church at St Andrews – the longest church is Scotland – seen here through the arches of the Chapter House doorway.

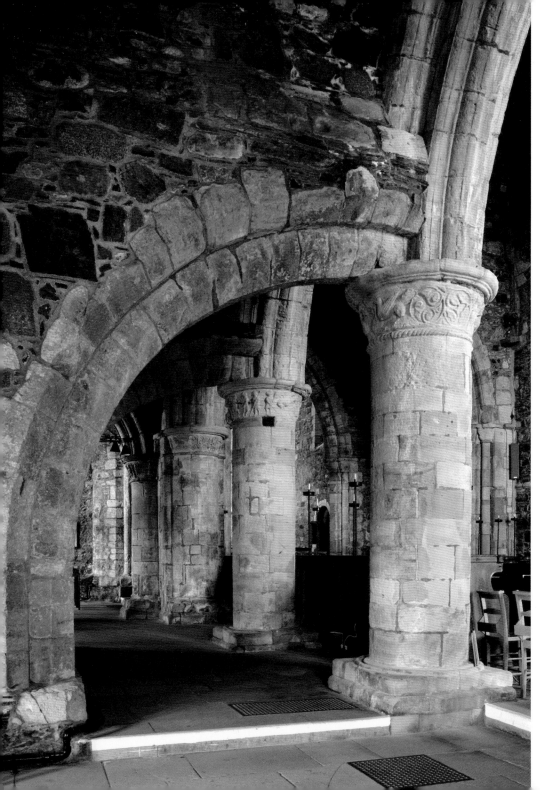

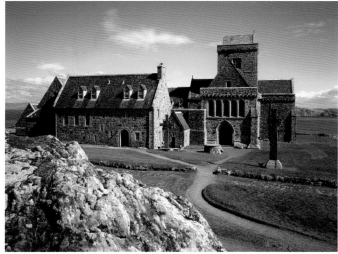

intricacy of their stonework, the complexity of their design, and the craftsmanship of the masons who built them, are a wonderful memorial to a time from the 12th to 16th centuries when such buildings could be conceived and constructed without all the building aids we take for granted today. While the buildings themselves are certainly worthy of preservation, and even more worthy of a visit today, it is the stories of the people who lived there, worked there, and worshipped there, which really bring them to life.

When a group of Benedictine monks arrived at the remains of Pluscarden Priory in Kale Glen near Elgin a little over 60 years ago, it must have taken an enormous amount of belief and considerable vision to ever imagine that the ruins that

[opposite page] The interior of the beautiful church of the Augustinian Nunnery on Iona, passed on the way from the ferry to the Abbey.

[above] Iona Abbey from the west. The view which greets visitors to the abbey today is a far cry from the fragmentary ruins which greeted visitors just over a century ago.

[left] Iona Abbey Church, south choir aisle. The beautifully restored interior of the church is the focus for many religious gatherings.

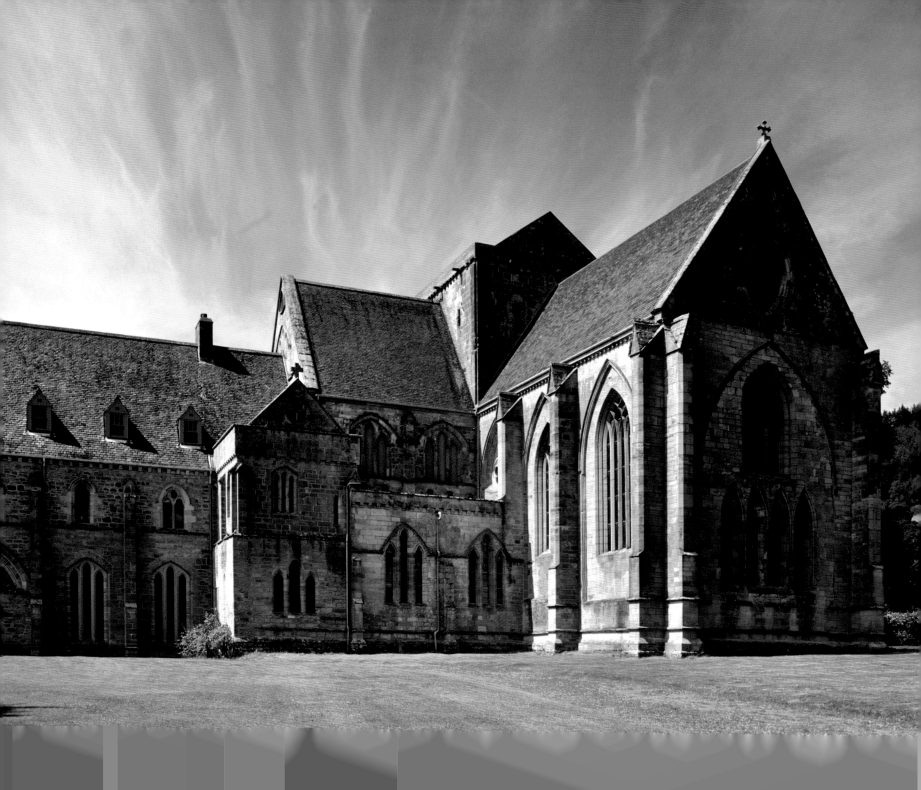

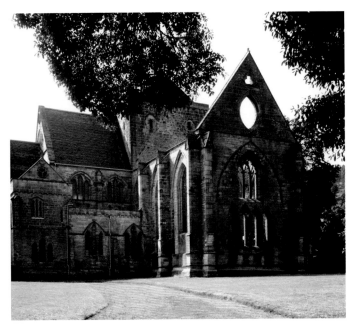

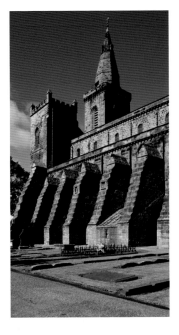

were used as quarries, but there was still more than enough left standing in 1943 for the monks of Prinknash to welcome the gift of the priory and its immediate lands. The 69 years since then have seen a remarkable rebirth, and the result gives the visitor a unique opportunity to visit a mediaeval abbey – for the priory was elevated to abbey status in 1974 – still being lived and worked in much as it must have been seven centuries ago.

A few miles away, Elgin Cathedral – described in the 14th century as the 'glory of the kingdom' – is sadly completely in ruins, although they are dramatic and magnificent ruins indeed. Once second in size only to St Andrews, this huge church was the most ornate and richly decorated of all Scotland's mediaeval cathedrals, and one of the very richest. Like everywhere else though, neglect in the 16th and 17th centuries saw it fall into disrepair, and when the tall central tower collapsed in 1711 it caused enormous damage.

At the opposite end of the country, the most beautiful religious sites in the southwest are undoubtedly the ruins of the three magnificent Cistercian Abbeys – Glenluce, Dundrennan and Sweetheart. The most spectacular of the three today – due to its glowing red sandstone construction – is undoubtedly Sweetheart Abbey, or New Abbey; the latter name still used by the village today. Sweetheart was known as 'New Abbey' because it was the last of the three Cistercian abbeys to be established. Devorgilla de Balliol founded Sweetheart, or *Dulce Cor*, in memory of her husband John de Balliol who had died in 1268. Twenty-four years later, Devorgilla's son, also John, would ascend to the Scottish throne and reign for four years until his forced abdication after the English defeated the Scots at Dunbar in 1296. Of Devorgilla's great abbey, only the shell of the church survives, but what a majestic ruin it is: undoubtedly the most beautiful and dramatic mediaeval church in Scotland. Almost all that is needed to restore it to its mediaeval glory is a roof.

When Thomas Pennant visited Sweetheart he referred to the place as 'Newby Abbey' and recalled that after her husband died, Devorgilla had 'embalmed his heart, and placed it in a cask of ivory, bound with silver, near the high altar; on which account the abbey is more often called Sweetheart and *Sauvi Cordium*.' Sweetheart was initially built and occupied by a group of monks from nearby Dundrennan Abbey, which had been established at least a century earlier by monks who had travelled to southwest

greeted them could be brought back to life as a monastic community. They had travelled north from Prinknash Abbey in Gloucestershire in 1948 to undertake their task, and within seven years the central tower of the church had been re-roofed. By 1960 they had completed work on the domestic range which runs south from the south transept, and today the choir and transepts of the abbey church are back in full use. King Alexander II originally established the priory in 1230 and the monks came from Vallis Caulium – the valley of the cabbage or kale – in France to establish one of only three monasteries of the order in Scotland. By 1454 however, the Valliscaulian monks had gone, and monks from Dunfermline Abbey in Fife populated the abbey, now under the Benedictine order. The Benedictines only left in the closing years of the 16th century; long after the Reformation, which had dismantled monasticism in Scotland. Throughout the following three centuries under a variety of owners, the buildings fell into disrepair and many

[opposite page] The beautifully restored buildings of Pluscarden Abbey are a breathtaking testament to the community of Benedictines who have rebuilt them.

[left] In the early 1970s the choir of the 600-year-old church was still awaiting its new roof.

[above] The nave of Dunfermline Abbey church from the south east. The first Benedictines to move into Pluscarden were monks from Dunfermline.

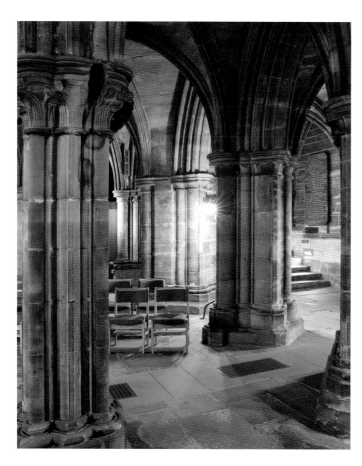

[above] The Lower Church, or crypt, of Glasgow Cathedral.

[right] The reconstructed Victorian west end of the cathedral replaced some unique mediaeval architecture.

[opposite page] The interior of the nave of Holyrood Abbey church, which stands next to the Palace of Holyroodhouse. While the rest of the abbey was demolished at the Reformation, the nave remained in use as the parish church for the Canongate. Attempts by King James II (James VII in the Scottish tradition) to re-establish Catholicism in the country, to create a Chapel Royal and to introduce a community of Jesuit priests, brought further attacks from the people of Edinburgh, leaving the ruin roofless and abandoned as we see it today.

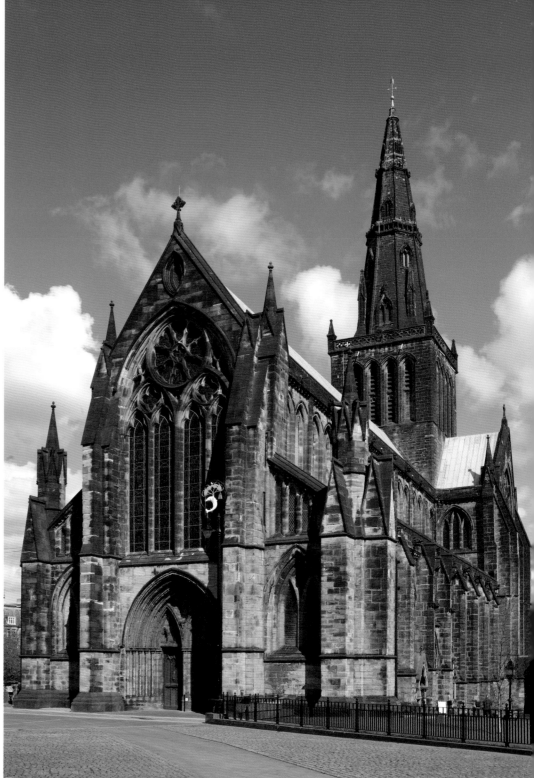

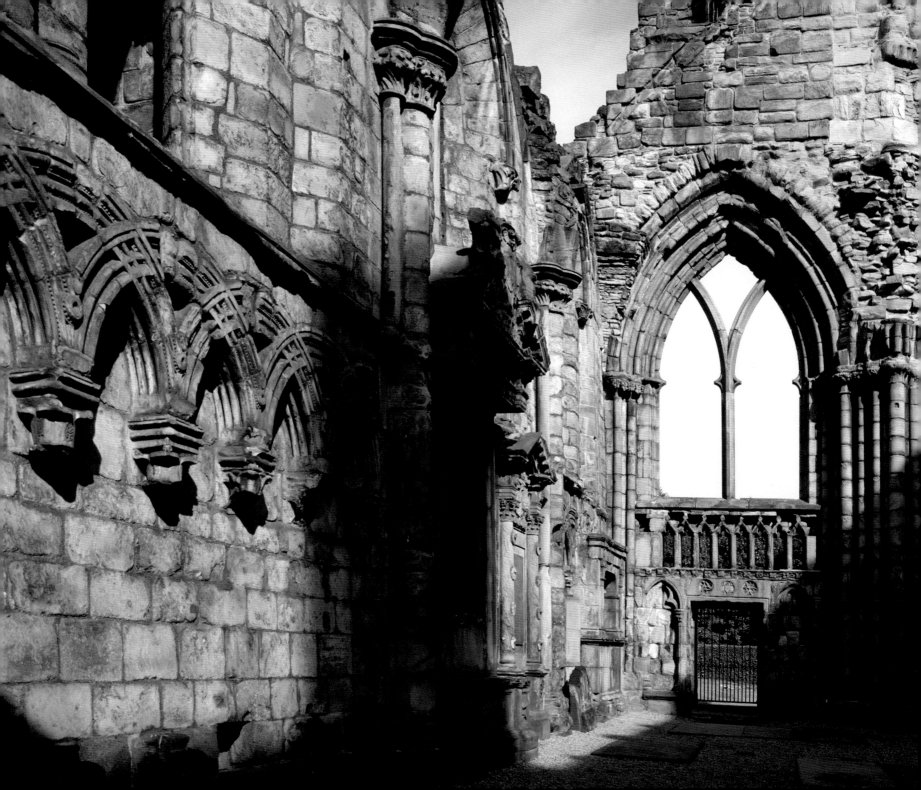

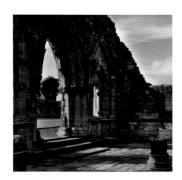

[top] The interior of the Chapter House at Dundrennan Abbey.

[above] The ornate decoration at the entrance to the Chapter House at Glenluce Abbey.

[right] The huge west towers of Elgin Cathedral are a major survival of this once vast church. The collapse of the central tower in 1711 caused enormous destruction of much of the rest of the church. The roofless choir still stands, as do vestiges of the building's outer walls.

[opposite page] At Sweetheart Abbey in Dumfriesshire, also known as New Abbey, the abbey buildings have all gone, but the skeletal red stone remains of the church dominate the little village which shares the name of New Abbey.

Scotland from the great Rievaulx Abbey in Yorkshire. But the only substantive remains are the transepts of the huge abbey church – remarkably standing on the east side almost to their full height – and the west face of the Chapter House. What remains however, tells us enough to know that this abbey, when complete, would have been a fine example of late-Romanesque and early-Gothic architecture.

The border abbeys of the southeast are just as important, historically, and just as beautiful. Dryburgh Abbey's ruins are the romantic setting for the tomb of Scotland's greatest Victorian novelist, Sir Walter Scott. It attracts visitors in their thousands each year, just to pay homage to the great writer. The beautiful setting of the abbey ruins sets Dryburgh apart from the other border abbeys which make up the four most famous abbeys in Scotland: Melrose; Kelso; and Jedburgh – all of which are in towns. Dryburgh, in its lush parklands is much closer in its ambiance to what the monks must have experienced, for they were farmers as well as holy men.

Dryburgh Abbey was founded by Premonstratensian Canons who arrived by the beautiful wooded banks of the Tweed from Alnwick in Northumberland in 1140, and much of what survives today on this huge site dates from the second half of the 12th century and the first half of the 13th. The abbey's cloisters and the remains of many of the conventual buildings, are just beautiful.

By the 1340s, the canons were engaged in extensive rebuilding after their abbey was plundered by the English. Given their originally English origins, this must have irked them somewhat. They were not unique however: their Cistercian neighbours a few miles away at Melrose suffered a similar fate. A catastrophic attack in 1385 required the almost total rebuilding of the abbey.

Melrose – the Cistercians' first Scottish abbey – can trace its origins back as far as 1136 when it was founded by a charter from King David I, bringing monks from Rievaulx in Yorkshire to the lush farmland by the banks of the Tweed. The choir of the church, where the monks gathered for Mass, was probably completed by the late 14th or early-to-mid 15th century, and

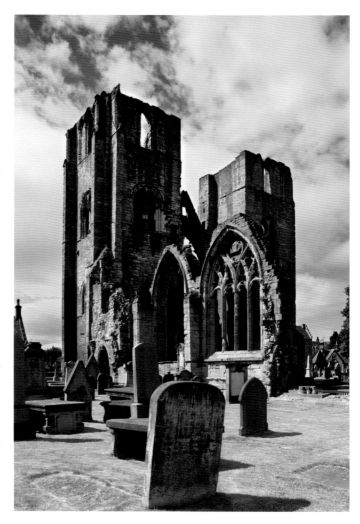

that is what largely survives today. The fact that the church continued to be used to serve the local community after the Reformation – much of the choir was extensively renovated and structurally altered in the 1620s – saved it from destruction. Indeed it continued to be used as the Parish Church into the early years of the 19th century, before a completely new church

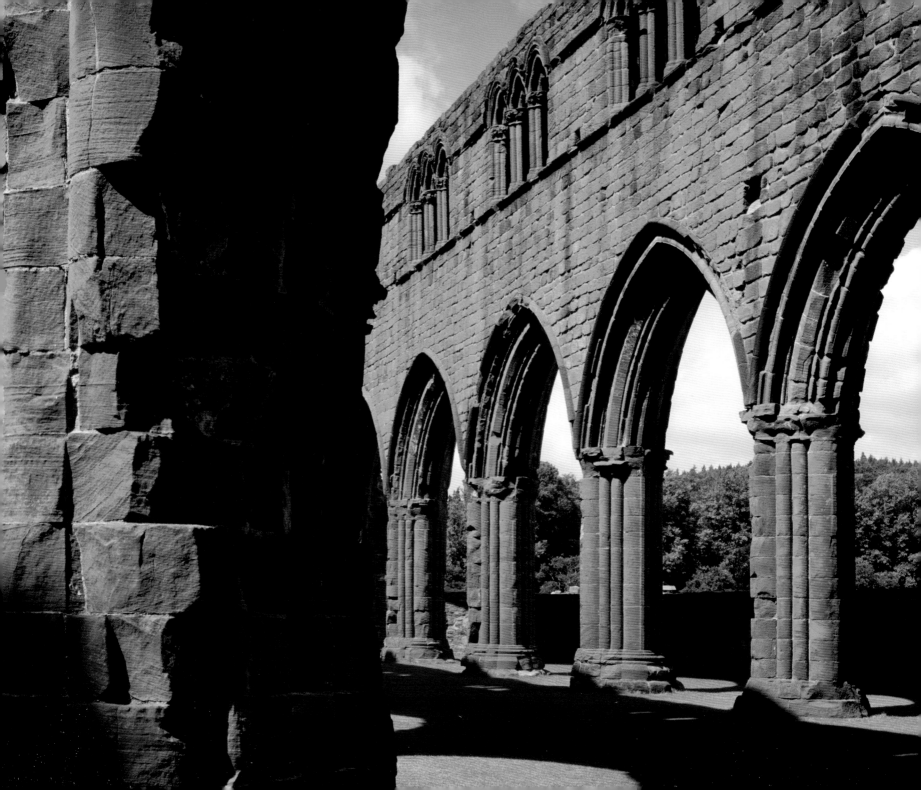

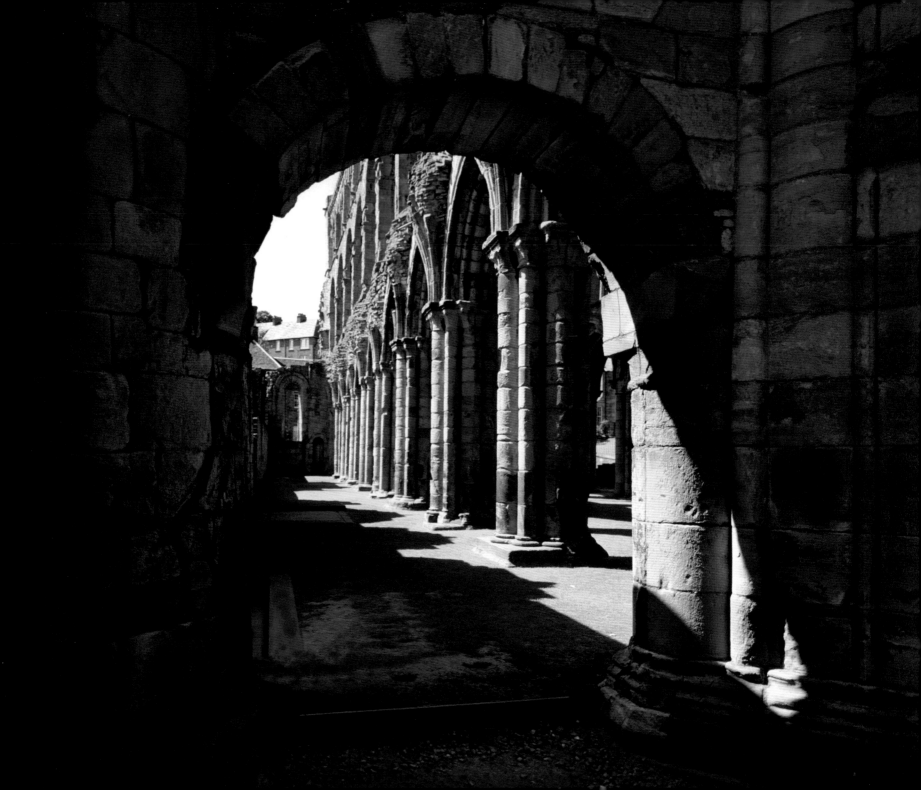

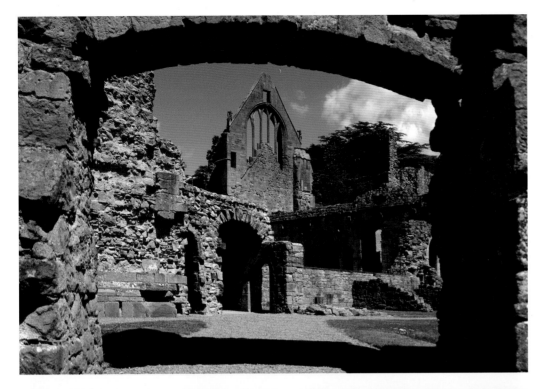

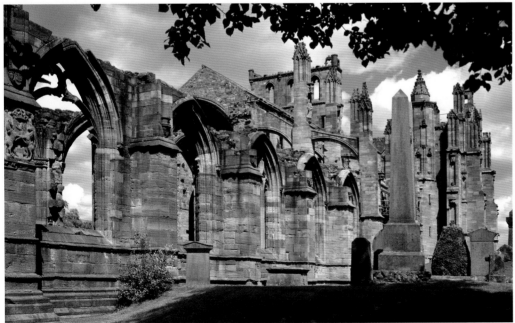

was built elsewhere in the town and Melrose Abbey was abandoned to the advancing forces of nature.

A similar story can be found at Jedburgh – where the huge Augustinian Abbey survives in considerable measure on its sloping site above the Jed Water. Much of the late-12th-century choir has been lost, but sufficient remains to give an idea of its austere beauty. The early-13th-century nave survives almost intact, complete with its dramatic west end and beautiful rose window high above the entrance.

Jedburgh's nave survived because the western end of it, like Melrose, became the Parish Church, fulfilling that function until well into the 18th century when the structural soundness of the whole building was brought into question by the collapse of part of the central tower. Luckily for us, the rest has stood the test of time.

At Kelso – another abbey founded by King David I and the third of the 'big four' to be sited by the banks of the Tweed – the huge abbey church built by the monks of Tiron was unique in Scotland in having two pairs of transepts: one pair in the usual place beneath the central tower and the others at the west end. All that survives of this remarkable 12th-century church with its double transepts is the northwest transept – surprisingly intact to its full height. Almost everything else has gone; the buildings used as quarries for centuries. Many a building in the town can trace its stone back to those 12th-century masons.

In St Andrews in Fife are the remains of the largest mediaeval church ever built in Scotland: St Andrews Cathedral. It was once the most important in the country. The Archbishop of St Andrews in mediaeval times was the most powerful churchman

[opposite page] The south nave aisle of Jedburgh Abbey Church, one of the richest and most powerful Augustinian abbeys in Scotland.

[above] The ruins of Dryburgh Abbey, a house of the Premonstratensian Canons. The great poet and novelist Sir Walter Scott is buried in the north transept.

[left] Melrose Abbey viewed from the southwest – little survives of the powerful Cistercian abbey except the church, which remained in use as the parish church long after the Reformation.

in the country, and his magnificent cathedral – which actually doubled as the church of the Augustinian Priory of St Andrews – broadcast that importance to anyone who came within sight of it. It was the longest church in Scotland by a long way: at 109m from east to west it dwarfed all of the others significantly. It was one of the most richly decorated, and certainly one of the wealthiest.

The first cathedral on the site was completed in the early 13th century, rebuilt after a storm in 1273, and finally completed in 1318. A disastrous fire in the 1370s caused extensive damage, and restoration work was not completed until 1440, by which time it was unrivalled in the land. However, as the most important pre-Reformation church in the country, it suffered at the hands of the reformers during the Reformation and was abandoned, slowly falling into disrepair as its stone, like Kelso, was used as a quarry from as early as 1577.

[above] The ornate faux-Gothic decorated facade on the west wall of the 15th-century Bothans Church near Gifford was added by Adam in the 18th century, hiding all trace of the original masonry.

[right] Detail of the stonework of Kelso Abbey. Only a fragment of the northwest corner of this once great Romanesque church has survived.

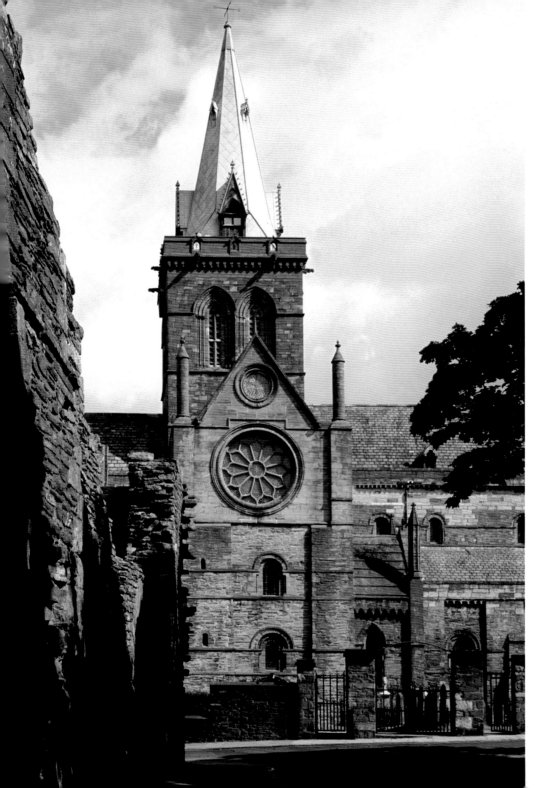

[left] The 12th-century south transept of St Magnus Cathedral, Orkney, and its 14th-century tower. Uniquely, the people of Kirkwall own this beautiful church. This was one aspect of a gift of King James III that gave much of the burgh to those who lived there. St. Magnus is also remarkable as one of the very few Scottish cathedrals to have been in continuous use as a church from its foundation to the present day. In 2012 the Cathedral celebrates 875 years of continuous use as a place of worship.

[above] Only a statue niche suggests that this fortified round tower was not part of a castle! It was in fact, part of the Bishop of Orkney's Palace – but in turbulent times, a measure of fortification was an essential feature even of an ecclesiastical palace.

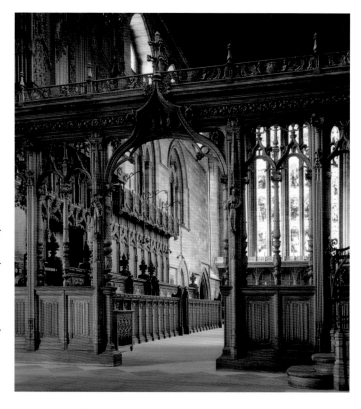

By the east end of the cathedral, St Rule's Church with its tall square tower, dates from the 11th century and was probably built to house the relics of St Andrew, as a place of pilgrimage. Today it offers wonderful vantage point from which to look out over the city, its university and its castle. And from the top of the tower, the foundations of St Mary's on the Rock, a mediaeval collegiate church just outside the cathedral priory precinct, can be seen.

But the stories of Scotland's mediaeval churches are not all of abandonment followed by ruin. A few miles southeast of Edinburgh, in Haddington, the former collegiate church of St Mary has a remarkable story to tell. The effects of the passage of time are nowhere more dramatically illustrated than by a visit to the church often referred to as the 'Lamp of the Lothians'.

H. V. Morton, writing in 1933, recounted his visit to Haddington and to St Mary's Church, specifically the grave of Jane Welsh, descendant of John Knox – the local-born man who had risen to lead the Scottish Reformation and who, according to many including Thomas Carlyle, was buried in the churchyard at Haddington. Morton writes:

'In the ruined nave of St Mary's lies that once lovely and brilliant woman, Jane Welsh Carlyle. Forty years of marriage with a mountain of philosophy were not easy, even if a woman married, as she once said in her impetuous way, for ambition; and she also had a temperament.

But at the end Carlyle came to her, to stand an old man with a melting heart, gazing up at the window as if she might pull aside the blind, as she did when she was young. In the dusk he went like an old grey ghost to the ruined nave to kiss her tombstone and to write perhaps the most pathetic tribute a husband has ever written to a wife.'

But Morton had got it wrong: the nave was in use as the parish church, having been repaired after the Restoration. It was the choir and transepts that were in ruins, and it was in the north choir aisle that Jane Carlyle was buried.

The church remained partitioned and partly abandoned until less than 40 years ago. Today, the church stands apparently complete in all its mediaeval glory. But all is not as it seems.

[this page] Three views of Dunblane Cathedral, which a century ago was restored from a partial ruin. Above, the lower courses of the tower date from an earlier cathedral. The Gothic choir, top right, acquired its Victorian choir screen at the time of the restoration. The ornate west doorway, showing the effects of centuries of weathering, is a scaled-down version of the French Gothic grandeur found in many of Europe's largest cathedrals. Dunblane however, is a small yet beautifully proportioned masterpiece.

[opposite page] St Mary's Church in Haddington was established as a collegiate foundation in the 1540s, only two decades before the Reformation.

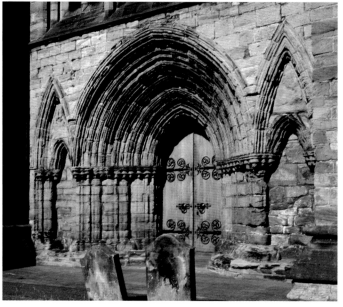

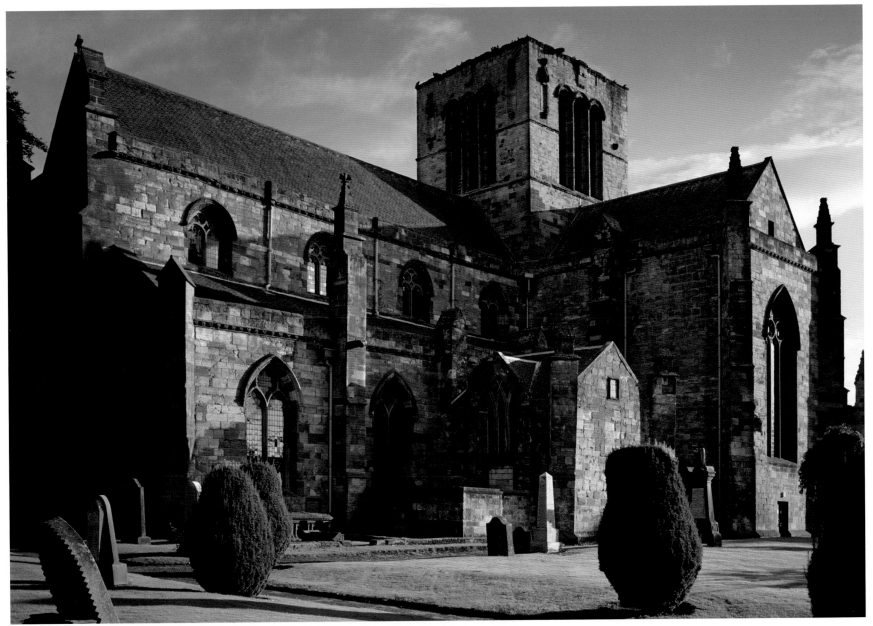

Haddington Collegiate Church was only established in the 1540s, just two decades before the Reformation, although the building itself dates from the 1460s. It is a large and beautiful cruciform church with a central tower, built on the site of an earlier 12th-century building.

Both John Knox and George Wishart preached from the pulpit in 1545, and unusually for the period, it is recorded that 90 per cent of the parishioners stayed away, preferring to abandon their obligation to attend Mass than listen to the two reformers preaching their fiery sermons. Within a few years their attitude towards John Knox would change, but for Wishart the future held only arrest after his last sermon in the church, followed by trial and execution at St. Andrews.

Of the church as it stands today, much is original, but much is not. The nave roof, originally a wooden beam structure, was replaced with the present plaster ceiling in the 19th century. The choir roof, lost centuries ago, was replaced only in the 1970s, at which time the 16th-century wall separating choir and nave was removed. The impact on the local clergy and community of revealing the church in its entirety for the first time in four centuries was considerable.

What appears to be a rich mediaeval vaulted ceiling over the restored choir is in fact late-20th-century fibreglass, carefully coloured and tinted to look like the original stonework. It was felt that the ancient walls, exposed to the elements inside and out for so long, could not bear the weight of a traditional roof. The effect is amazing and a visit is strongly recommended – the Lamp of the Lothians is a very special place.

Edinburgh's ancient churches tell their own stories of Scotland's turbulent religious past. The nave is all that remains of Holyrood Abbey next to the royal palace at the foot of the Royal Mile, having been comprehensively demolished by the reformers and leaving only the nave in use as the parish church for the Canongate. What little may remain of the abbey buildings lies beneath the well-manicured lawns of Holyroodhouse. The destruction of the nave then came about in the closing years of the 17th century, by which time James VII had refitted it as a royal chapel. An angry mob, stirred into action by the arrival of William

[right] St Michael's Church, Linlithgow: a magnificent 16th-century building which is one of Scotland's most beautiful parish churches. Its tower is now topped with a 20th-century golden coronal, and the church stands just outside the walls of the great royal palace.

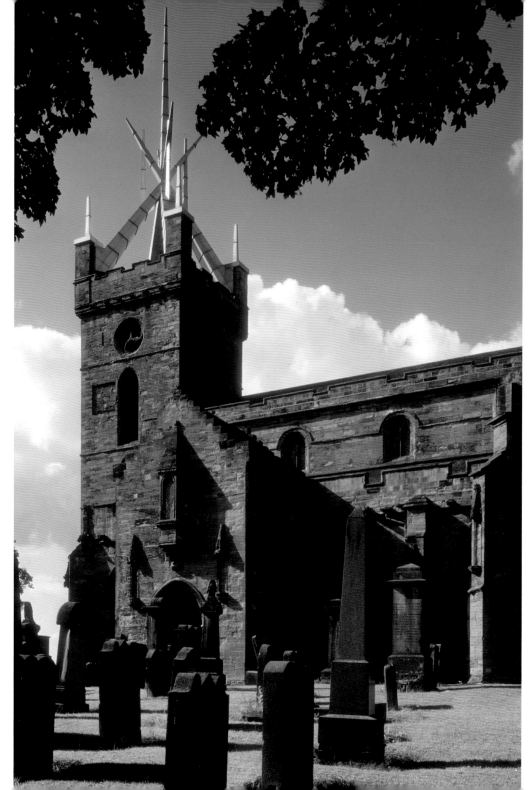

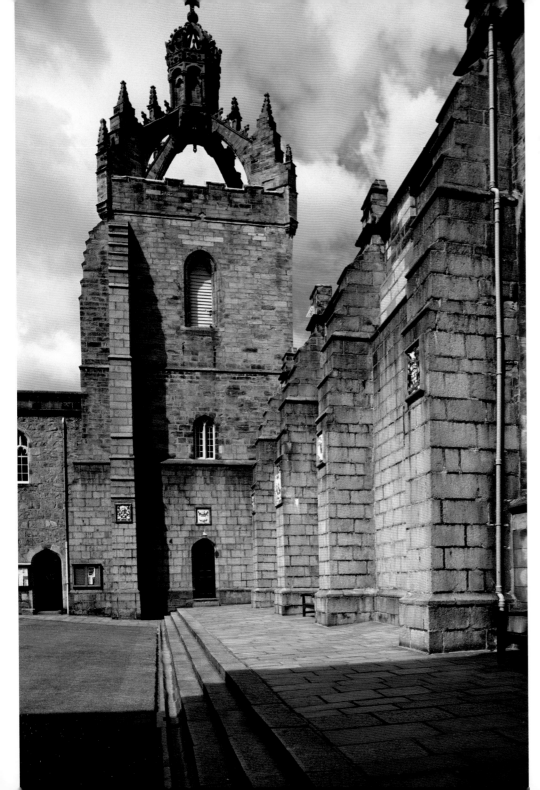

of Orange in England in 1688, attacked the church, leaving it the ruin we see today. Daniel Defoe would later comment that 'Certainly the Scots rabble is the worst of its kind'.

A mile away, amongst the ornate gravestones in Greyfriars Churchyard stands the memorial to some of the early Presbyterian martyrs who lost their lives in the 17th-century struggle to stop the re-introduction of bishops and their ecclesiastical hierarchy less than 80 years after the Reformation. The signing of the Scottish National Covenant in that same churchyard was a vigorous attempt by the Scots to assert their religious independence – only a quarter of a century after the union of the crowns in 1603 had started the process of eroding their national identity. The signing of the Act of Union would erode it yet further.

Thomas Pennant attended Sunday service at Greyfriars in 1772. 'In this church', he wrote, 'I had the satisfaction of hearing divine service performed by Dr Robertson. It began with a hymn; the minister then repeated a prayer to the standing congregation, who do not distract their attention by the bows and compliments to each other, like the good people of England'. The church he attended was already a century old, having been built on the site of the mediaeval friary and its associated college. The new Greyfriars was a simple structure, a far cry from the original church that was said, according to Pennant, 'to have been so magnificent'.

The Scottish Reformation had drawn a line under the construction of large and ornate churches in which to conduct centuries-old rituals, ushering in an era of austere design and simple services. The golden age of Scottish ecclesiastical architecture had come to an abrupt end.

[left] The tower of King's College Chapel, Aberdeen: a magnificent surviving example of a pre-Reformation college church. The college was established in 1495 by Bishop William Elphinstone, originally to be known as the College of St Mary the Virgin, but then changed to 'King's' in honour of King James IV. The bishop was reportedly concerned that in late-15th-century Aberdeen there were too many 'people who were rude, ignorant and almost savage'. The chapel was completed in 1500 and despite the turbulent years that ensued in the following two centuries, it has survived virtually intact – as have its 16th-century choir stalls, rood screen, and original timber roof.

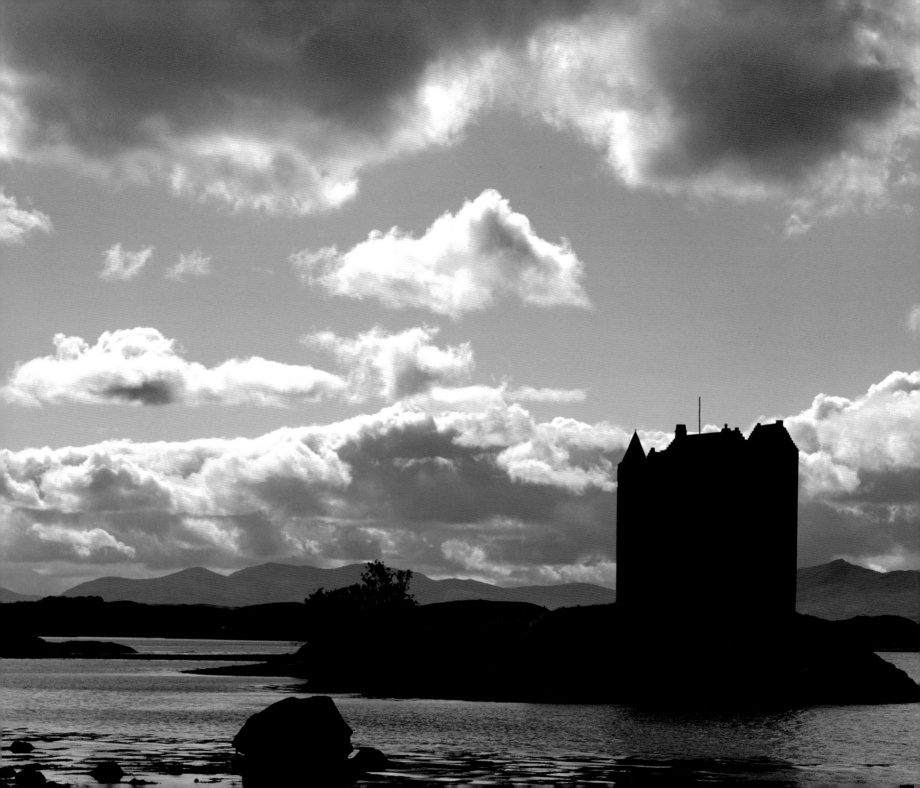

The Land of a Thousand Castles

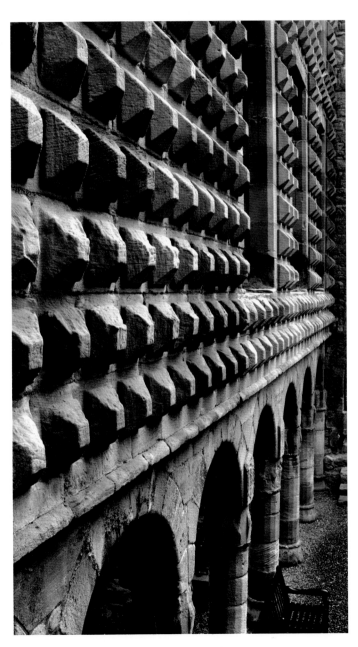

If it is true that the turbulence of a country's history can be measured by the number of fortified structures within its boundaries, then Scotland's past was turbulent indeed. From Iron Age hill forts from *c*.700BC to the huge castles of mediaeval times, the Scots have a history of building strong defences to protect themselves and their property.

The real castle building period started about 800 to 1000 years ago – dating from a time when there was a clear distinction between lord and peasant and when the castle was seen very much as the source and seat of local power. What happened to the peasantry may indeed have been of little consequence to the laird or lord as long as he and his family, together with his trusted staff, were safe from attack.

The castle evolved through the 13th to 16th centuries into a magnificent defensive structure, which it was hoped, neither man nor nature could destroy. Just as in England, many castles in Scotland evolved over the centuries from simple fortified towers or keeps designed to protect a few people into large and complicated buildings within often quite extensive perimeter walls. Others never developed beyond the tower-house stage. So the range of buildings to be seen today range from the small, compact and relatively simple castles such a Neidpath near Peebles, to the huge and impregnable fortresses of Stirling and Edinburgh.

Interestingly only one circular structure – by far the easiest to defend – survives, at Orchardton in Galloway. Amongst the others, we can find an assortment of architectural styles covering eight or nine centuries, creating buildings which are as complex as they are fascinating. Each has its own charm and fascination and there can hardly be anyone who does not relish a climb up the narrow spiral staircases leading to the top of any accessible towers.

Many of the castles developed into the strongholds of the Scottish Clans. Some still bear the names of the great families who once controlled vast tracts of Scotland – Castle Fraser near Aberdeen, Castle Campbell near Dollar and many others. Others started out with Royal connections and in the days of Britain's military might, were developed into garrison forts and barracks

[left] Crichton Castle – one of the strongholds of the Hepburns – played host to Mary Queen of Scots for three days in January 1562 while she attended the wedding of her half brother Lord James Stewart to Lady Janet Hepburn. The ornate Italianate stonework of the inner courtyard (seen here) was completed long after Mary's visit. The first monarch to see it was Mary's son, King James VI, when he visited Crichton in 1585, two years before his mother's execution at Fotheringhay Castle.

[opposite page] Castle Stalker, which is still a private residence, sits tantalisingly just beyond reach off the west coast near Portnacroish. Built in the 1540s by the Stewarts of Appin, the castle was occupied continuously until the middle of the 18th century, after which time it was abandoned. For the entire 19th century and half of the 20th, it stood a gaunt roofless ruin on its rocky islet: amazingly, restoration only started as recently as the 1960s.

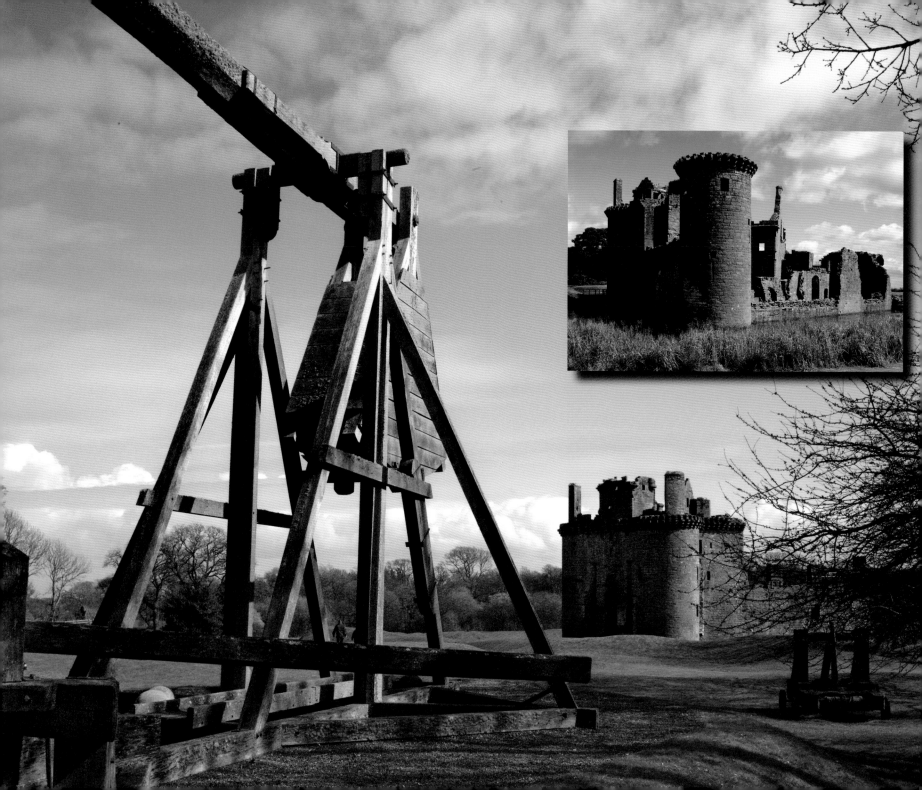

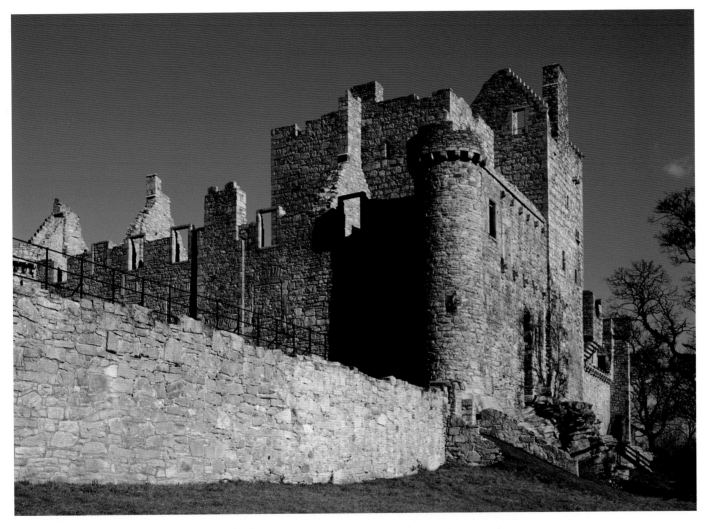

[opposite page] The magnificent moated ruins of Caerlaverock Castle, southeast of Dumfries, date back to the closing decades of the 13th century and must rank as one of Scotland's most spectacular and picturesque ruins. It is the epitome of the mediaeval fortress, albeit in miniature – for this is not a large castle. It was one of the strongholds of the once-powerful Maxwell family and its triangular shape and deep moat are classic examples of 13th-century defensive designs. Additions in the 17th century date from its role-change from border fortress to country home. A recreation of a 14th-century siege weapon – the trebuchet – stands as a reminder of the many attacks made on Caerlaverock.

[left] At the time of Mary Queen of Scots' first visit for a week in early September 1563 the giant fortress at Craigmillar had been recently repaired after an English attack 20 years earlier. She spent another period in residence in late 1566. The castle, home to Sir Simon Preston (a member of her Privy Council) was, in those days a few miles from Edinburgh, but today is surrounded by the city.

for the troops that held the empire together. Stirling Castle, Edinburgh Castle and Blackness Castle in Central Scotland all fulfilled that role, adding 18th and 19th-century buildings (of often less than memorable architecture) to the work of earlier builders. In some cases, the barracks replaced much more impressive buildings and in Stirling Castle, conversion for troop use almost lost priceless mediaeval treasures, as ancient oak roofs and decoration were ripped out to make way for accommodation for soldiers in what had once been a Royal palace.

The castles were obviously built as a response to the threat of military attack – and either the unsuitability of their design, or the intensity of the attacks to which they were subjected has

left many of them as mere shells. Once great castles such as Kildrummy survive only as a few rubble walls. Others such as Craigmillar – Edinburgh's second and less famous castle – survive roofless but otherwise almost intact. Indeed, Craigmillar is in many ways a much more satisfying and impressive castle to visit than its more famous neighbour.

Eilean Donan Castle – perhaps the most photographed in Scotland – stands at the lochside just a couple of miles before the road reaches Kyle of Lochalsh and the bridge to Skye. It has been almost totally rebuilt: 100-year old photographs of the site show the tiny fragment which was all that then survived of the original mediaeval castle. It looks the part however, and fits very well with our expectations of a castle in Scottish landscape.

Doune Castle looks every bit as picturesque – but Doune is all original – and in Dumfries & Galloway, Caerlaverock – moated and very French in its design – is without question one of the most scenic of Scotland's castles. It is also remarkably well preserved, having been in use well into the 18th century. Given the close relationship between Scotland and France – and the undoubted French influence in many of Scotland's churches – it is surprising that examples of French style castles are so few.

Crichton Castle has a courtyard based on an Italian design, showing that in 16th-century Scotland the ruling classes at least

[right] The silhouette of Duart Castle – home to the Clan MacLean – is the visitor's first glimpse of Mull as the ferry from Oban approaches the island. Built in the 13th century by the MacDougalls, ownership passed subsequently to the Macdonalds, the MacLeans, the Campbells, and then back to the MacLeans again. Like many of Scotland's more spectacular castles, Duart was a ruin for centuries before extensive restoration in the early years of the 20th century.

[opposite page] Not everything that looks like a castle actually is or was a castle. Ruthven Barracks may occupy the typical hilltop location favoured by the mediaeval castle-builders – indeed a succession of castles has stood on this site since the 13th century – but it is, in fact, the shell of one of four great early-18th-century barracks built to house a Hanoverian garrison force of up to 120 men sent to quell the Jacobites. Historians believe it was never fully occupied, and after it was attacked by the Jacobites and partially destroyed in 1746 – when only 12 men were stationed there – the site was abandoned, leaving the shell we see today.

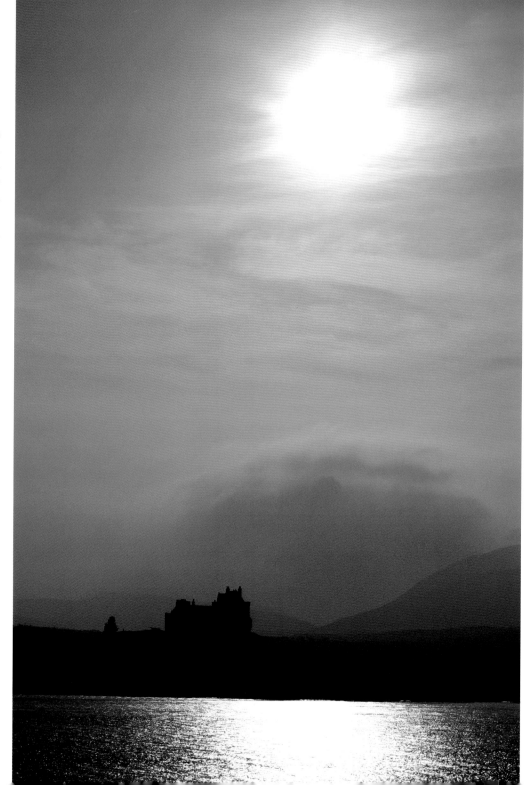

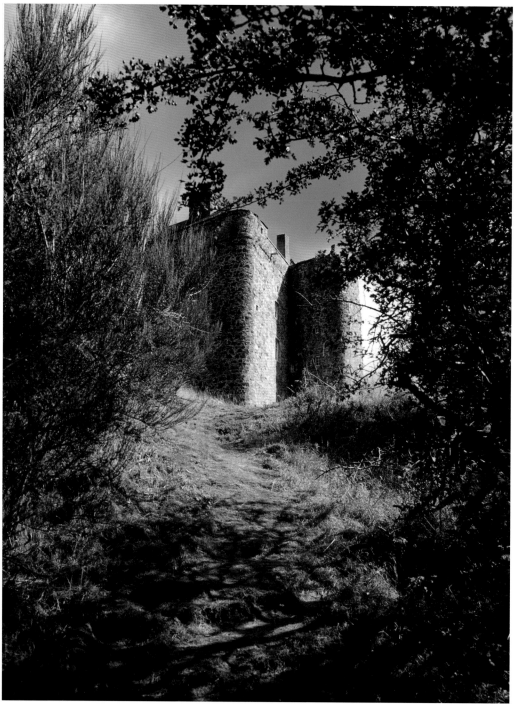

were much traveled. Despite the foreign influences however, the rugged and solid stonework has an undeniably Scottish style to it: simple stark and functional, with decoration only being tolerated in exceptional cases.

The setting of many castles on islands all adds to the delight of a visit. A boat across the River Dee to Threave Castle in Galloway seems so much more of an adventure than merely walking from the car park to the ticket office. The same is true of Loch Leven Castle – with its strong connections with Mary Queen of Scots – also only to be reached after a pleasant boat ride, this time from Kinross.

It is the variety of setting, sizes, states of repair and past histories which makes visits to a Scotland's castles so interesting. Grampian Council pioneered their 'Castles Trail' some years ago. Ably supported by posters, route maps, literature and easily recognisable road signs, the Castle Trail was an idea which went a long way towards presenting the region's castles as part of a greater national history rather than

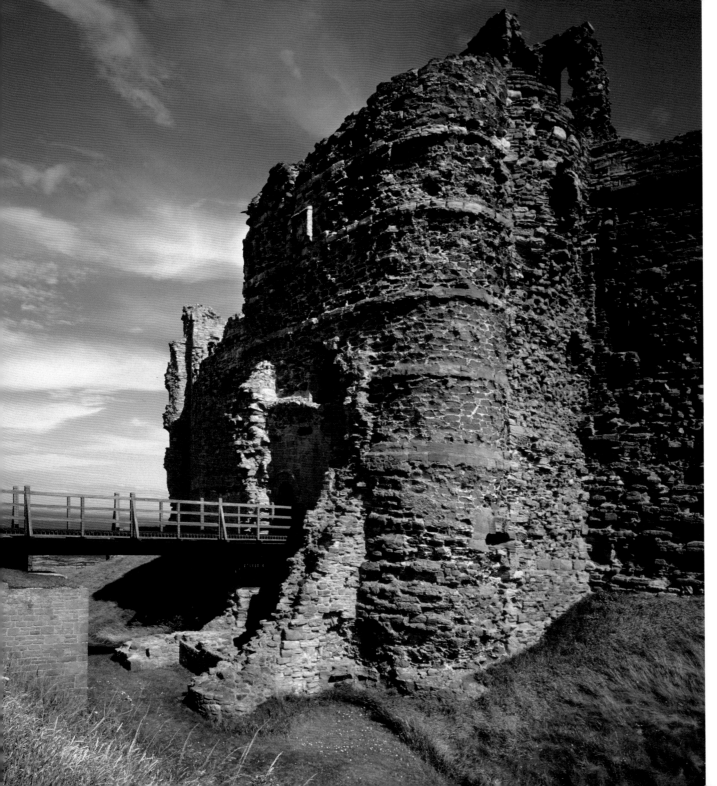

[left] The imposing entrance to Tantallon Castle. The ruins of the mid-14th-century fortress, built by William 1st Earl of Douglas, sit on top of a cliff near North Berwick. It has been the focus of several sieges, from James IV to Cromwell, and still exhibits many of the scars.

[middle] Neidpath Castle a few miles from Peebles occupies a dominant and commanding position above the River Tweed. The 600-year-old tower was built during the same turbulent period which provoked much of Scotland's castle and tower building, but it seems to have enjoyed a relatively peaceful existence. Indeed, by the middle of the 16th century the castle was renowned not for the stout defences it had put up against attackers, but for the beauty of the terraced gardens which ran down the steep slopes to the river. Those gardens were developed and tended for almost 300 years, before being abandoned in the early 19th century.

[far left] While tradition has it that there has been a fortress here for 1,000 years, the present Threave Castle – a stronghold built by the delightfully nick-named 'Archibald the Grim' and later owned by Black Douglas – dates only from the closing years of the 14th century. The castle is sited at the edge of an island in the River Dee on a ledge of land only just above the normal river level. It was sited there to give direct river access – one of a very few in Scotland to have had its own dock (substantial evidence of which can still be seen today). It is unclear if plans to convert it into a prison for Napoleon's soldiers in the early 1800s were ever carried through.

115

[above & right] Blackness Castle – its shape echoing that of a ship, the prow pointed towards the prevailing winds off the estuary – protected the port which gave access to the Royal Palace at Linlithgow.

[below] The entrance barbican of Stirling Castle, which dominates the city with its commanding position high on its rock, and (bottom) the Palace Wing.

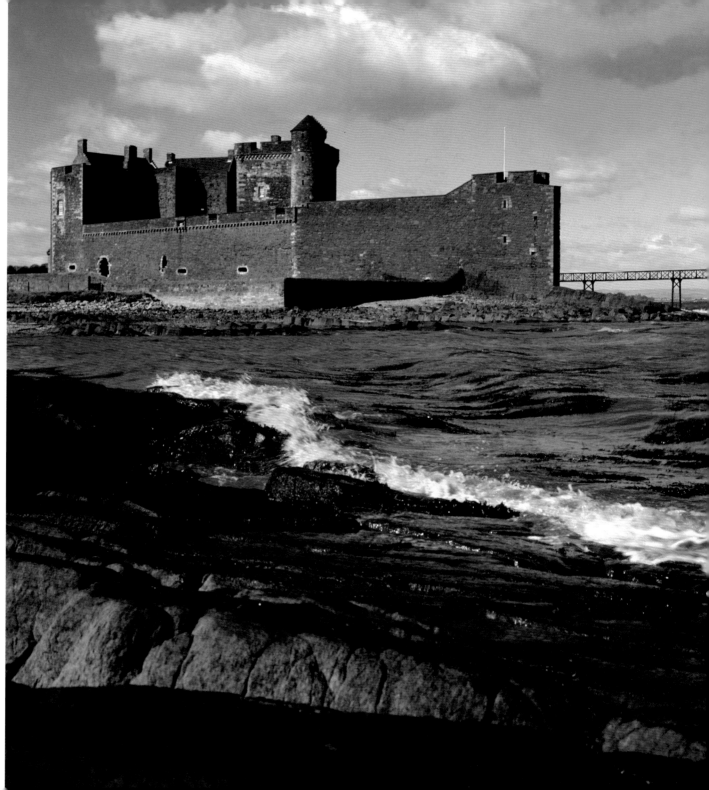

simply individual curios. This then lead to the popular hobby of 'castle-bagging'.

Many castles of course, were built as coastal defences. Sailing up the River Forth in mediaeval times – be you welcome guest or unwelcome foe – the sight which greeted you as you approached Blackness would have sent a chill through even the hardiest sailor. Blackness Castle – shaped unmistakably like a ship, its prow towards the prevailing winds off the estuary – protected not just this stretch of the river, but more importantly the port which gave access to the great Royal Palace at Linlithgow. The castle is first mentioned as late as the middle of the 15th century, and in 1453 the Crichton family gifted it to King James II. Subsequent monarchs used it both to defend the port, and as a prison for high-status prisoners. Cardinal Beaton was perhaps its most famous to be held there – in the mid 16th century – by which time it was as near to being an impregnable fortress as 16th-century castle-designers could make it.

Cardinal Beaton's name appears in connection with yet another of Scotland's great coastal castles: at St. Andrews in Fife. As an exemplar of how close to nobility the upper echelons of the mediaeval clergy were, the first St Andrews Castle was constructed in the early 13th century as a residence for the bishop. Later bishops, whose religious duties were often indistinguishable from their involvement in politics, enlarged and strengthened it. By the mid 16th century – after Beaton has incurred the wrath of the English King Henry VIII by refusing to sanction the marriage of Henry's son Edward with the three-year-old Mary Queen of Scots – the castle was being turned into a veritable fortress for the cardinal. Having also incurred the wrath of the Protestants with the killing of George Wishart, Beaton's castle was overrun by Wishart's supporters rather than the English. The cardinal was himself murdered and his body hung from the walls of his own newly fortified castle.

One of the most imposing, yet curious, of Scotland's coastal castles must be Dunstaffnage, with its strategic location by the shores of Loch Etive just outside Oban. As the visitor approaches the ancient 13th-century castle, it appears to have a 17th-century house perched precariously on top of it! The castle sits on a solitary outcrop of rock, and its shape is determined by that rock. With the exception of the house on top, the exterior view is hardly changed from that envisaged by

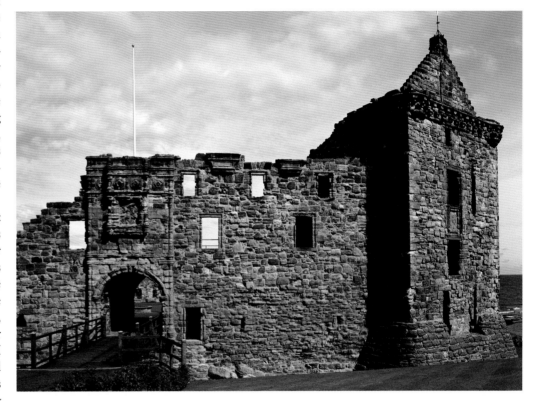

its 13th-century designer. Inside, the castle has been altered and updated periodically, but if Robert the Bruce – who captured it in 1309 – were to approach it today, its shape would be wholly familiar to him. The house astride the gateway dates from extensive alterations to the gatehouse in the 17th century and must surely be a uniquely eccentric feature.

The story of Mary Queen of Scots is a magnetic force which draws visitors to many of the castles she visited during her few years in Scotland. The links between the romantic ruins and the tragic queen are what makes exploring Scotland's history special, and what keeps drawing us back again and again to the remote outposts of the country's mediaeval power-brokers. Legally, Mary was Queen of Scotland for almost all of her life –

[above] The shell of St Andrews Castle, which has seen some of the most turbulent events of Scotland's history.

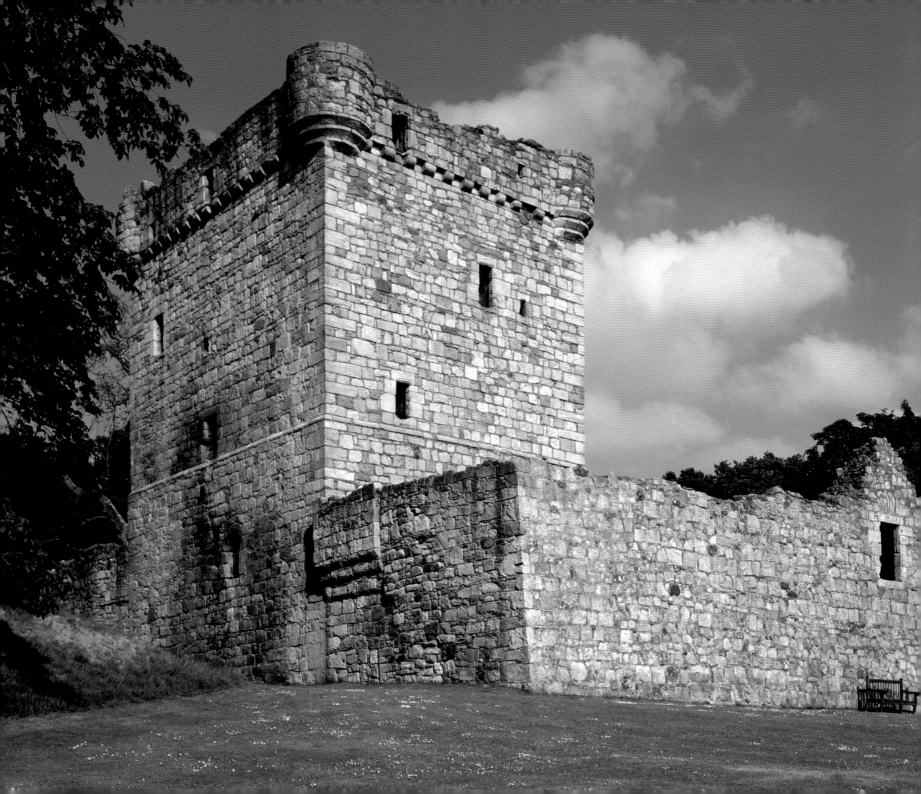

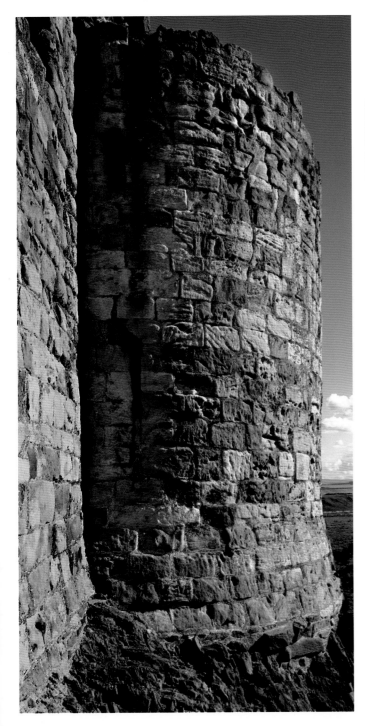

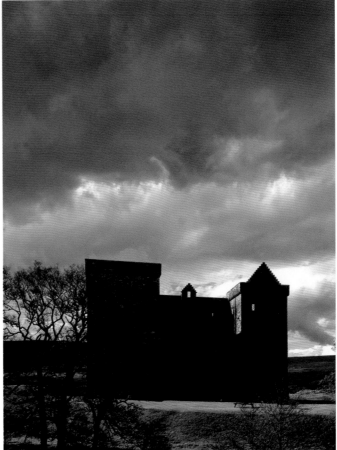

[opposite page] Loch Leven's island Castle, near Kinross, was probably established in the late 13th century. It was Mary Queen of Scots' prison for almost a year – between June 1567 and May 1568 – and was where she was forced to abdicate the Scottish throne in favour of her infant son James VI in July 1567.

[far left] Dirleton Castle, much of which dates from the 13th century, stands on a rocky outcrop overlooking the village and the Firth of Forth. Like many Scottish castles, this magnificent fortress suffered from English sieges, most notably by the armies of Edward I in 1298, who after having extensively damaged the castle's fabric with great catapults, then immediately set about rebuilding parts of it. Dirleton Castle continued to figure in Scotland's history right up until the time of the Commonwealth and, indeed most of the damage evident on today's remains can be attributed to a siege by Cromwell's men in 1650.

[left] In 1566, Mary Queen of Scots visited the wounded Earl of Bothwell – whom she would marry in the following year – at the remote Hermitage Castle in the borders: an event which helped precipitate her downfall. It had been the family seat of the Hepburns since the late 15th century. Implicated in the death of Mary's second husband Lord Darnley, Bothwell was already unpopular and widely distrusted within the Scottish nobility before his association with the Queen enhanced his power.

becoming Queen at the age of only one week upon the death of her father, King James V. She was born at Linlithgow Palace in December 1542, betrothed to the infant Edward, heir to Henry VIII of England, at the age of 6 months, and when that fell through, she was whisked off to France in 1548 and betrothed to the sickly and short-lived Dauphin Francis.

By 1561, aged 19 and widowed, she returned to Scotland to reclaim her throne and to impress upon her earls and barons that she was in charge. She undertook several Royal Progresses over

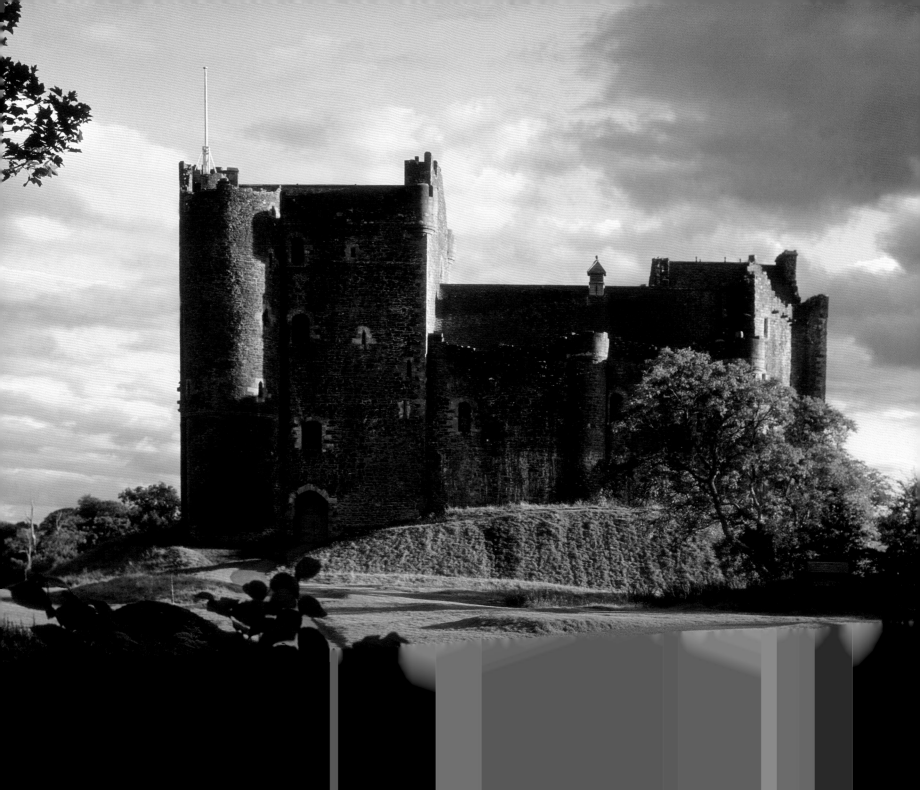

the ensuing six years – as was normal practice for the monarch at the time – travelling extensively throughout Scotland and staying at many of the great castles, palaces, stately homes, and a few abbeys along the way.

She obviously had closer relationships with the owners of some of the great castles than others, and visited them more often. One such was the bleak 14th-century Dunnottar Castle, seat of the Earl Marischal on the east coast south of Aberdeen, which she visited twice in 1562 and again in 1564. She made a single visit to Tantallon Castle, with its magnificent views across the Firth of Forth and the Bass Rock, staying there on 19 November 1566; and visited Craigmillar for a week in early September 1563. She spent another period in residence there in late 1566. Crichton Castle, one of the strongholds of the Hepburns, played host to the Queen for three days in January 1562 while she attended the wedding of her half brother Lord James Stewart to Lady Janet Hepburn.

Other castles with links to Mary include Castle Campbell, perched high on the hills above Dollar. There, in January 1563, Mary attended the wedding of the Earl of Argyll's daughter to James Stewart, the Lord of Doune. She stayed in the castle for three nights, but the turbulence of Scottish life at the time meant that within a couple of years – after Mary married Lord Darnley – the Earl and the Queen found themselves on opposite sides of the political divide. The central tower-house of the castle was built in the 15th century and its austere design and isolated position earned it the nickname of 'Castle Gloom'. The celebrations of the wedding however, reportedly brought much colour and glamour to the place, with masked balls, a riot of colour and music.

Three months later, the Queen made one of her earliest visits to Lochleven Castle – she had probably first visited in 1562. By 1567, shortly after her marriage to the Earl of Bothwell and the subsequent defeat of her armies at Carberry Hill, Mary was back in the island castle, but this time as a prisoner. During the year she spent in the bleak fortress, she miscarried Bothwell's child and suffered a period of ill health, before escaping in May 1568, eventually making her way to England and into the hands of her cousin Elizabeth who would eventually order her execution at Fotheringhay in 1587.

Mary visited Hermitage Castle only once, in late 1566, visiting the wounded Bothwell, whom she would marry in the following year – an event which helped precipitate her downfall.

The Earls, and later Dukes of Atholl have lived at Blair Castle, northwest of Pitlochry, for centuries, and the hills and forests

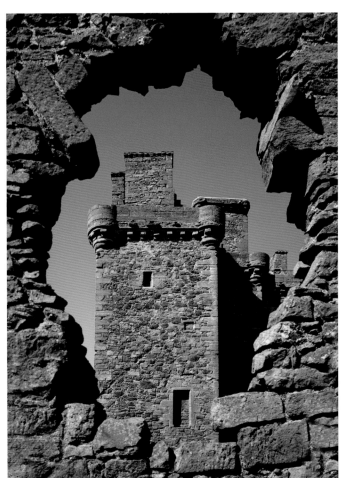

[opposite page] Doune Castle has occupied a prominent position overlooking the River Teith for over 600 years, having been built for Robert Stewart, Duke of Albany, and Regent of Scotland. Stewart was at the heart of late-14th and early-15th-century Scottish history and in 1828 his story was woven into *The Fair Maid of Perth* by Sir Walter Scott. At the time of the '45, the Castle was a Jacobite prison, and Scott also drew on its history when writing *Waverley* in 1814. Scott's epic poem *Lady of the Lake*, written in 1810, was also set in part at the Castle of Doune.

[left] Balvaird Castle was one of the homes of the Murrays of Tullibardine, until they inherited the Earldom of Mansfield and moved to Scone Palace. The tall tower-house was built towards the end of the 15th century during the reign of James IV and was the main residence of the family until 1685.

[below] Bothwell Castle, a detail.

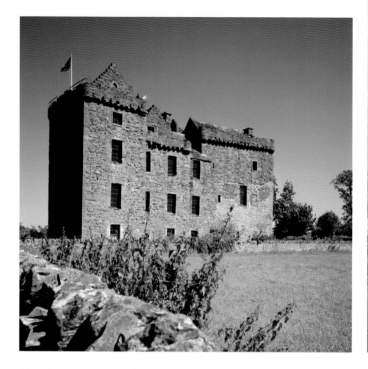

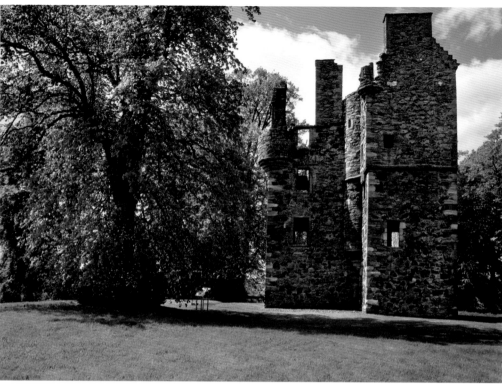

[above] Huntingtower Castle near Perth was constructed as two separate tower-houses in the second half of the 15th century and was known as the House of Ruthven until c.1600. Until the late 1600s, the two tower-houses were linked by a 3m-wide arched gateway. The buildings were joined and reconfigured as a mansion house more suited to the tastes of the time by the Murrays of Tullibardine, who had acquired the property after the downfall of the Ruthvens in the early 17th century.

[above right] Greenknowe Tower, near Gordon in the Scottish Borders, is a late-16th-century L-shaped tower-house. Built in 1581 by James Seton, it sits on a low mound and was given some measure of protection from attack by the surrounding marshy ground.

surrounding the great white-harled castle were renowned for their fine hunting. The Queen visited Blair once, for a spectacular hunt and banquet in August 1564, during which a reported 160 deer were slaughtered – hunting on a grand scale! The castle today contains some fine portraits and miniatures of the Queen.

Huntingtower Castle near Perth was known as the House of Ruthven or Ruthven Castle in Mary's day, and Patrick, Earl of Ruthven, was a great friend of Lord Darnley and the Queen. He entertained them at his castle during their honeymoon in the autumn of 1565. The Earl would shortly thereafter become implicated in the murder of David Riccio in Edinburgh and in another of those familiar twists in Scottish political allegiances, Patrick's son William would become a central figure in Mary's imprisonment at Loch Leven. In addition, Ruthven Castle would be the setting for another pivotal episode in Scottish history when Mary's son, James VI, was briefly imprisoned in the castle during the notorious 'Ruthven Raid' of 1582 – a

plot to persuade the young King to distance himself from his Catholic heritage and advisors. Two years later he was back as a guest, but although he appeared to have forgiven the family for their treachery towards him and his mother, in actuality he had not! In a series of episodes over the following 20 years, the family suffered a number of violent deaths, culminating in a charge of treason being brought in 1600 against the Earl – or more accurately against his body, as he was already dead! Despite that minor detail, he was found guilty and hanged in Edinburgh. The family was disgraced, their lands and houses forfeited and the castle's present-day name of Huntingtower came into use.

Now, some centuries after the turbulence of Scotland's mediaeval period, many of the country's castles are still lived in. Some have, over several centuries, been converted into stately homes and while externally they still retain their forbidding mediaeval appearance, inside the expected conveniences of family living have been gradually introduced. Others have been

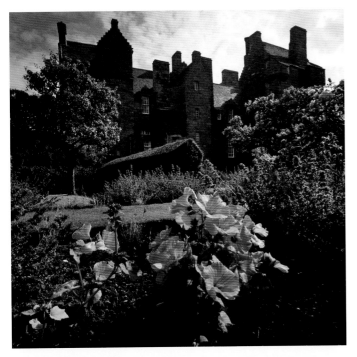

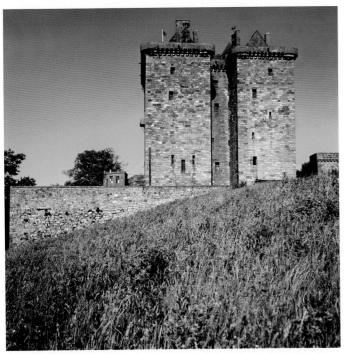

[far left] Kellie Castle, near Anstruther in Fife, was an abandoned ruin for centuries. Built in the 14th century as the home of the Oliphant family, who lived there until the early 19th century. After the death in 1829 of the last in line it was used as a grain store, and its condition deteriorated rapidly until Professor James Lorimer set about its internal restoration – not as a medieval castle, but returning it largely to its late-18th-century character as an elegant mansion.

[left] The most famous of them all: Edinburgh Castle dominates Scotland's capital city. Here, the moon is rising behind the floodlit castle, with the lights of Princes Street Gardens below the rock.

[below left] The 15th-century Borthwick Castle was also restored from a ruin and turned into a luxury hotel.

[above] Falkland Palace in Fife was built as a hunting lodge for the early-16th-century Stuart monarchs. In its grounds is the oldest tennis court in Britain – laid out for 'real' tennis rather than the lawn tennis played today.

restored from empty shells and converted into luxury hotels, much loved by visiting ex-patriots who relish the chance to savour something of the country's baronial past. Today it is not just the nobility who can enjoy brief hospitality in these ancient fortresses – that opportunity is open to anyone able to afford the tariff.

For the majority of visitors, however, it is probably the surviving spectacular ruins which are the major attractions. It is certainly the remains of once-powerful fortresses – some of them just fragments of walls atop remote hills – which tell the real story of the power struggles which defined Scotland as a nation. H. V. Morton, writing in 1929 of his visit to Lithlithgow Palace, summed up that attraction: 'enough of it remains for a man to prowl round in silence, hearing in imagination the creak of harness, the skirl of pipes, and the uneasy footfall of sad kings and even less happy queens.'

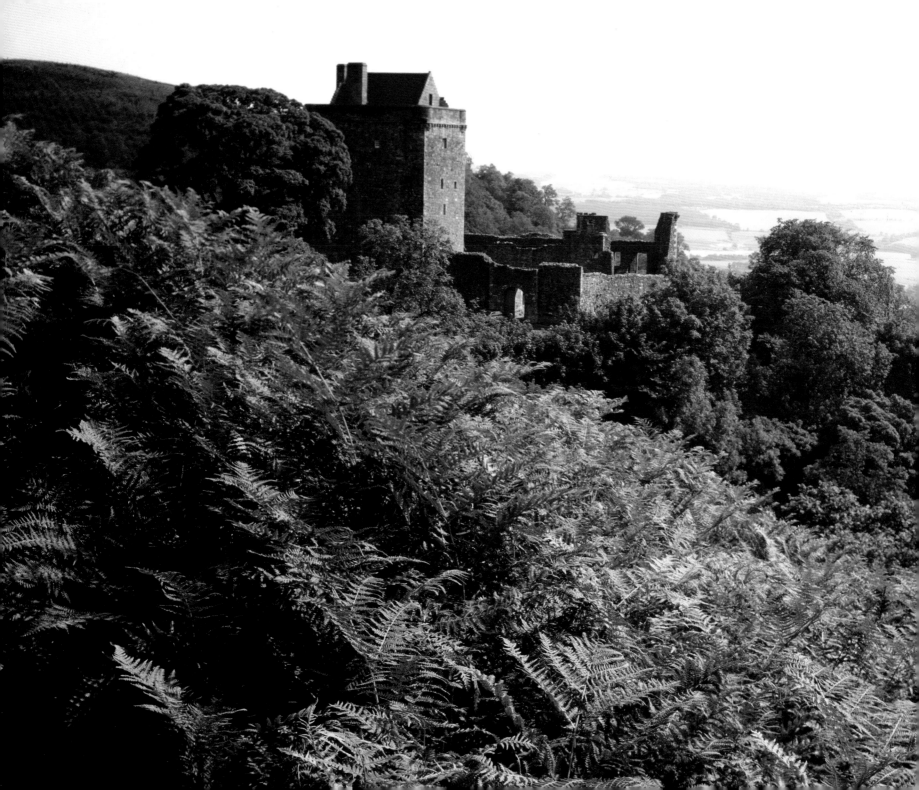

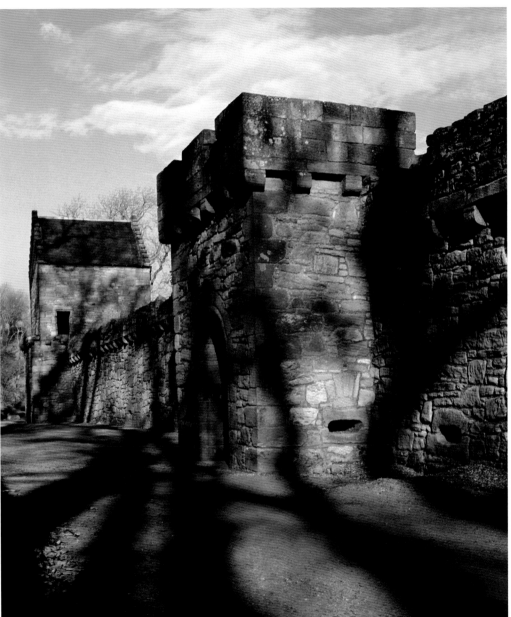

[far left] Castle Campbell, high on a hill above Dollar, was built in the 15th century and its austere design and isolated position earned it the nickname of 'Castle Gloom'.

[left] Craignethan Castle was the last really defensible mediaeval castle to be built in Scotland. After Craignethan was completed in the early 1530s for Sir James Hamilton – known as the 'Bloody Butcher' – castles may still have looked powerful, but their design was increasingly driven by appearance and (a measure of) comfort. Situated high above the River Nethan, the castle's construction was seen as a powerful political statement by Hamilton, but a political statement which did not preface a long and peaceful life behind its thick walls and heavy artillery. Hamilton – King James III's Master of Works when the castle was being built – fell from grace and was executed in 1540. His immediate descendants also fell out of favour when they backed the cause of Mary Queen of Scots, and Scotland's last mediaeval fortress was all but abandoned before the end of the 16th century.

[overleaf left] Dunnottar Castle sits on a rocky outcrop which has been inhabited for more than 6,000 years. Most of the present buildings were constructed in the 14th century.

[overleaf right] The spectacular ruins of the 13th-century Castle Tioram stand on the tidal island, Eilean Tioram, in Loch Moidart.

125

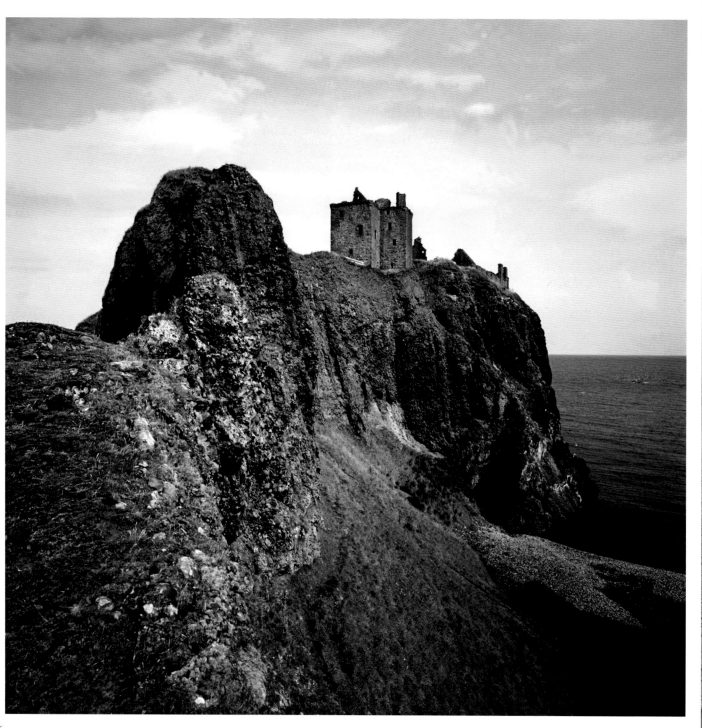

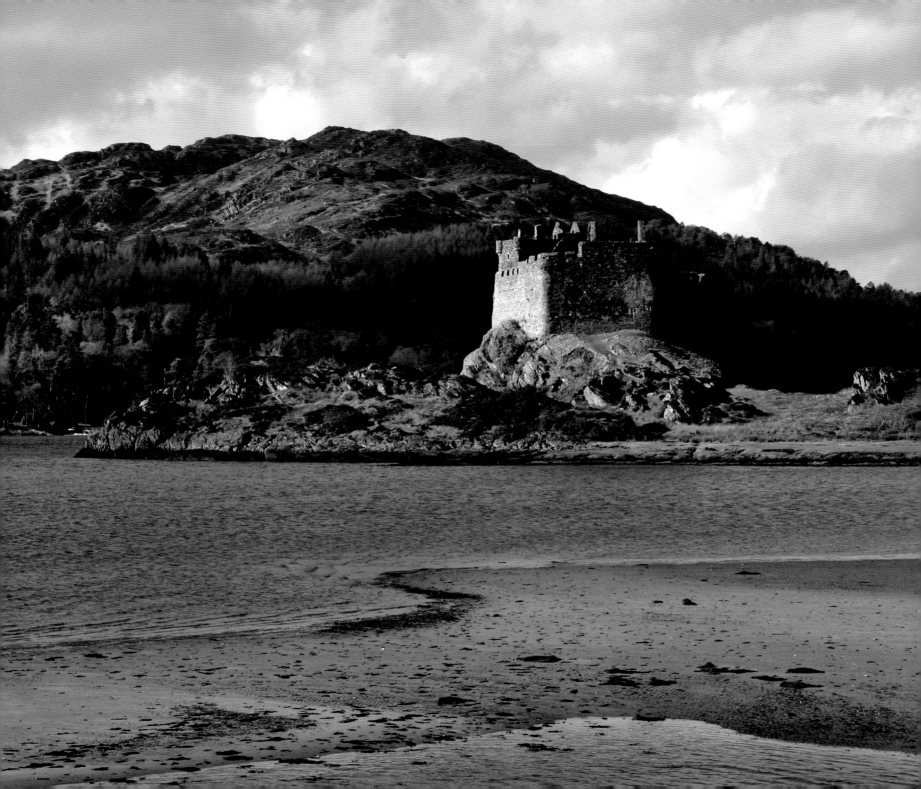

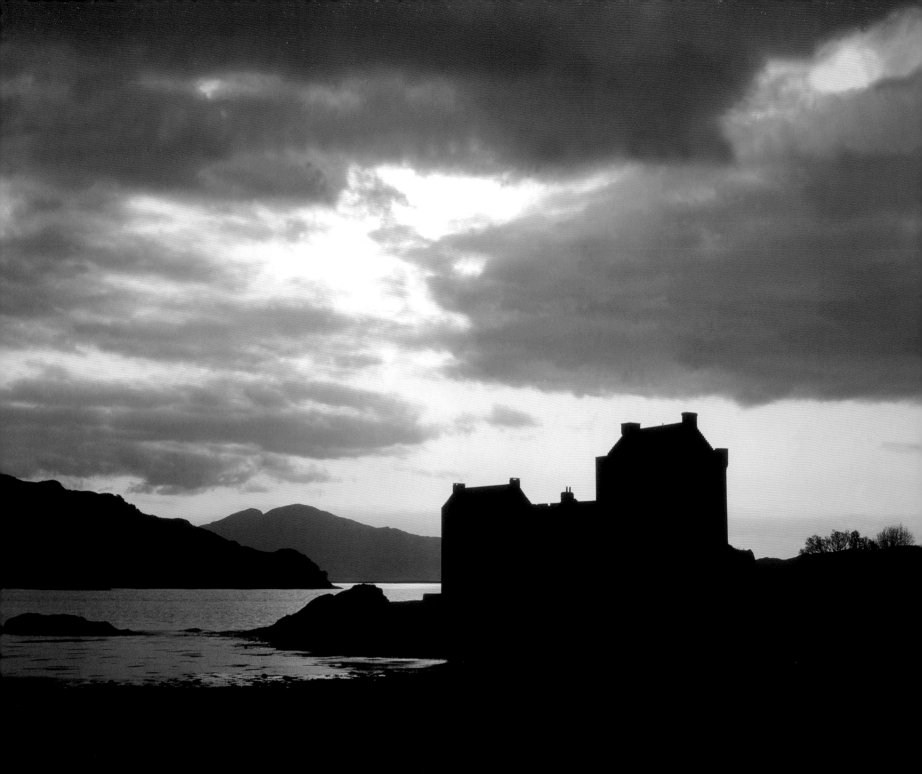

[opposite page] Eilean Donan Castle is probably the most photographed and most recognisable castle in Scotland, yet what we see today is not yet 80 years old! A castle has stood on this site since the 13th century – the first was probably built by King Alexander II – and with re-buildings and enlargements, a castle stood there continuously until 1719 when Spanish troops sympathetic to the Jacobite cause occupied it. That was when three warships (often described as English warships) reduced the site to rubble during that year's failed Jacobite uprising. And so it stayed for over two centuries until the task of undertaking a complete rebuilding by George Mackie Watson was completed in 1932.

[left] Orchardton Tower has the unique claim to being the only circular tower-house ever built in Scotland. Mid-15th-century estate agents might have described it as 'a bijou residence' with a cellar and three rooms. It was built for one John Cairns about 1460. Above the cellar, the main hall would have served as living room and dining room. Above that, the two upper floors, each with a circular 25-foot diameter room, would have served as sleeping accommodation for the family. A walled courtyard, with stables and other buildings within, would originally have surrounded the tower but only scant remains of those now remain. Just why Scotland only appears ever to have had one circular mediaeval tower-house is unexplainable, especially given the 2,000-year-old tradition of building brochs – circular Iron-Age fortified towers – the remains of which can be found in various places along the west coast, the Western Isles, and up into Orkney and Shetland. Indeed, the so-called 'Doon Castle' at Ardwell Point near Stranraer only a few miles from Orchardton, is the remains of just such a tower.

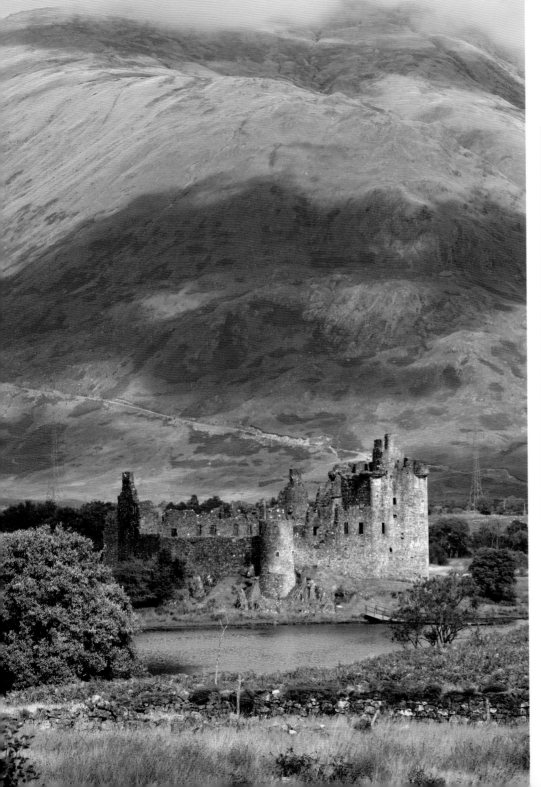

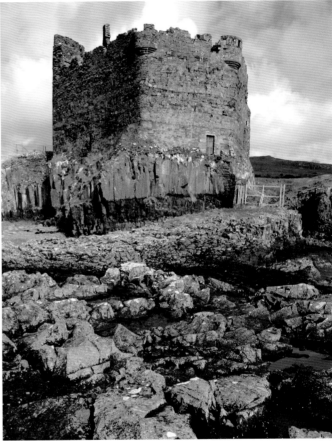

[opposite page] The Caponier at Craignethan Castle is a rare survival of a mediaeval failure. The idea was to create a fortified shooting chamber with narrow gun slots to enable the defending troops to kill their attackers, but the chamber filled with musket smoke rendering them incapable of keeping their eyes open! The slot through the wall measured about 12 inches wide by 4 inches high.

[above] Mingary Castle sits on the shore of the Ardnamurchan peninsula at Kilchoan, looking over the waters towards Mull.

[left] Beneath the towering slopes of Ben Cruachan, the dramatic ruins of Kilchurn Castle stand on the shores of Loch Awe.

131

[right] Burleigh Castle – the home of the Balfours – was built in the first half of the 16th century. One of a line of castles across Kinross, each was within beacon-range of its neighbours so they could warn each other of approaching danger.

[far right] Bothwell Castle was built overlooking the River Clyde between 1250 and 1400. Due to repeated attack and destruction, the planned grand design was never completed and much of what survives dates from c.1400.

[below] The scant remains of Castle Coeffin on the west coast of Lismore.

[below right] The mid-15th-century Smailholm Tower between Melrose and Kelso stands at the head of a small lochan.

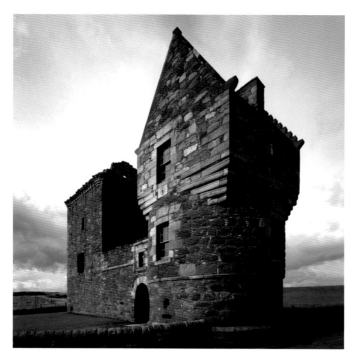

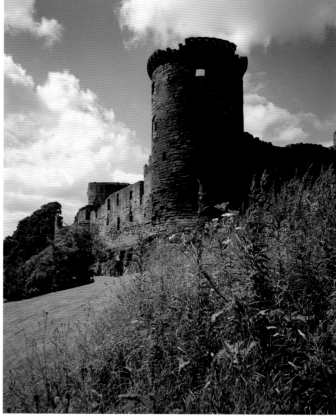

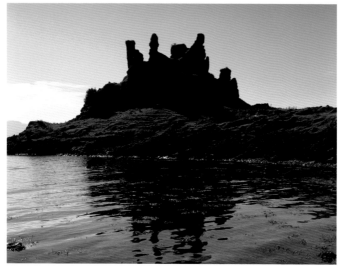

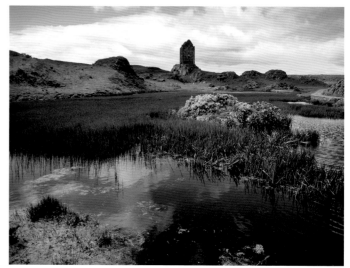

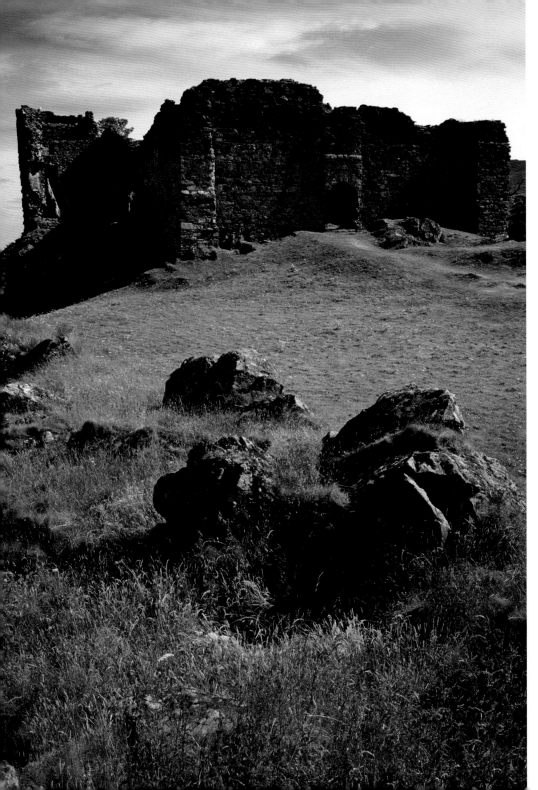

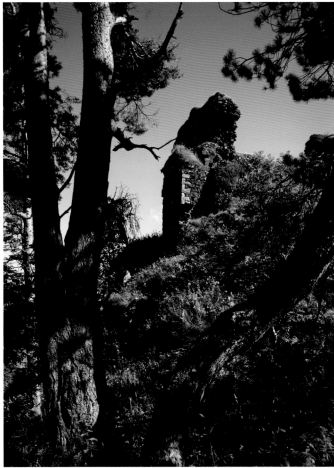

[left] Castle Sween looks out west across Loch Sween in Knapdale. One of the first stone-built castles in western Scotland, it dates in part from the 12th century. After Robert the Bruce evicted the Clan MacSween in the 14th century, ownership of the castle passed to the MacDonalds.

[above] The 13th-century Aros Castle on Mull, now just a fragment of its former glory, was once one of the strongholds of the MacDonalds. It stands on a headland near the mouth of the Aros River just outside the village of Salen. It was one of a number of castles built in the 13th and 14th centuries to overlook and defend the Sound of Mull.

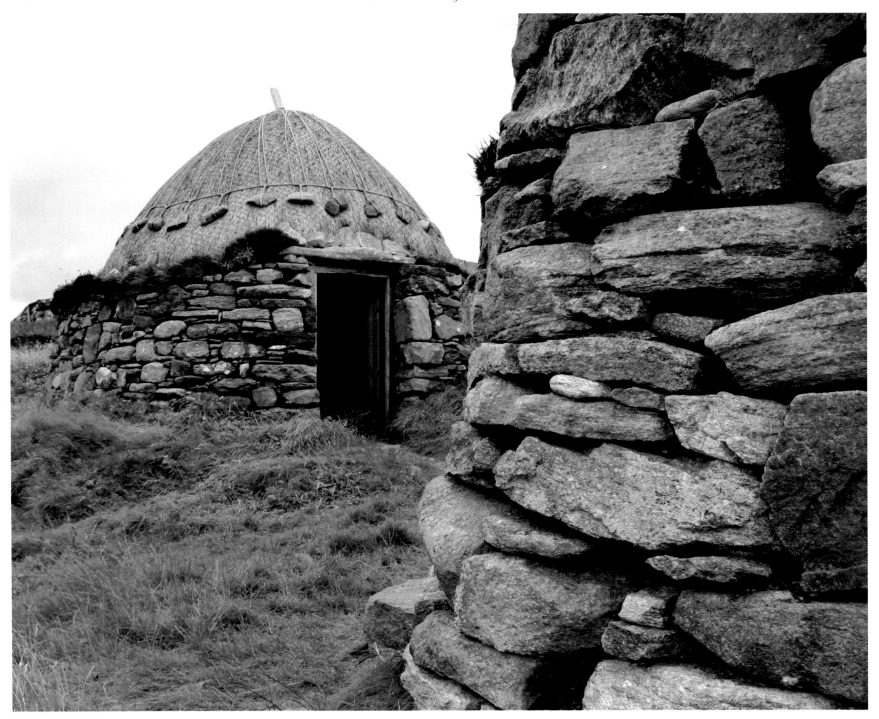

One Thousand Years of Industry

Scotland has a rich industrial tradition. While ship-building and coal mining have left the most obvious scars on the landscape in the past century, the country also has many survivals from earlier industrialisation, amongst them fishing ports, distilleries, mills, iron foundries, bridges, docks and harbours. Pioneering communities such as New Lanark all have engaging stories to tell.

But the most frequently-found industrial relic is probably the corn mill – the focal point of every agricultural community, and a key component of the food supply chain. The mill's location was dictated by geography. Ideally it needed to be near the farming community whose corn it ground, near those who bought and used its flour, and located close by a plentiful supply of water.

While some mills were established in remote locations simply because there was a ready supply of fast running water, a number of towns and villages owe their very existence to their mill, being developed around this key facility and sharing its water supply.

The first mills in Scotland were probably 'Norse mills' (also known as 'Greek mills'), so it is not surprising that examples are still to be found in the Orkneys, Shetland and in the Western Isles. Such mills were in use over 2,000 years ago, their simple design being easy to construct with even rudimentary expertise. However, they were not efficient, so could only be used when there was a substantial supply of water. While Orkney today has but a single example, those on Shetland and in the Hebrides have fared a little better.

The design was very simple: a stream of fast moving water drove a rotating set of paddles beneath the mill floor, directly turning the millstone above. With some mills it was the natural force of the water which did the business, but where the water moved more slowly, it was collected in large millponds and when the mill was working, it was directed through narrowing channels to increase its flow, eventually passing under the mill and driving the rotor.

In more populous and 'civilised' places, Roman influences saw the rotor mills replaced with what were known as 'Vitruvian mills' – presumably named after the Emperor Vitruvius

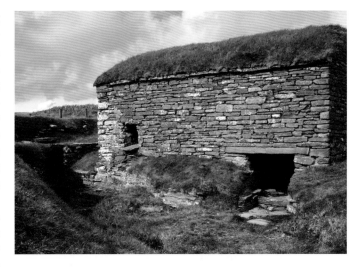

[opposite page] The reconstructed Norse Mill at Siabost, now known as Shawbost, on Lewis is a survivor of over 200 such mills on the island. This view looks past the dry stone wall of the mill itself towards the kiln room. The group of thatched buildings was restored in the 1990s. The millstones are directly driven by a rotor or paddle mechanism beneath the floor of the mill building.

[above left] Dounby Click Mill, Orkney. Now in the care of Historic Scotland, this turf-roofed 'Norse' style undershot rotor mill is the last horizontal watermill left in the Orkneys.

[above] The reconstruction of the type of paddle rotor that would originally have powered Dounby Mill.

[left] The remote Glendale water mill on the Isle of Skye. An early overshot mill, dating in part from the 18th century, Glendale was fully restored to working order in the 1970s, but has since fallen into disrepair once again. At the time of writing, part of the roof has collapsed.

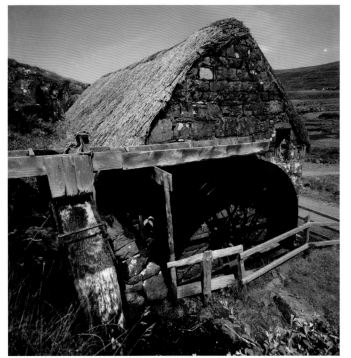

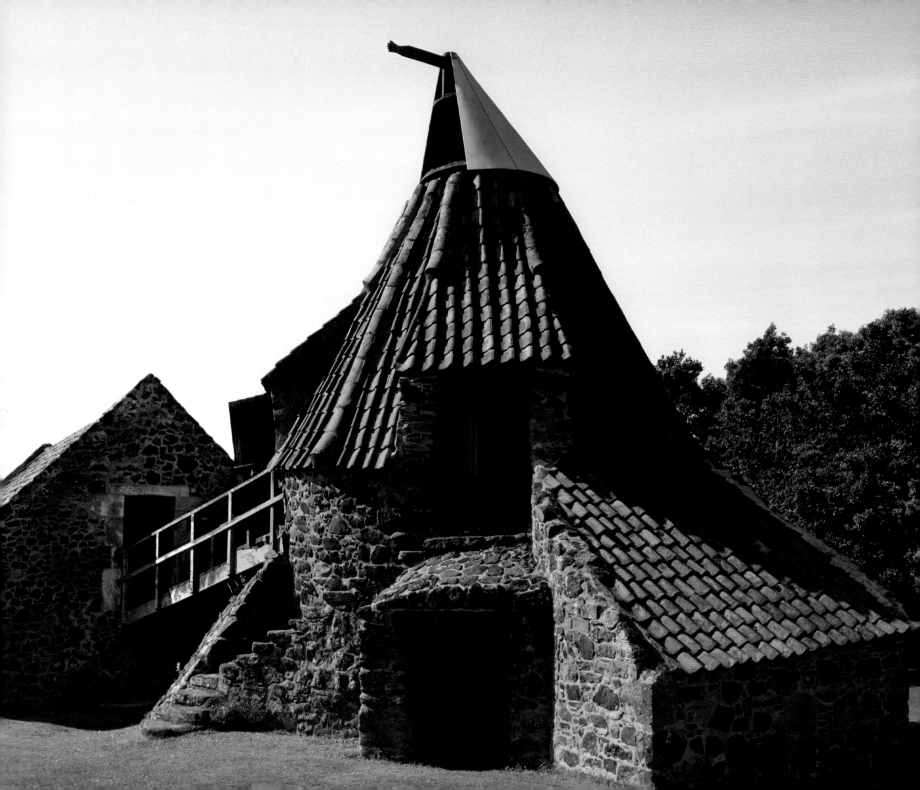

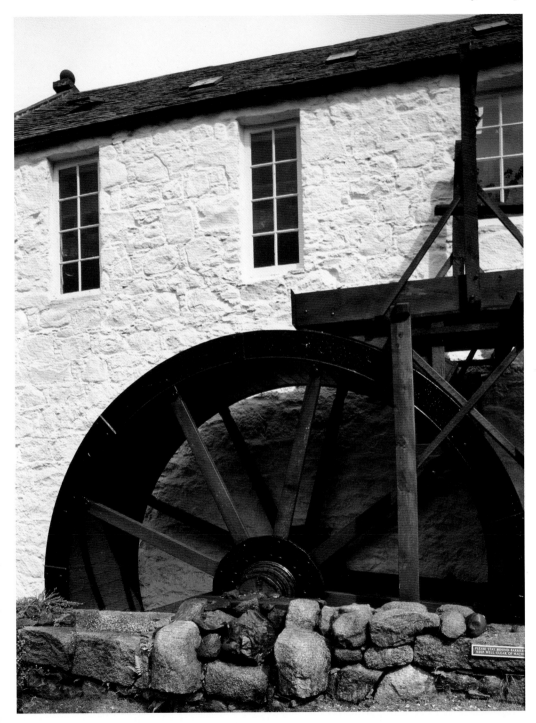

(1st century BC) – and they marked the introduction of the overshot mill into Britain. Perhaps surprisingly, enthusiasm for the overshot mill did not last and much mediaeval development went into the development of the undershot wheel, where it was the speed of flow which propelled the blades of the waterwheel forwards.

A fine example of a 17th-century undershot mill can be found in the Lothian village of East Linton. Preston Mill (see opposite page) has been restored to working order by the National Trust for Scotland. Undershot wheels were fine when rivers were in flood and the water flow was considerable, but tended to be at their least efficient in the dry autumn when the corn was ready to be ground. So water needed to be conserved and stored for when it was needed, and that requirement drove the development of the mill-pond, or in many cases, a series of ponds sited successively higher above the mill.

More efficient was the breastshot design, where water was introduced via a narrowing mill-lade to fall on to the blades of the wheel at axle level. This proved twice as efficient as the undershot wheel, and with this design the same quantity of water produced over double the energy, combining the water power itself with the natural forces of gravity.

But it was the overshot wheel (see left), where water was introduced at the top of the wheel, which drove later mills and the water-powered 'manufactures' of the Industrial Revolution.

[opposite page] The eccentric shapes and pan-tiled roofs of Preston Corn Mill in East Lothian form a quaint group of buildings around a small pond. Set in the midst of corn-fields on the edge of the village of East Linton and drawing water from the River Tyne, the mill, its oast house and kiln, date back to the 17th century. There was a major overhaul and rebuild in the middle of the 18th century, but corn has been milled on this site since the 12th century.

[left] The overshot waterwheel of New Abbey Corn Mill in Dumfriesshire. The mill buildings today date from the 18th and 19th centuries, but corn has been milled on this site for over 700 years. The original mill was erected by the Cistercian monks of New Abbey (Sweetheart Abbey) nearby, initially to grind flour for their own food, but they also operated the mill as a commercial venture offering milling services to local farmers. The restored mill today is still driven by water from the large and ancient mill-pond (see next page) located on an elevated position above the site.

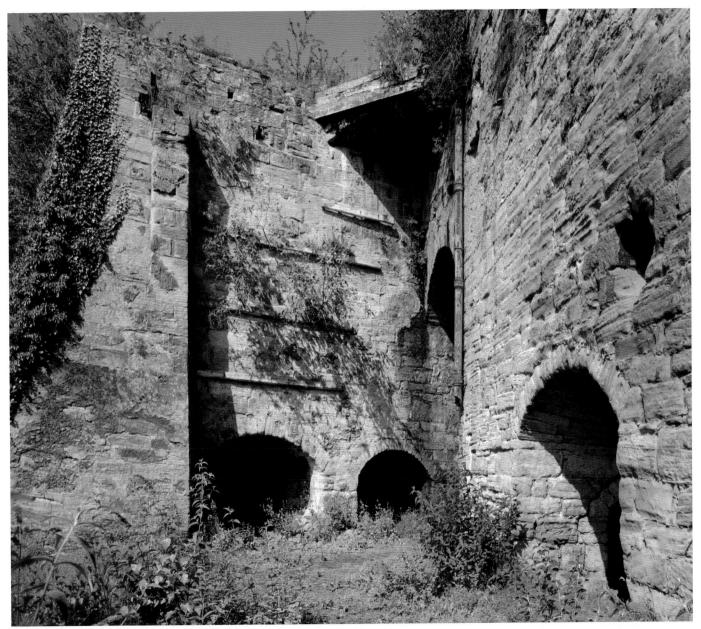

[opposite page] The mill-pond is every bit as much a part of the industrial landscape of Scotland as the mills themselves, and also of the later factories and the textile mills which depended on water for their power. Without the mill-ponds – the first industrial reservoirs – there would rarely have been sufficient water-power to drive the heavy machinery. This is the pond for New Abbey Corn Mill in Dumfriesshire. A watermill has stood on the site since the early 1300s, so the origins of the mill-pond can also be traced back seven centuries.

[inset] The interior of Tormiston Mill, Orkney. Built in the 1880s, the original waterwheel and much of the internal machinery still survives. The mill, in the care of Historic Scotland, now serves as a reception centre for Maeshowe, the spectacular Neolithic chambered cairn which dominates the surrounding landscape.

[left] The 18th-century limekilns which occupy much of the waterfront at Charlestown on the Fife shore of the Firth of Forth are, perhaps, Scotland's most neglected industrial monuments. Built in the 1750s by Charles Bruce, Earl of Elgin, they were still being expanded in number and output when Thomas Pennant visited in 1772. The kilns were, he said: 'the greatest perhaps in the universe, placed amidst inexhaustible beds of limestone, and near immense seams of coal.' The kilns were so vast that it took two weeks for the limestone to fall to the bottom of the furnaces and be raked out as lime.

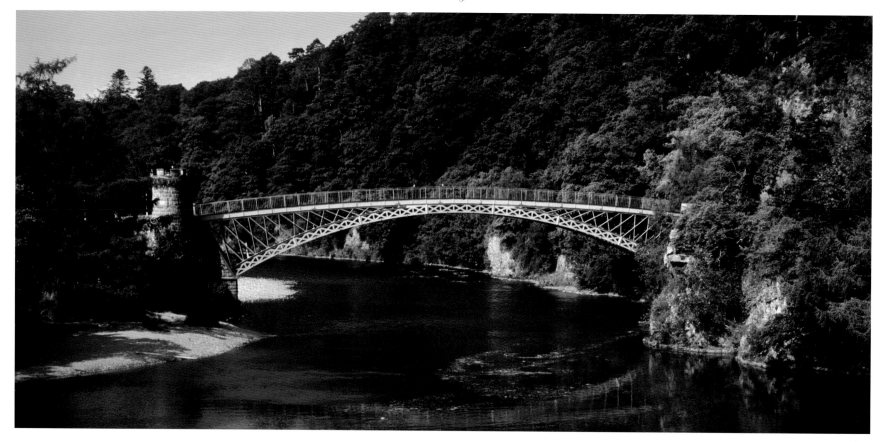

[above] Telford's elegant bridge over the River Spey at Craigellachie.

[right] The 'Atlantic Bridge' to Seil Island.

[centre right] A reminder of bridge design from earlier times: the Clapper Bridge at Altbea in the Highlands.

[opposite page] An unusual view of the most recognisable of Scotland's bridges – the Forth Bridge seen from on board the Inchcolm ferry as it passes underneath. The Forth Bridge, opened in 1890, took 60,000 tons of steel and seven years to build, and cost 57 lives. The Forth Road Bridge was opened in 1964.

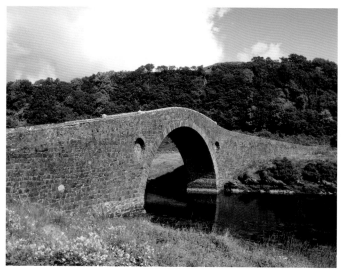

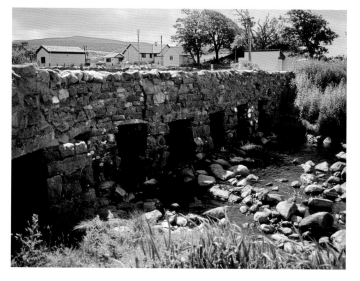

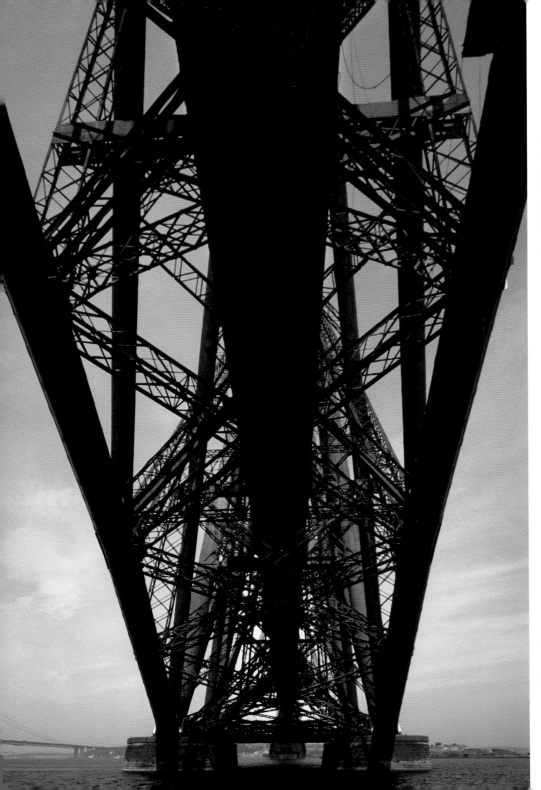

As larger mills were developed, and demands on farmers and millers increased to meet a growing population, getting the grain to the mills and the flour from the mills to the bakers clearly demanded an improved transport system. The drove-roads and tracks of old were ill-suited to the needs of larger horse-drawn vehicles and ever-heavier loads.

No one was more central to the development of Scotland's network of roads and bridges than Thomas Telford. The poet Robert Southey once described the Eskdale shepherd's son who became one of Britain's finest engineers as the 'Colossus of Roads'; so important was his contribution to developing the nation's transport system. On a plaque on the bridge which crosses the river at Invermoriston on the north shore of Loch Ness, can be read the claim that this bridge was 'one of nearly a thousand built by Thomas Telford between 1803 and 1819' to improve the transport system of the Scottish Highlands – and if that is anywhere close to the truth, it's more than 60 bridges a year in Scotland alone!

In a career which spanned 60 years, Telford's vision changed the face of Scotland – and of Britain. He designed and oversaw the construction of thousands of miles of road, some of the most imposing bridges of his day, hundreds of miles of canals, some major docks, several harbours, and a host of little churches. His tally of bridges included mighty structures such as the Menai Straits Bridge linking Anglesay with mainland Wales – in its day celebrated as the longest bridge span in the world – Dean Bridge in Edinburgh, and the tiny 'Atlantic Bridge' to Seil Island off the west coast of Scotland.

While the sheer scale of Telford's achievements is reason enough to celebrate him, it is the beauty of many of his constructions which give them an enduring attraction. He didn't just build bridges, canals, harbours and churches; he endowed them with style and proportion which raised them to the level of engineering art. So many of his creations still survive today – indeed so many of them are still in everyday use – that there is much for the explorer to discover right across Britain. Working both in stone and cast iron, his bridges and his buildings survive as evidence that he could combine function with real

141

[right] When the original designs for the Caledonian Canal were drawn up in the closing years of the 18th century by James Watt, the dimensions of the canal and its locks had been chosen to ensure easy passage for the largest naval vessels of the day – 32-gun frigates – but by the 1840s those locks were already much too small. The canal also had serious construction faults and had to be closed for extensive modifications and repairs, including the insertion of an additional lock to help control water flow. As far as its original purpose was concerned, it was all but obsolete by the time it was re-opened in 1847.

[below right] An empty lock at Fort Augustus. The locks were designed to accommodate ships up to 150ft in length and up to 35ft beam, with a draught of up to 9ft: very large indeed by 1801 standards, but tiny by today's.

[right] The *Vital Spark* of Neil Munro's stories will always be captained by Duncan Macrae or Roddy McMillan as Para Handy, and Rothesay will always be a 'terrible place'. The puffer which starred in the original 1960s television series has long gone, but the *Vital Spark* captained by Roddy McMillan is tied up at Crinan Basin at the western end of John Rennie's Crinan Canal, under its original name of Vic 32.

[far right] Lock 13 at Dunandry on the Crinan Canal. More than 200 years after it opened, it is largely pleasure craft that make their way through on the canal today.

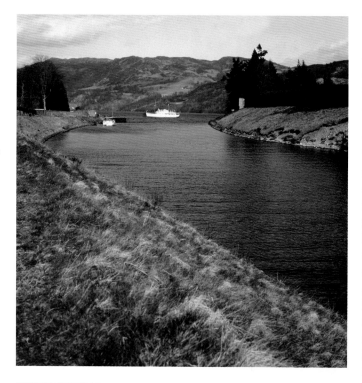

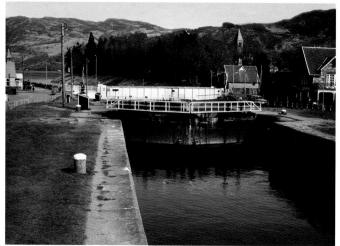

beauty. His designs are both practical and elegant, combining strength and endurance with visual features that raise them well above the level of his contemporaries. While many of the thousand bridges may just have been simple structures crossing tiny streams, Telford's major spans followed no standard pattern. Each was an individual creation.

From his early days as an apprentice mason, through to his two years working as a stonemason in Edinburgh's developing 'New Town', Telford was apparently fascinated by the ability of architects – then a relatively new profession – to produce the detailed drawings others used to construct buildings, bridges, or in the case of Edinburgh, complete new towns. The skill of the architectural draughtsman would be the foundation of Telford's later success. Indeed, his involvement with the majority of those thousand Highland bridges may have been only as architect or designer – not that that belittles his achievement in any way! Amongst his many bridges, the solidly-built Tongland Bridge in Dumfries and Galloway and the elegant Craigellachie Bridge over the River Spey are both worthy of a closer look. Most remarkable of them all perhaps, is the tiny bridge which links Seil Island to the Scottish Mainland near Oban. Until the completion of the Skye Bridge a few years ago, this tiny span, basking in the acquired name of the "Atlantic Bridge", could claim to be the only bridge in Scotland to span the Atlantic Ocean!

But Telford's transport achievements were not limited simply to roads and bridges. He was responsible for the completion of the Caledonian Canal, intended as the ultimate 'short cut' from Scotland's west coast to the northeast – saving hundreds of miles of often-treacherous sailing. Telford was not the first to suggest such a canal – two other eminent Scots had similar ideas. James Watt had proposed just such a project in the 1770s, and 20 years later John Rennie had resurrected it; but it was a report by Telford in 1801, in consultation with Watt, which had finally received Government backing. The canal was officially opened in 1822, over 60 miles in length, with 13 locks and designed to accommodate what were considered to be large vessels at the time. Each lock was 170 feet long and 40 feet deep.

While John Rennie's earlier plans to build a canal through the Great Glen came to nothing, his Crinan Canal across the top of the Mull of Kintyre was completed and opened in 1801 – the year Telford had received approval for the Caledonian Canal. The canal was initially quite successful, and David MacBrayne even built a steamer especially for it to ferry passengers from his Clyde steamers at Ardrishaig to connect at Crinan with his west-coast steamers to Oban and the islands. But the Crinan Canal proved equally unsuitable for the increasing size of vessels.

143

[right] The Leamington Lift Bridge on the Union Canal at Fountainbridge, Edinburgh. After years of dereliction and virtual abandonment, the canal is seeing a revival of interest, thanks in no small part by the completion of the Falkirk Wheel project breathing new life into the canal network.

[below right] The Forth & Clyde Canal at the Falkirk Wheel.

[below] Reflections on the still waters of the Union Canal near Polwarth, Edinburgh.

[opposite page] The magnificent Falkirk Wheel: the world's only rotating boat lift, completed as the centrepiece of Scotland's major Millennium Link project. So perfectly engineered is the structure that rotating the wheel – 1800 tons fully laden – uses no more electricity than six electric kettles. Thanks to the boat-lift, the Union Canal – running from Falkirk to Edinburgh – and the Forth & Clyde canal – linking Glasgow with Grangemouth – are connected once again after nearly 50 years. The Falkirk Wheel is one of the most impressive new landmarks created in Scotland for many decades, as well as being a highly original and elegant solution to a centuries-old problem. Before the canal link was severed during road-building projects in the 1950s and 1960s, raising boats up from the Forth & Clyde Canal to the Union Canal required a flight of 11 locks at Camelon. The new layout uses the wheel and three locks, after which the Union Canal – a contour canal built in 1822 – makes its way to Edinburgh without any further locks.

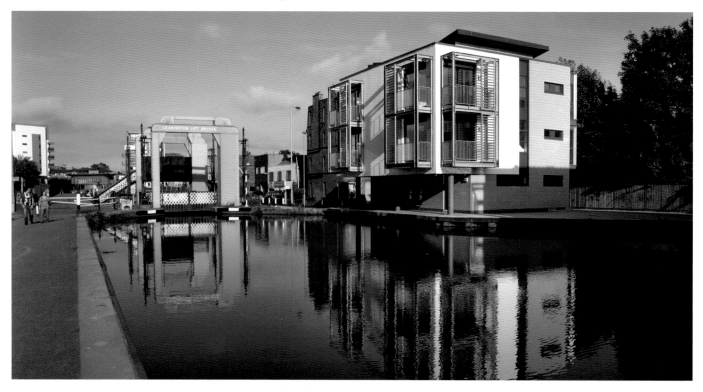

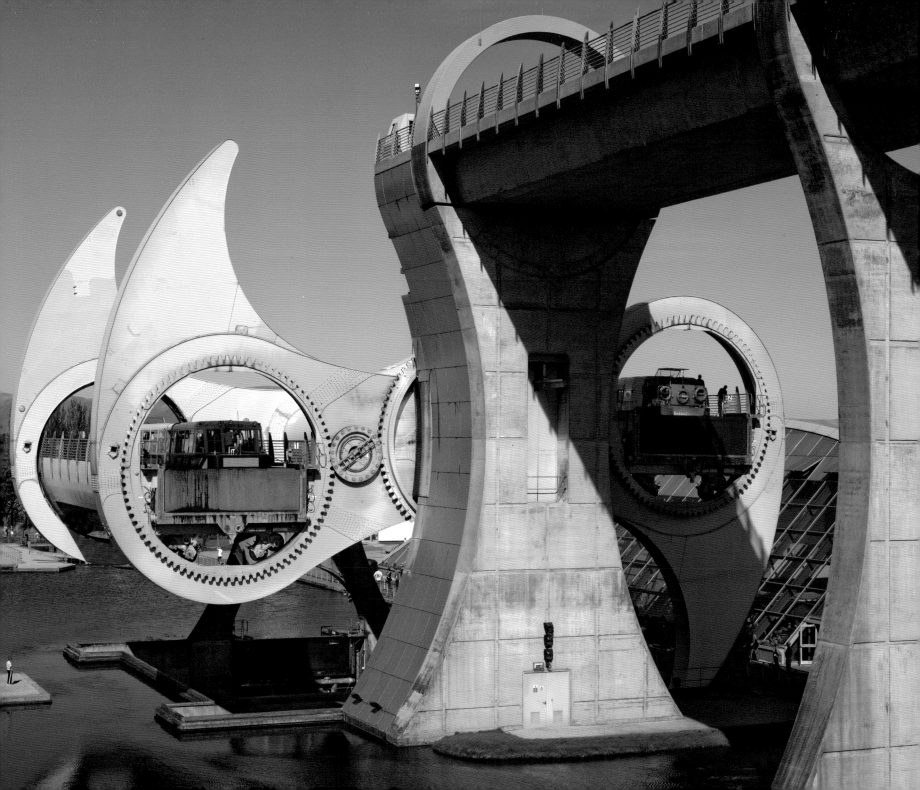

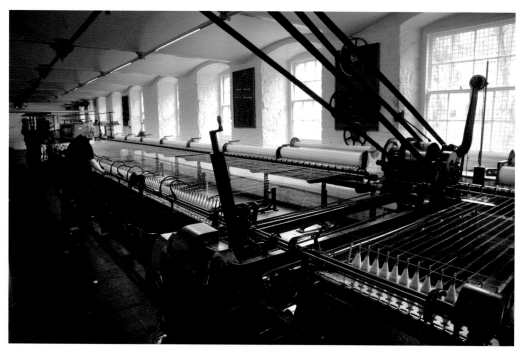

Robert Owen's New Lanark is now a World Heritage Site, retaining the integrity of this remarkable group of buildings, combining modern housing interiors with a faithful restoration of the 18th-century working environment. Clockwise from above: demonstrations of cotton spinning continue daily; the village shop doubles as a souvenir shop, and a recreation how it might have been 200 years ago; the view from the doorway of Owen's house; the mills as seen from the riverside walk; and the view of the buildings constructed along the narrow valley floor through which the River Clyde flows. The Clyde and its fast-moving waters proved ideal for powering the complex of mills.

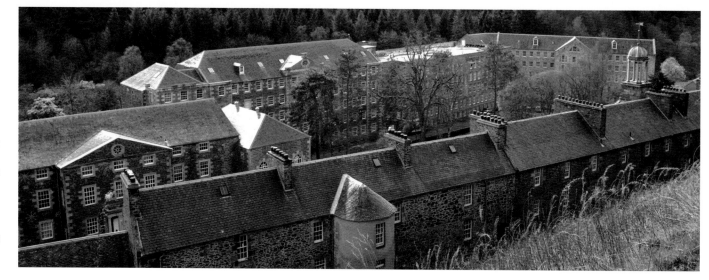

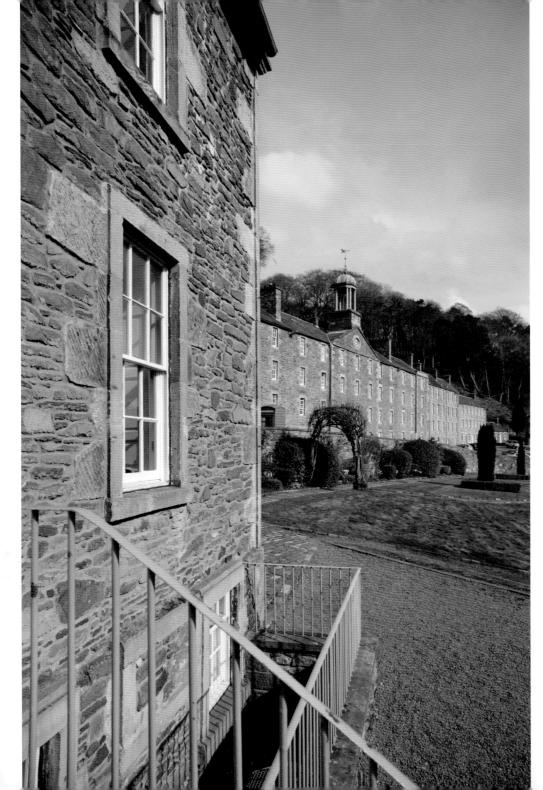

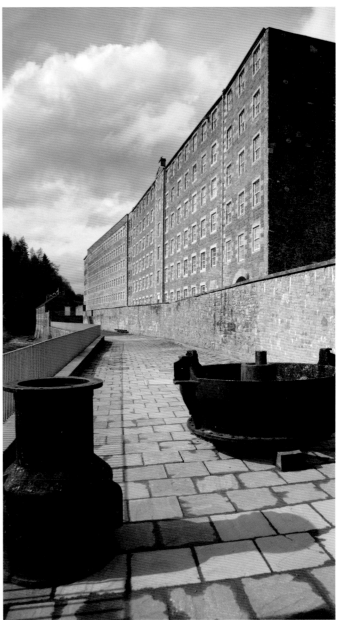

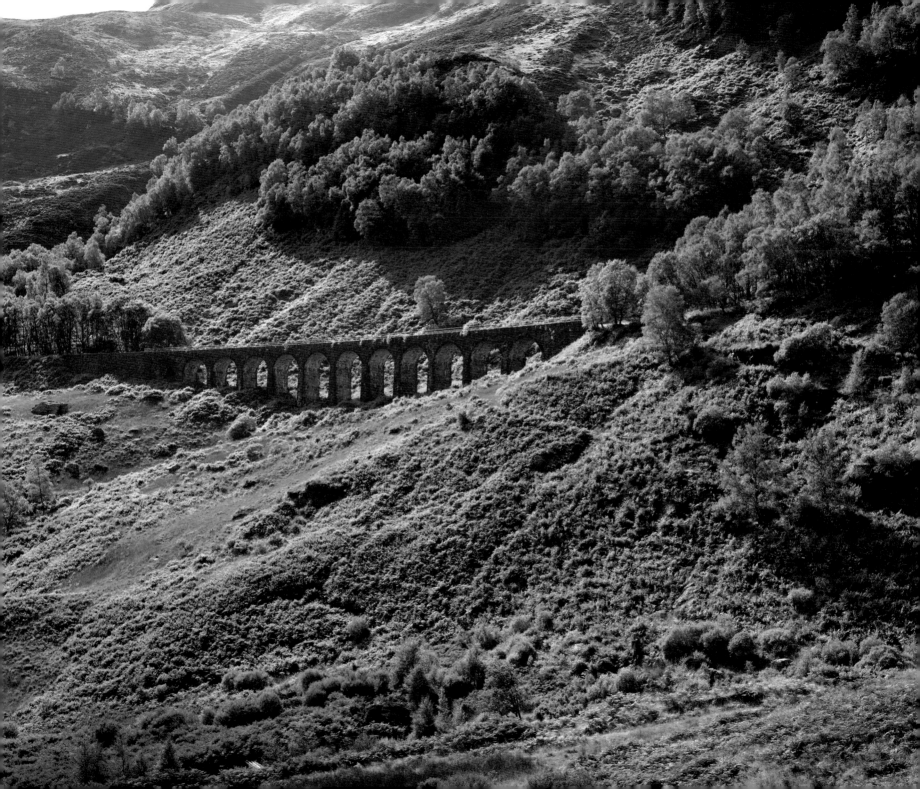

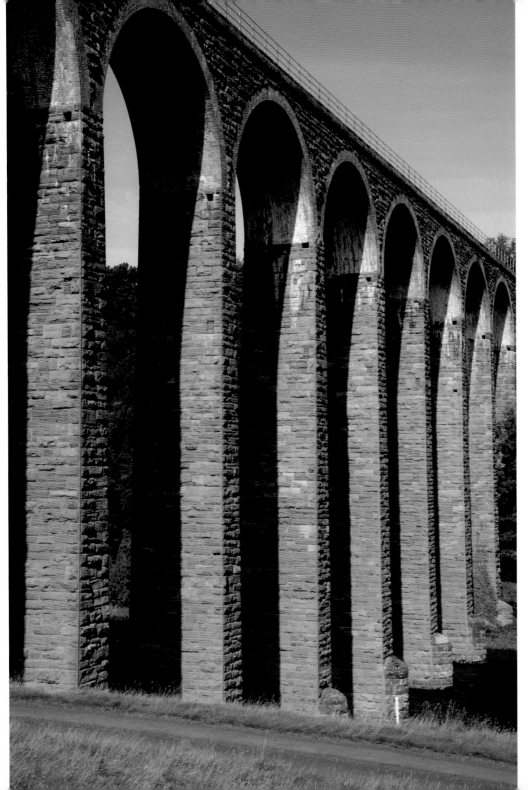

The canals did open up much of Scotland, with the Forth & Clyde Canal – originally known as the Great Canal – particularly useful in easing the transport of goods from the west coast to the east. Indeed, while the Highland canals were the more spectacular, the Lowland canals were the commercially successful ones. The Forth & Clyde Canal, built in the 1770s and linking Bowling on the Clyde with Grangemouth on the Forth, and the 1822 Union Canal linking the Forth & Clyde Canal at Falkirk with Edinburgh, were the motorways of their day: the most important transport links in the days before either railways or metalled roads.

But it was the arrival of the railway which signalled the greatest change in Scotland – change in the manner and ease with which goods could be moved around, and change in the mobility of the population. With rail travel came the ability to go further afield for holidays, and with rail travel came a great mobility for the workforce, and the eventual development of residential suburbs moving large numbers of people out of city centres.

The importance of the railway in 19th and early-20th-century Scotland cannot be over-estimated and, although very few of the 146 companies which opened routes ever showed a profit for their investors, they were central to the development of the country – linking far flung communities and industries and, perhaps most importantly, linking Scotland with the more populous centres south of the border.

Scotland's first railways were mineral and coal lines, amongst them the Monkland and Kirkintilloch Railway, which opened as early as 1824 and became the country's first railway to use steam locomotives in 1831. It ran from Monkland's Cairnhill Colliery to the Forth & Clyde Canal at Kirkintilloch.

Now, more than a century and a half after the enormous optimism about the benefits the country would accrue from its railway, ScotRail's network accounts for less than 10% of

[left] The beautiful Leaderfoot Viaduct, which spans the River Tweed just outside Melrose, was opened in October 1865 to carry the Berwickshire Railway, linking Reston on the East Coast Main Line with St Boswells on the picturesque Waverley Route.

[opposite page] Many of the more picturesque lines have long gone, leaving only viaducts and footbaths, as here in Glen Ogle.

149

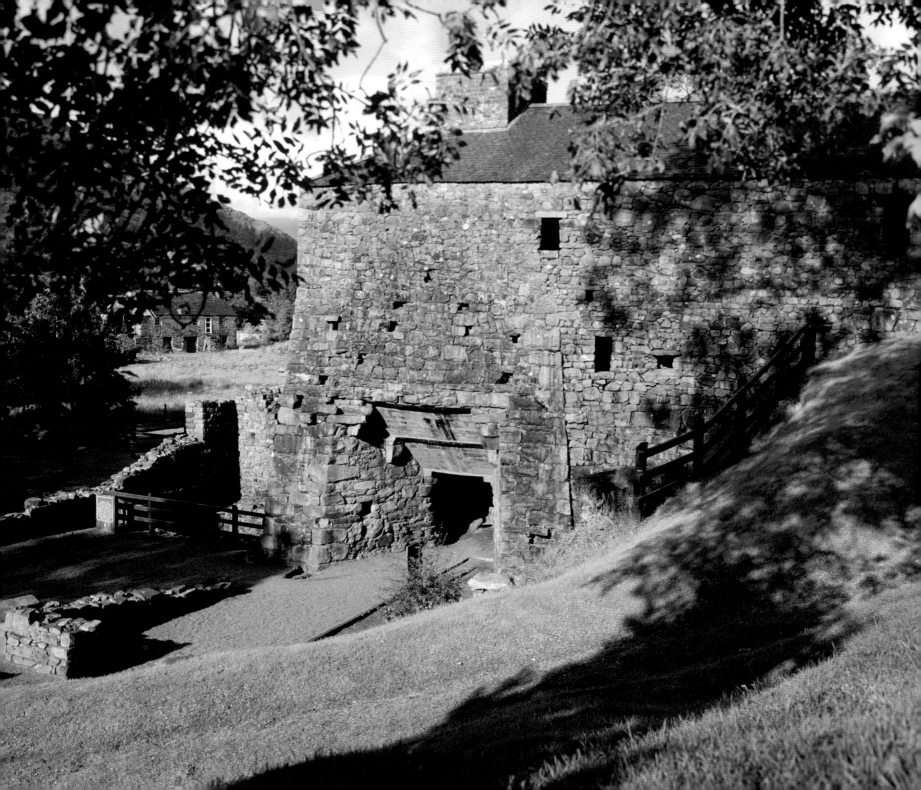

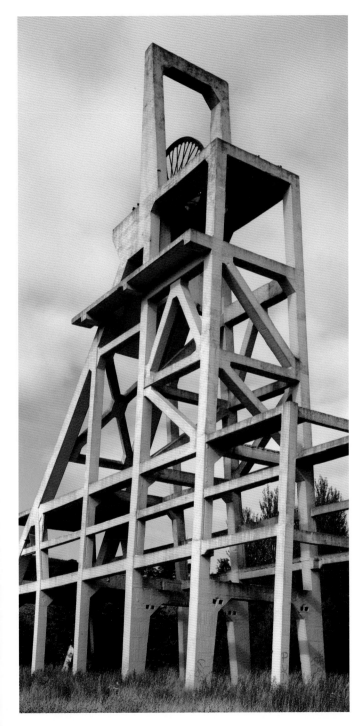

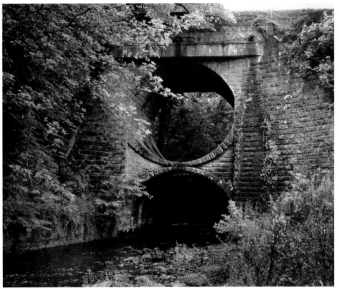

[far left] The 1902 headgear is all that remains of Ballingry Colliery: the pit yard now landscaped as Lochore Meadows Country Park. Of Scotland's hundreds of other collieries, few traces remain.

[left] One of Thomas Telford's most spectacular bridges – over the Bannock Burn in the town of the same name – stands largely unseen, although thousands of people drive over it each day. Hidden by trees and straddling a deep gully, the bridge remains unseen almost until you climb down to it. And even then, sunshine rarely reaches down to the river. In his account of a journey he made through Scotland with Telford in 1819, the poet Robert Southey recalled that the bridge was 'one of Mr Telford's works, and has a huge circle over the single arch—the first bridge which I have seen in this form: the appearance is singular and striking'.

[opposite page] Bonawe Iron Works neat Taynailt was opened in 1753 with a charcoal-burning furnace. The iron ore it smelted was brought by sea from Furness in Cumbria, where there was a plentiful supply of ore, but little fuel. It was apparently cheaper to ship the ore to the source of fuel rather than the other way round.

the mileage in use at the time of nationalisation, and an even smaller percentage of the lines which had been opened by the end of Queen Victoria's reign. But the good news, as our roads become more and more congested, is that a few key miles of track are being re-laid, at least one new line is being planned, and some new stations are being built.

Railways depended upon coal, and Scotland had – and still has – a plentiful supply of coal, despite the closure of all the country's mines. Coal fuelled Scotland's industrial revolution, and the huge expansion of shipbuilding and engineering through the 19th century and well into the 20th. Mines dotted the landscape right across Scotland's central belt, as well as throughout Ayrshire and the Kingdom of Fife. In the years leading up to the Great War, Scotland's coalfields produced 42 million tons of the stuff – one seventh of the total British output – and the Fife port of Methil alone exported upwards of three million tons annually at its peak.

Within five years of the end of the Miners' Strike in 1985, only one deep mine remained – the last of a tradition which could

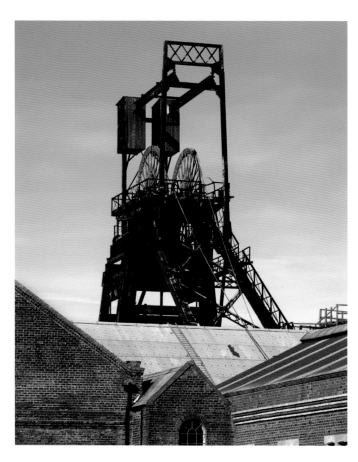

[above] The winding gear of the Lady Victoria Colliery at Newtongrange, now home to the Scottish Mining Museum. From the top of the headgear, the Forth Bridge can be seen on a clear day. The bridge, like the winding gear, was erected by William Arrol of Glasgow. The Scottish coalfields once employed tens of thousands of men but, as in so many other parts of Britain, mining is now a thing of the past. The museum includes a reconstruction of an underground roadway, complete with cutting equipment.

[right] The NCB gates may be closed, but the Lady Victoria is very definately open to visitors. Still a 'job in progress', the restoration of the colliery will be continuing for years to come, as funding becomes available. The huge railway yards where once fully laden coal trains left several times each hour is now the car park.

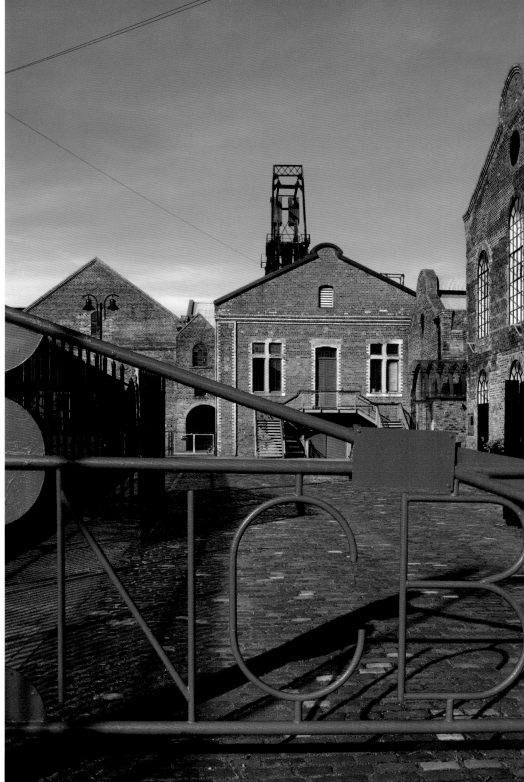

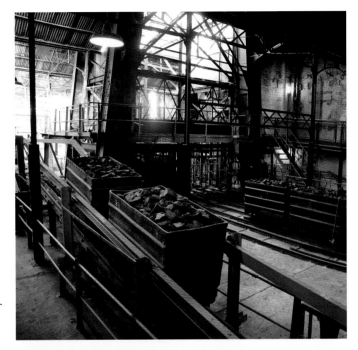

trace its origins back at least to the 16th century and Sir George Bruce's pioneering mines at Culross on the River Forth. That last mine – feeding the power station at Longannet – carried on alone, although several other pits were mothballed for a time. Ironically, the first and last deep mines in Scotland were just a few miles apart, and both worked seams deep under the Forth.

Sadly, little trace of the country's mining heritage survives. A rare example is the Lady Victoria Colliery in Newtongrange near Dalkeith south of Edinburgh, now home to the Scottish Mining Museum. Sunk in the 1890s by the Lothian Coal Company and opened in 1895, the Lady Victoria – named after the wife of the Marquis of Lothian on whose land it was constructed – offers visitors the chance to explore the most extensive and best preserved group of Victorian mine buildings in Europe. For over 80 years, the miners worked six of the twenty-plus coal seams under Newtongrange and Dalkeith, yielding several different types of coal. The Diamond, Jewel and Coronation seams produced domestic coal for household fires, while the Kailblades and Splint seams produced steam coal, powering the factories and railways of Britain. In the days when domestic gas was coal gas rather than North Sea gas, the Parrott seam of cannel coal was ideal for that purpose.

The pit closed in 1981 and was one of the lucky few to be mothballed. The good state of repair of its core late-Victorian buildings made it an ideal candidate site for the museum.

The Lady Victoria Colliery has something in common with the Forth Bridge – visible from the top of the headframe on a clear day – in that William Arrol & Company of Glasgow built both the headframe and the bridge. The railway bridge came first, opened in March 1890 – about the same time work started sinking the Lady Victoria shaft – and the 85-foot frame was erected three years later.

As recently as half a century ago, Central Scotland's landscape was punctuated by the huge spoil heaps, or bings, from the many collieries. They smoked continually, and some even caught fire, glowing red against the night sky. The burned-out ash and stone from these huge dumps was used as the foundations for many of Scotland's new roads and motorways in the 1960s and 1970s – those same roads and motorways which hastened the demise of the country's railways. But arguably it is the rise of the motorcar and ease of transport which allows us to visit places like Newtongrange.

[left] The Tub Circuit above the shaft at Newtongrange. Tubs of coal raised from below were moved around on a narrow gauge railway system – most of it by gravity – to be weighed and then transported to the shaker screens. This layout was introduced in 1962.

[below] Newtongrange's boiler-house stands as it was the day the pit closed – except, of course, that vast sums have been spent removing the asbestos. A maze of steam pipes leads to the engine house with its huge winding engine, capable of lifting 11 tons at a time from below ground. The engine's two 42-inch horizontal stroke cylinders drove a huge drum 20 feet in diameter and 10 feet wide, which in turn wound the steel ropes over the two 19-foot diameter broad-spoked whorls – the red-painted winding wheels – at the top of the headframe.

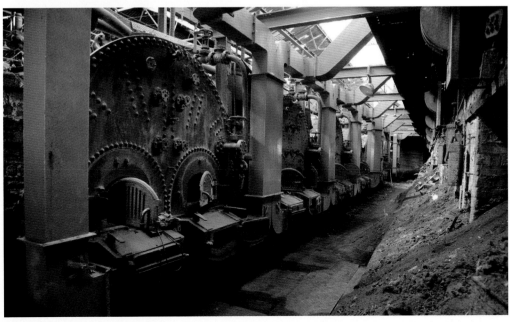

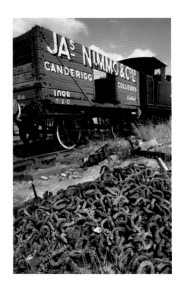

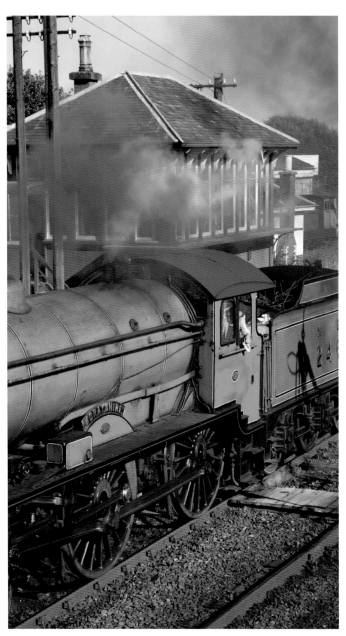

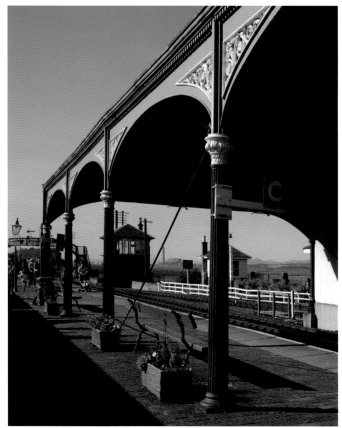

[above] A reminder of Scotland's past as a coal producer.

[centre] Morayshire was built in Doncaster in 1928 for use on the LNER's Scottish routes. It was a regular visitor to Perth, Dundee and Edinburgh and is the only preserved example of the 76 'Shire' class locomotives.

[top right] As part of the Scottish Railway Preservation Society's re-creation of a typical Scottish branch line on the Bo'ness & Kinneil Railway, Wormit Station, which closed in 1969, was dismantled from its original position at the south end of the Tay Bridge and rebuilt at Bo'ness.

[bottom right] The canopy from Haymarket Station, Edinburgh – built in 1842 as the terminus of the Edinburgh & Glasgow Railway – was also transported to the site and rebuilt.

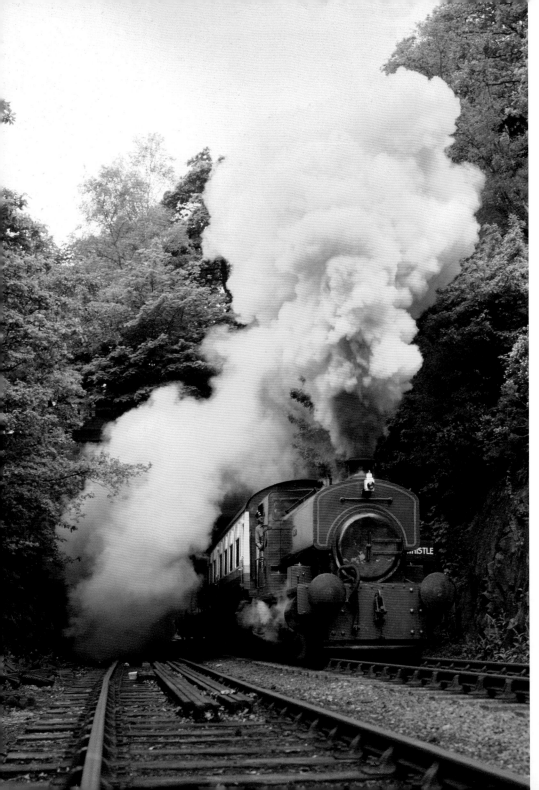

[far left] The Barclay 0-4-0 saddle tank was the workhorse of many collieries and engineering works, and was produced in large numbers. Andrew Barclay built his first locomotive as early as 1859, and this example was built in Kilmarnock almost a century later in 1952. In the age of preserved steam railways, the Barclay tank has fared well, with several being rescued from docks and collieries and restored to serve heritage lines. Now known as David, Works No.2333 was delivered to the Millom Ironworks on the River Duddon estuary in Cumbria on the 25 January 1953, where it worked for almost 20 years before being preserved. It is seen here emerging from Haverthwaite Tunnel on the Lakeside & Haverthwaite Railway in Cumbria.

[above left] Caledonian Railway No.419 was completed at the company's St Rollox works in Springburn, Glasgow, in 1907. The Caledonian had started building its own locomotives in 1856, and No.419 was one of a class of 92 engines in the John F. Macintosh-designed '439' class. The locomotive worked the Caley, LMS, and later British Railways lines for 55 years before being retired in1962.

[left] Another Caledonian locomotive, No.828, was rolled out of the Springburn factory in August 1899. It is the only surviving example of Macintosh's '812' class, and remained in service at Ardrossan until withdrawn in August 1963. Preserved by the Scottish Locomotive Preservation Trust, for many years the engine was steamed on the Strathspey Railway. She is currently in the final stages of a major overhaul.

[above] Seen through a mechanical sculpture near Glasgow's Science Centre, the funnels of the PS *Waverley* – the world's last ocean-going paddle steamer – provide a splash of colour. Built by A. & J. Inglis at Pointhouse on the Clyde in 1947 to serve the route between Craigendoran and Arrochar, *Waverley* has become one of the country's most popular tourist attractions.

[left] The paddle-steamer *Maid of the Loch* undergoing a long-term restoration at Balloch Pier. Also built by A. & J. Inglis, at 555 tons she was the largest steamer ever to sail on the loch. She was also the last paddle-steamer ever built in Scotland. As was common practice with large loch and lake steamers, she was assembled in the shipyard then dismantled – and every plate numbered – before being shipped to Balloch slipway for re-assembly at the lochside. She was launched on to the loch on 5 March 1953. It is hoped eventually to steam her again, once sufficient funds have been found to complete her restoration, but whether or not today's health and safety rules would ever allow her to take on board the thousand passengers she was designed to carry is quite another matter.

[opposite page] There have been steamers on Loch Katrine since 1843. The current steamer *Sir Walter Scott* – seen here approaching Trosschs Pier on a late autumn afternoon – was built in 1900 by Denny Bros Ltd at Dumbarton on the Clyde. The steamer was assembled then dismantled and transported in pieces by barge up Loch Lomond, then overland by cart to Stronachlachar pier on Loch Katrine, where she was rebuilt and launched. She cost £4,269, of which more than £2,000 was for delivery. For her first 107 years, her steam boilers were fired by coke, but since 2007 – when she underwent a major overhaul and refit – she has used a bio-fuel. At that time, her beautiful lines were radically altered by the construction of a large cabin on the foredeck.

[inset] The profile of the steamer looked very different in 1979.

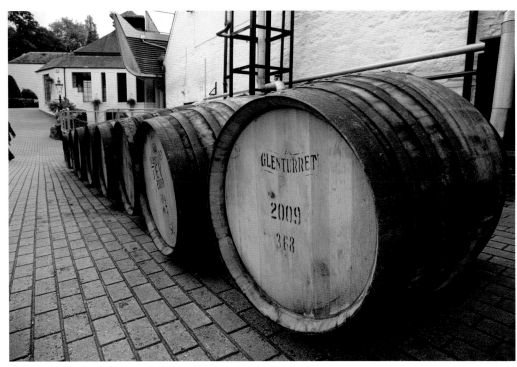

Evidence of Scotland's malt whisky industry can be seen all over the country, in the distinctive buildings of maltings, distilleries, and bonded warehouses.

[this page, clockwise from above] Glenturret Distillery, Crieff – barrels for 2009 Gleturret Malt, much of which will find its way into the Famous Grouse blend; ripening barley; the waters of the Blackford Burn near Tullibardine Distillery; Glengoyne Distillery, a few miles south of Loch Lomond.

[opposite page] Dallas Dhu Distillery, a few miles south of Forres, was opened in 1898, and is now a scheduled historic site.

[inset] Tullibardine Malt bottled in 1969.

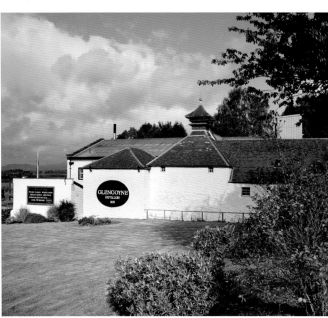

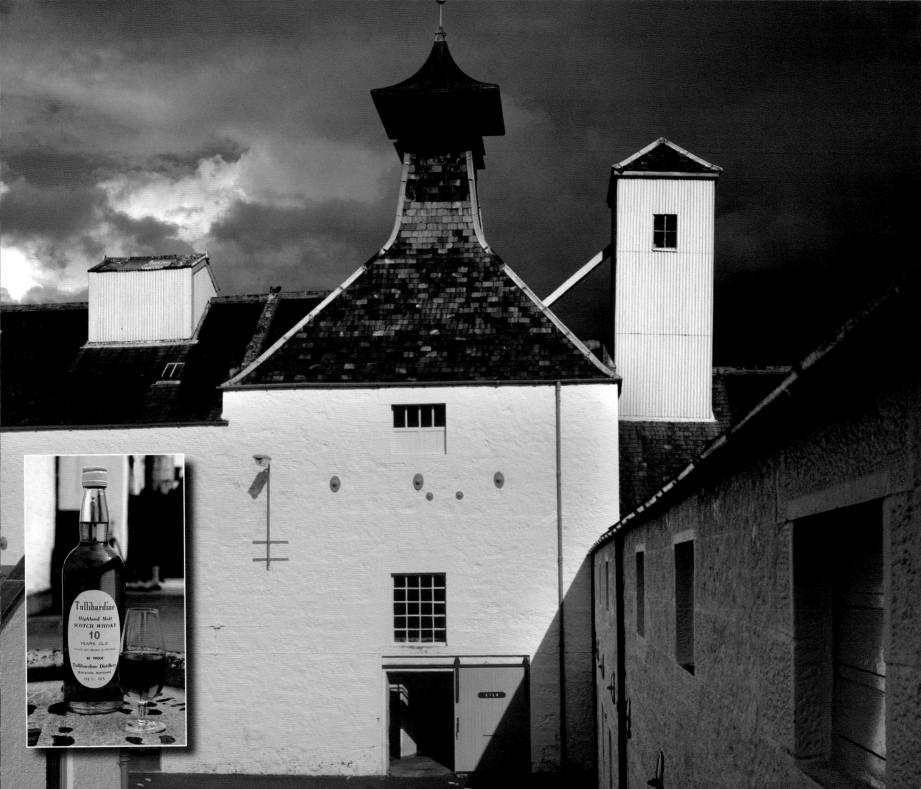

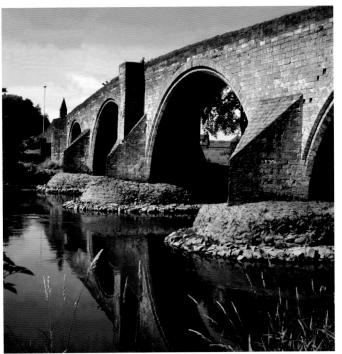

[opposite page] Scotland looks to the future with the development of huge wind farms across bleak expanses of high ground. While everyone recognises the need for 'green' electricity, few are happy with these huge turbines in their own backyards. This is the Dun Law wind farm in the Borders.

[left] Once at the heart of Scotland's coal industry, Methil Docks are virtually idle today. They once shipped the millions of tons of fuel produced each year by the Fife coalfields and which powered industries and warmed homes throughout Britain and Western Europe.

[above left] The old bridge across the River Forth at Stirling has long since been closed to traffic. Originally constructed in the late 15th or early 16th century, it was substantially rebuilt in the middle of the 18th century.

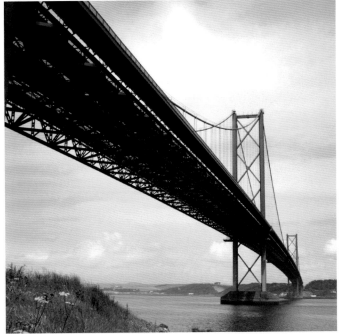

[below left] The Forth Road Bridge was completed in 1964, but the huge increase in traffic flow across it has substantially impacted upon the structure and on its projected lifespan. Measuring just over a kilometre between the two towers, when it was completed it was the fourth longest in the world. The three longer bridges were all in the United States. The bridge is over 2.5 km long, and was constructed from 39,000 tonnes of steel and 125,000 cubic metres of concrete. After less than 35 years, it was found that the hanger cables were fraying and were all replaced before the year 2000. While research continues into whether or not the main cables can be replaced, work has started on a new three-pier cable-stayed bridge to the west of the present structure and it is planned that the new bridge will be completed by 2017. The existing bridge will then be used only by public transport, pedestrians and cyclists.

161

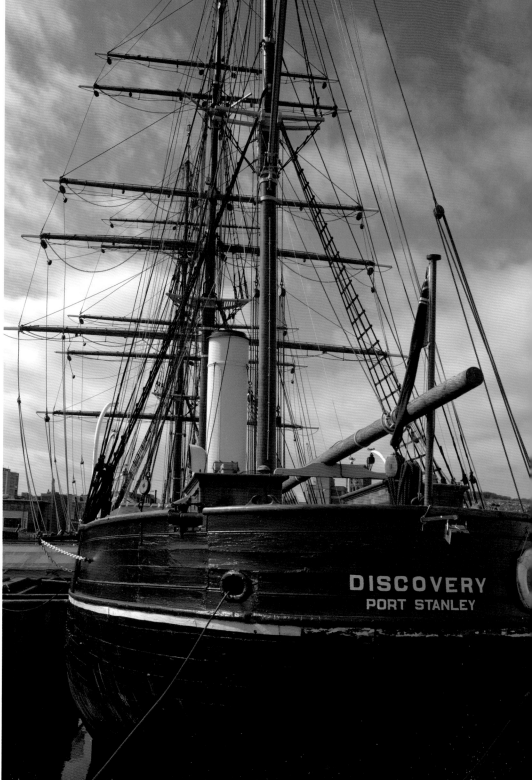

[above and right] RRS *Discovery* – the last wooden-hulled three-masted ship to be built in Britain – has had a varied life since she was launched by Lady Markham in Dundee on 21 March 1901. Most famous as the ship which Captain Robert Falcon Scott sailed to the Antarctic in the autumn of that year, she is now permanently berthed back in her home port. In more than a century afloat, she has been trapped for months in pack ice, worked as a Hudson Bay Company cargo ship, been refitted as a research ship, returned to the Antarctic twice in the 1920s, and spent over 60 years as a training ship. When she was designated a Royal Research Ship in 1923, her port of registration was changed to Port Stanley in the Falklands.

[opposite page] As the evening light starts to fade, a trawler makes its way through the sea lock from Crinan Basin for a night's fishing off the west coast.

Living and Working by the Sea

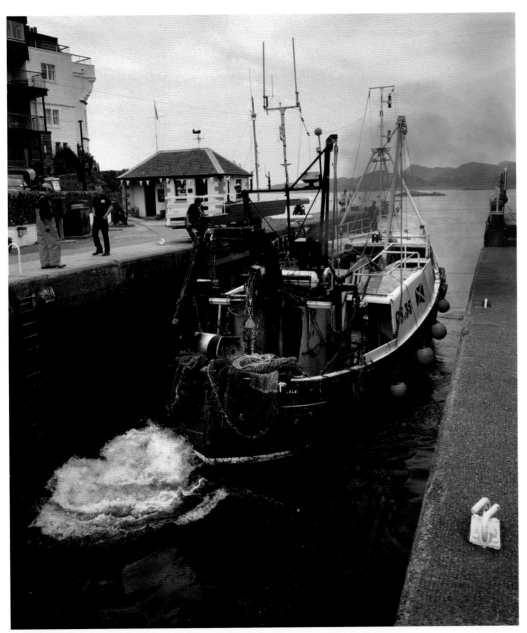

In the introduction to the Scottish chapters of *A Tour Thro' the Whole ISLAND of GREAT BRITAIN*, Daniel Defoe wrote that: 'Hitherto, all the descriptions of Scotland, which have been publish'd in our day, have been written by natives of that country, and that with such an air of the most scandalous partiality, that it has been far from pleasing the gentry or nobility of Scotland themselves, and much farther has it been from doing any honour to the nation or to the country.'

Defoe undertook a series of extensive journeys throughout Scotland (probably in 1724), gathering material for the third volume of his acclaimed three-volume travelogue. Just a few years after publishing Robinson Crusoe, the author had embarked in 1722 on a project about as different as could be from his epic account of life on a desert island.

The first edition of *A Tour Thro' the Whole ISLAND of GREAT BRITAIN* did not bear his name; the credit on the title page identifying the author simply as 'A Gentleman'. The published *Tour* was never intended as a guidebook, although it did set out to offer 'useful observations' on the 'Principal Cities and Towns, their Situation, Magnitude, Government and Commerce; The Customs, Manners, Speech, as also the Exercises, Diversions, and Employment of the People; The Produce and Improvement of the Lands, the Trade, and Manufacture' and 'the Public Edifices, Seats, and Palaces of the NOBILITY and GENTRY'. Some of his observations are very 'useful' indeed, and highly illuminating about life in Scotland nearly three centuries ago.

His tour was compiled as a series of 'Circuits or Journies', split up into chapters described as 'Letters'. Scotland is to be found in Letters 11, 12 and 13, and in the introduction he proclaimed: 'The world shall, for once, hear what account an Englishman shall give of Scotland, who has had occasion to see most of it, and to make critical enquiries into what he has not seen.'

As Scotland was already regarded as a second-rate part of Britain – a Britain dominated by the English less than two decades after the 1707 Act of Union had removed the governance of Scotland to London – Scots would have taken Defoe to task over the use of 'for once' in that opening remark.

Defoe's account is highly illuminating, despite its concentration on the gentry. While we learn much less about the Scots people than in the accounts of Thomas Pennant, or Boswell and Johnston in the 1770s, he does tell us a great deal about Scotland's imports and exports and its maritime trading with Western Europe. With well established links with Norway, Sweden, Netherlands, France, Spain and the northern ports of present-day Germany and Latvia – listed by Defoe as Bremen, 'Hambrough', 'Dantzick' and Riga – Scotland's ports were both busy and successful. Exports included coal, salt, lead, corn, woolens, 'linnen', and both dried and pickled herring. The ports of Aberdeen, Dundee and Leith already had well-established European trading links, while Culross was exporting large tonnages of coal from Sir George Bruce's mines – with the coal ships returning empty save for the orange pantiles, used as ballast. The Earl of Wemyss was also exporting coal from his Fife coalfields, and developing the port of Methil – or 'Methuel' to Defoe – to cope with it. Imports were considerable and varied even in the early 18th century: linseed oil

The Glenlee is a rare survival of the countless sailing vessels to have been built on the Clyde. A three-master steel-hulled sailing barque, she was built in 1896 by Anderson Rodger & Company of Port Glasgow for service with the Glen-line. Over the following 20 years under a succession of owners, she travelled the world, delivering cargos as far afield as Australia and South America before being sold to the Stella d'Italia shipping line in 1919 and being renamed the Clarastella, registered in Genoa. Three years later she became a naval training ship, this time named Galatea: the name she was to carry for the next 47 years.

Her rediscovery in Spain in the 1993 as little more than a hulk, and her subsequent restoration to the condition she is seen in today is a remarkable success story, and in summer 2011 she was moved to become one of the major attractions of Glasgow's new Riverside Transport Museum at Pointhouse Quay, where so many great ships were once built.

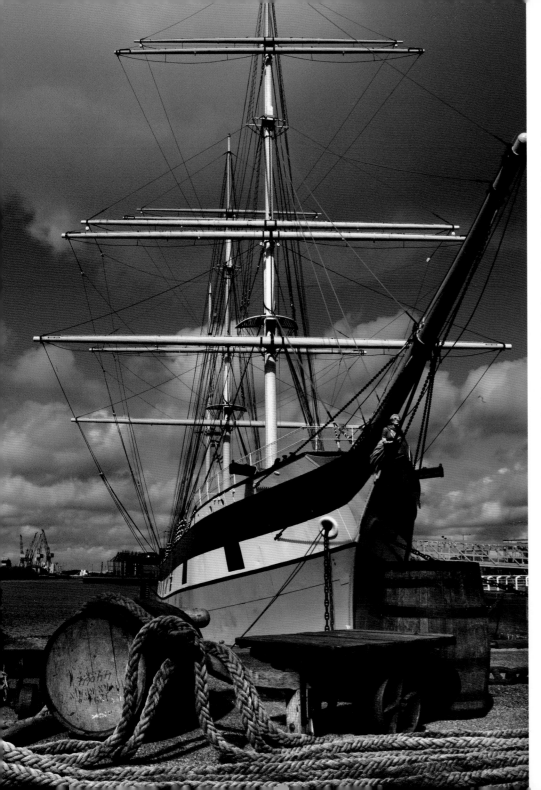

and 'East-India goods' from Holland; pitch, tar and timber from Norway; timber, iron and copper from Sweden; and a wide range of other products from Germany, Latvia, Russia and elsewhere. 'And all these put together', wrote Defoe, 'if I am rightly inform'd, do not balance the lead, coal, and salt, which they export every year: So that the balance of trade must stand greatly to the credit of the account in the Scots commerce'.

When Defoe got to Kirkcudbright – 'or, as vulgarly call'd, Kirkubry' – he wrote:

'Here is a harbour without ships, a port without trade, a fishery without nets, a people without business; and, that which is worse than all, they do not seem to desire business, much less do they understand it. They have a fine river, navigable for the greatest ships to the town-key; a haven, deep as a well, safe as a mill-pond; 'tis a meer wet dock, for the little island of Ross lyes in the very entrance, and keeps off the west and north west winds, and breaks the surge of the sea; so that when it is rough without, 'tis always smooth within. But, alas! there is not a vessel, that deserves the name of a ship, which belongs to it; and, though here is an extraordinary salmon fishing, the salmon come and offer themselves, and go again, and cannot obtain the privilege of being made useful to mankind; for they take very few of them.'

His criticism was tempered by a little hope:

'all the shores of Galloway must remain unnavigated; the fine harbours be unfrequented, the fish be secure and safe from nets till time and better opportunities alter the case, or a people better able, and more inclin'd to business, comes among them, and leads them into it.'

But he acknowledged that:

'The people of Galloway do not starve tho' they do not fish, build ships, trade abroad, & yet they have other business, that is to say, they are meer cultivaters of the earth, and in particular, breeders of cattle, such as sheep, the number of which I may say is infinite, that is to say, innumerable; and black cattle, of which they send to England, if fame lies not, 50 or 60,000 every year.'

A century after Defoe's visit, Kirkcudbright had developed a thriving fishing industry, as well as considerable sea trade

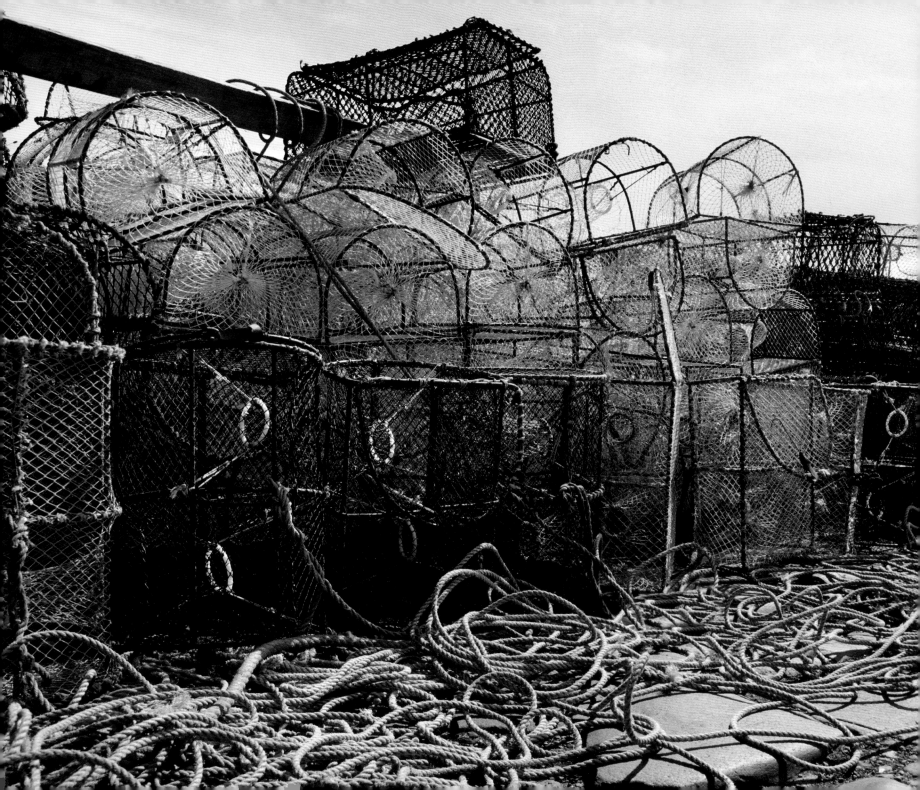

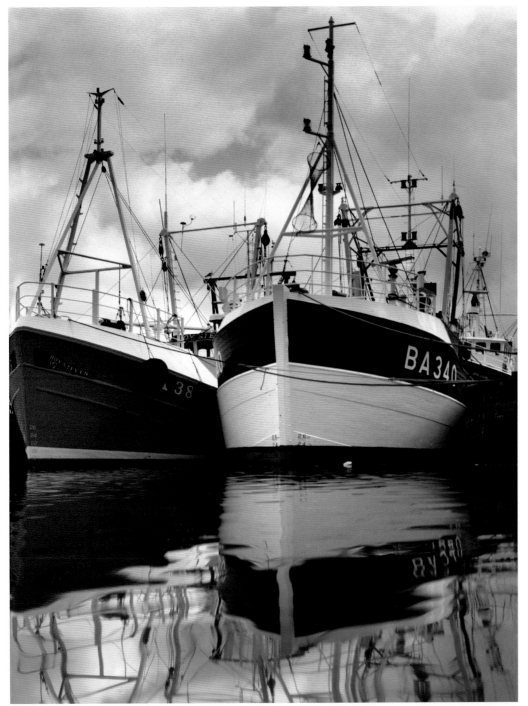

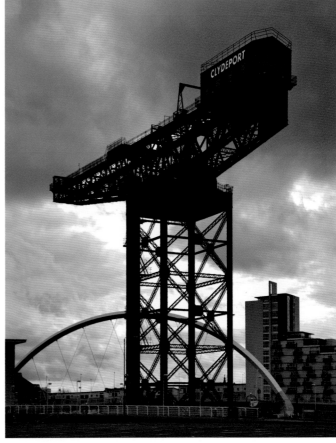

[above] The last great crane from Glasgow Docks now looms over acres of wasteland awaiting redevelopment. The Finnieston Crane, which once graced the lid of every Meccano set is a Glasgow icon. It was built by the Clyde Navigation Trust in 1932 primarily to lift steam locomotives on to ships ready for export.

[left] Two trawlers moored on the still waters of the River Dee at Kirkcudbright harbour, Dumfries and Galloway. A small fleet of boats, registered in Ballantrae, Kirkcudbright and elsewhere, regularly land their catches along the harbourside.

[opposite page] Creels stacked on Mishnish Pier, Tobermory, Isle of Mull.

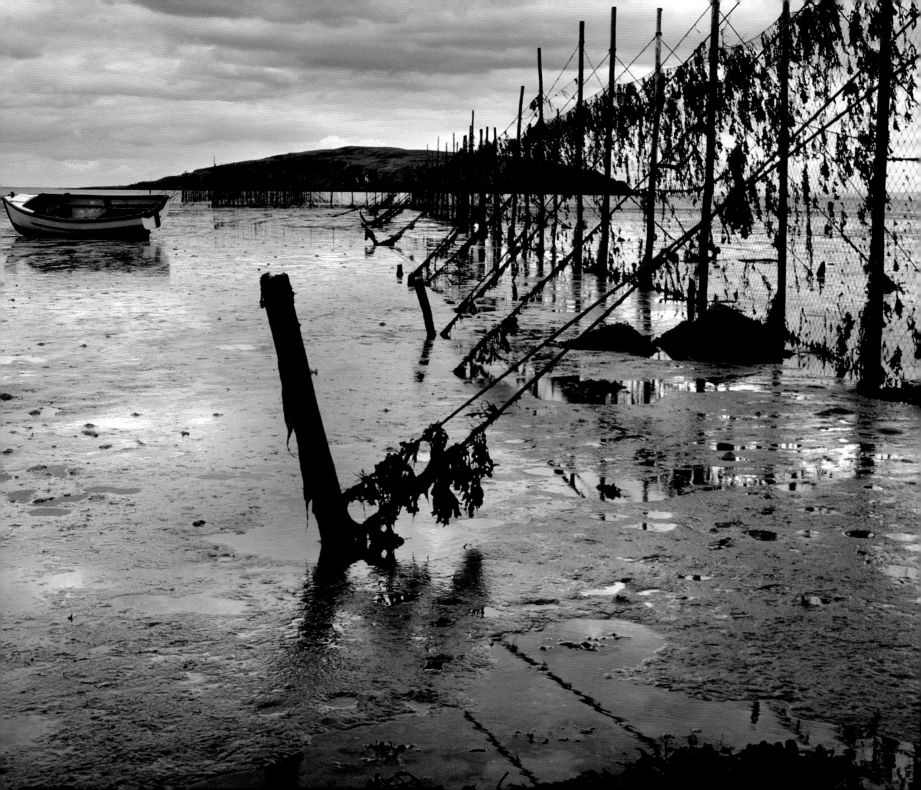

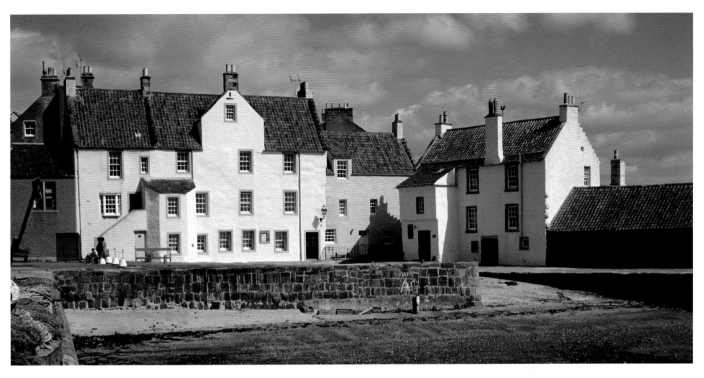

with Ireland and northern England. The town today may no longer have the harbour Defoe would have seen – it has long since been lost beneath a car park – but it does still have a small fishing fleet and a bustling quay.

Further north, Defoe praised the reputation for good seamanship enjoyed by the men of Greenock, and extolled the virtues of using the port of Glasgow 'in the expence of the ships, and especially in time of war, when the channel is throng'd with privateers, and when the ships wait to go in fleets for fear of enemies; whereas the Glasgow men are no sooner out of the Firth of Clyde, but they stretch away to the north west, are out of the wake of the privateers immediately, and are oftentimes at the capes of Virginia before the London ships get clear of the channel'.

Were Defoe, Pennant or the other writers of early gazetteers of Scotland to return today, they would be amazed. In the two or three centuries since they journeyed through the country, the hundreds of little fishing harbours have seen the herring come and go, and their fortunes with them. The great ports have been first developed and then largely abandoned, leaving behind them huge tracts of contaminated land.

[opposite page] Auchencairn Bay at low tide, near Balcary, Dumfries & Galloway.

[above left] Typical of many of the Fife coastal villages, these harled and pantiled houses on Pittenweem harbour echo a style which has been commonplace since the 17th century.

[above] The statue of Alexander Selkirk has looked out to sea from a house in Lower Largo since 1885. Selkirk was the original Robinson Crusoe, on whose exploits Daniel Defoe based his novel.

[left] Caledonian MacBrayne's steamer MV *Hebrides* sails into Tarbert on the island of Harris. The 5,500 ton *Hebrides* launched by the Queen in 2000 at Ferguson Shipbuilders of Port Glasgow, is CalMac's third – and by far the largest – ship to bear the name. She carries the bell from the first *Hebrides*, which entered service in 1898.

169

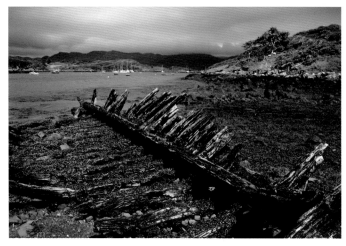

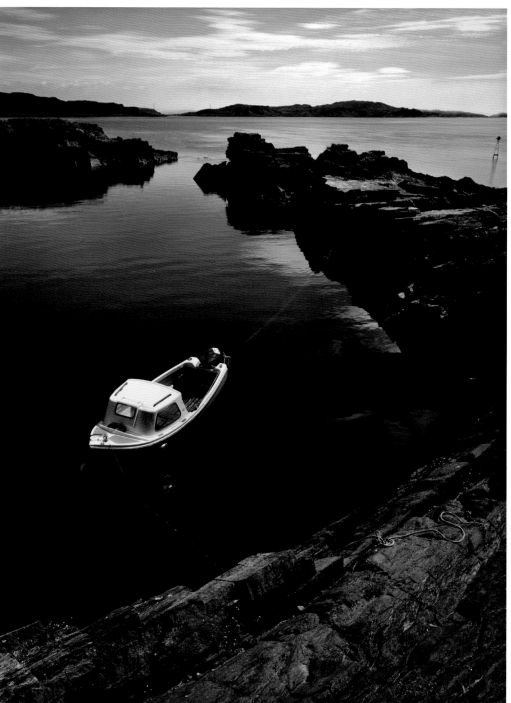

[top] A solitary shell lies amongst the rocks on the shore along the southwest coast of Colonsay.

[above] Revealed at low tide near Badachro, Wester Ross, the skeleton of a long-abandoned fishing boat partially overgrown with seaweed.

[right] The still waters of Ellenabeich on Seil Island offer a safe haven for small boats.

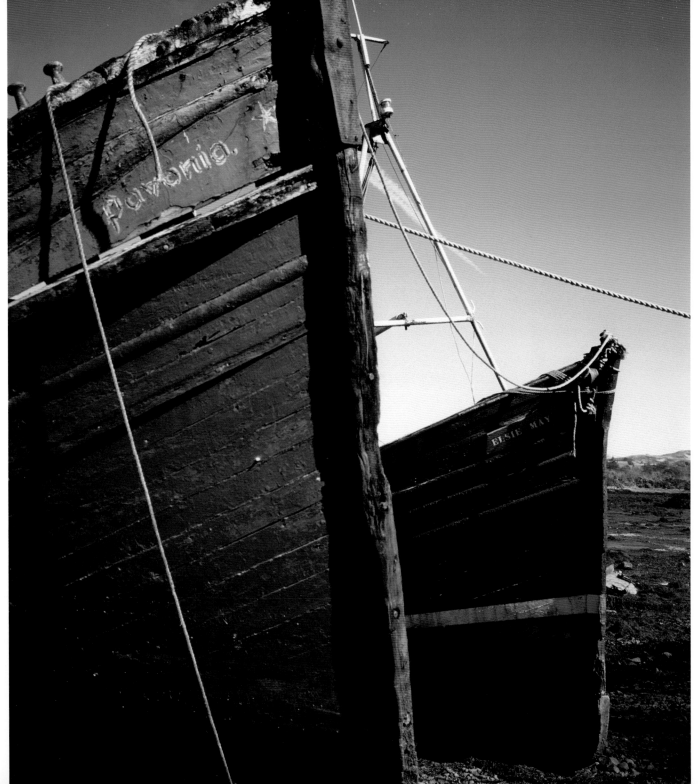

[left] Beached fishing boats at
Salen in the Isle of Mull. Cutbacks
in fishing quotas and the move to
fewer but larger boats over the past
decades have resulted in many
otherwise seaworthy vessels being
left to rot around the coast.

[above] Gulls hover above the stern
of Caledonian MacBrayne's ferry
Isle of Mull as it makes its way past
Duart Point on its regular crossing
from Oban to Craignure.

171

All around our coast, the relics of Scotland's maritime heritage have a magnetic attraction to artists and photographers. The skeletal remains of beached and abandoned boats can be found on numerous beaches and in small coves. Several of the country's great docks are all but abandoned – indeed parts of the once huge coal port at Methil have already been filled in, and vast acreages at Leith have already been turned into modern housing developments. The banks of the Clyde – perhaps because of the sheer scale of the redundant quays and buildings – will take a lot longer to redevelop.

[above] Southernness Lighthouse overlooks the Solway Firth.

[right] A solitary small fishing boat at anchor in the calm waters of Loch Crinan.

[opposite page] A beached fishing boat at Achnacroish on Lismore, looking across the Lynn of Lorne with Benderloch and the mountains beyond.

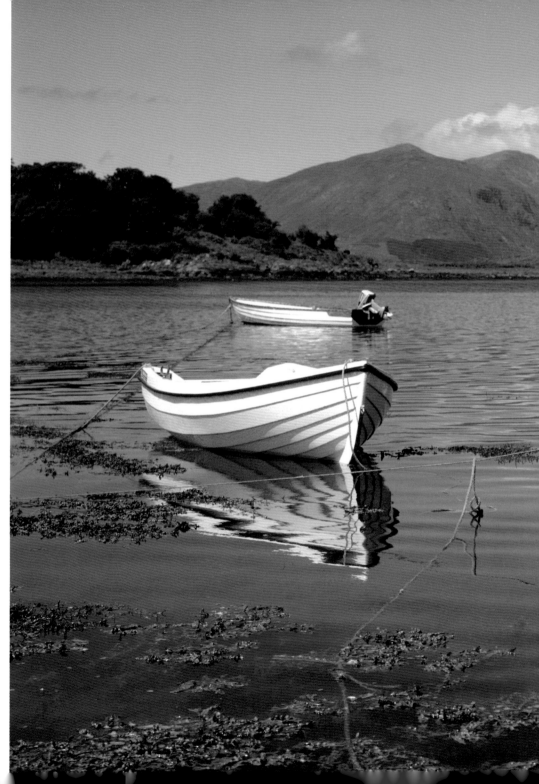

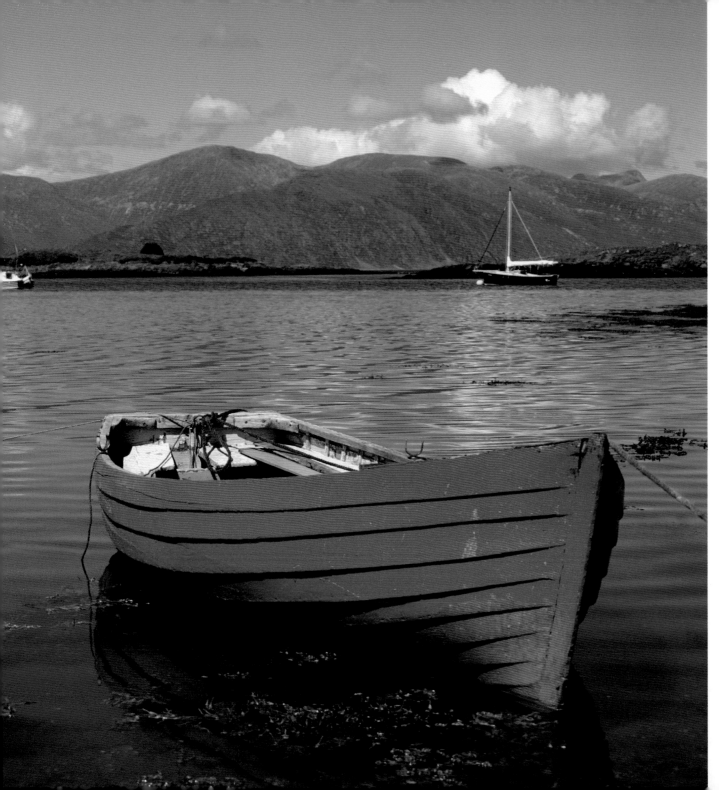

[above] As part of the redevelopment of Glasgow's docklands, several large projects have already been completed – including a new footbridge across the Clyde and new headquarters for BBC Scotland – and other developments are underway. Here, spring sunlight is reflected in the glass cladding of the new Glasgow Science Centre.

[left] Looking northwest across Loch Linnhe from Port Ramsay, at the northern tip of Lismore, with the mainland hills behind. This is the idyllic view of Scotland's coast, which is celebrated in hundreds of books, calendars and postcards.

[far left] In sharp contrast, an abandoned jetty at Leith docks leads the eye to a solitary large container vessel tied up in what was, a few decades ago, a bustling and thriving port. Today most of the remaining docks are empty. To one side of this view is the Royal Yacht *Britannia*, now moored as a tourist attraction hard against a quayside dominated by a huge modern development dedicated to shopping rather than shipping.

175

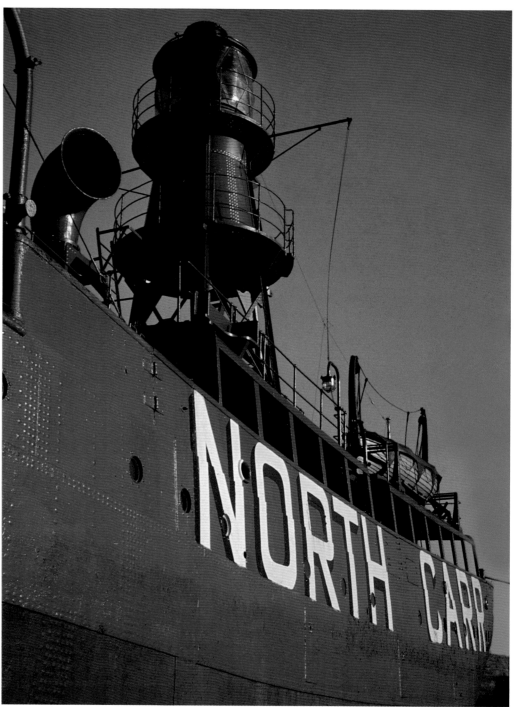

The biggest change to our country's coast in recent years has been the rapid demise of the fishing industry, which once, directly and indirectly, employed hundreds of thousands of people. Recent figures suggest that in the past century, fish stocks around British waters have dropped by over 90%, bringing about the dismantling of one of the country's major industries. Fishing was as important to coastal Scotland as coal mining was to inland Scotland. The annual trawl of herrings – the 'silver darlings' of so many songs and stories – dwindled into insignificance with dramatic rapidity, and the introduction of quotas dramatically reduced the deep-sea fleets.

The eminent travel writer Henry Vollam Morton wrote evocatively in his 1929 book *In Search of Scotland* of the arrival of the herring fleet into Aberdeen harbour. At that time, the herring industry had already passed its peak, but Morton's essay described a scene that would have been played out daily in many other Scottish ports:

'The trawler fleet', he wrote, 'lies – 'berthed' is, I suppose, the right word, but 'parked' is much more expressive – at the quay-side, thick as motor cars at the Derby. They steam gently with the effort of their incoming. Their decks are foul with fish-scales and slippery with crushed ice. Salt is on their smoke-

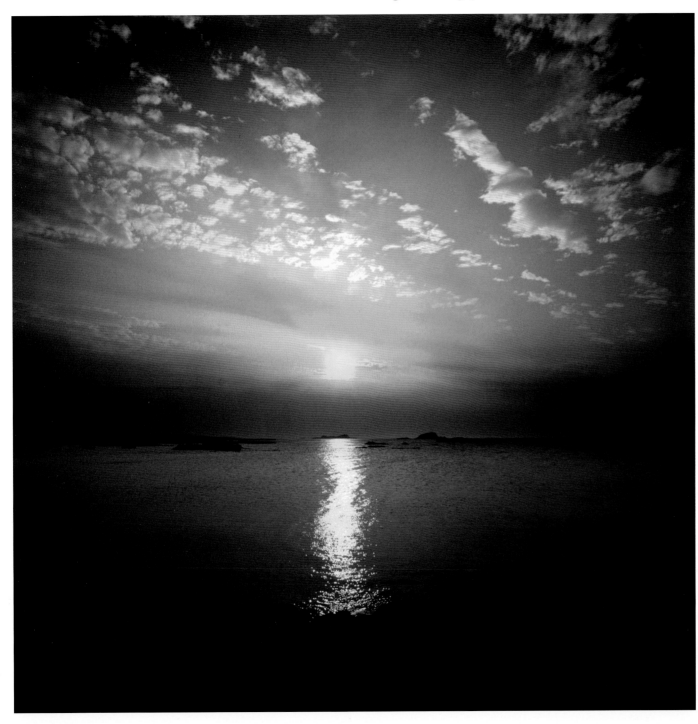

[opposite page left] Seen here from the viewing platform in the adjacent shopping mall, the Royal Yacht *Britannia*, decommissioned in 1997, is now a major tourist attraction in Leith Docks. Built by John Brown on the Clyde and launched in 1953, she entered service in January 1954 and toured the world for the following 43 years. Over 400 feet long and with a gross registered tonnage of more than 5800 tons, she was the largest and most powerful royal yacht in British history and, with a top speed in excess of 22 knots, she was also the fastest. Sadly, in turning her into a tourist venue, her beautiful lines have been spoiled by the addition of a large visitor centre on her aft deck.

[opposite page right] The great engineer Robert Stevenson proposed the building of a stone lighthouse or beacon on the North Carr Rocks in the early 19th century, but his plans came to nothing. Instead, a wooden lightship was eventually moored over the reef in 1887 – the first of three vessels to warn shipping of the danger. The third North Carr Lightship spent over 40 years on station off Fife Ness, until she was replaced by a beacon in 1975. She has a unique place in Scottish maritime history, as for many years she was the only manned lightship in northern waters. Built on the Clyde in 1933 by A. & J. Inglis – who also built the surviving paddle-steamers *Waverley* and *Maid of the Loch* – her light could be seen for over ten miles. After decommissioning, she was towed to Anstruther on the Fife coast, where she became a floating museum, but she is now in Dundee, her condition deteriorating rapidly as she awaits major restoration. This photograph was taken during her stay in Anstruther harbour.

[left] A dramatic sunset off North Berwick.

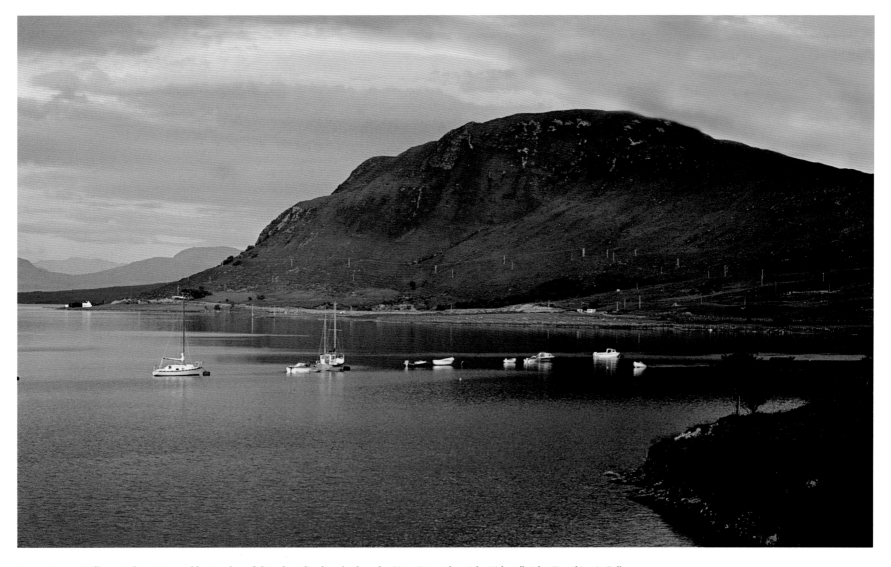

[opposite page] Silhouetted against a reddening sky, a fishing boat lies beached on the River Dee at low tide. Kirkcudbright, Dumfries & Galloway.

[inset left] Oban recedes into the distance as the Caledonian MacBrayne ferry MV *Isle of Mull* steams out of Oban Bay on her regular crossing to Craignure on the Isle of Mull.

[above] Near Strollamus, boats sit at their moorings in Loch na Cairidh – the narrow stretch of water which separates the Isle of Skye from the island of Scalpay.

stacks, and their high fo'c'sles are wet still with the North Sea spray. The grimy faces of engineers peer up from hatchways; down companionways clatter the crews in enormous thigh boots. Vivid, arresting and even, as are all things connected with the sea, exciting as this fleet is, it simply fades before the spectacle of its cargo.

Imagine a million bare babies being soundly smacked, and you have the sound of Aberdeen Fish market as a million fish are slapped down on the concrete.'

In Morton's day, hundreds of 'Scotch fish lasses' still moved south along the east coast each year following the fishing fleets as they in turn followed the shoals of herring – as they had done for decades – earning their living at the gruelling tasks of gutting and pickling the fish. A century ago, these hardy women were featured in hundreds of postcards sold in every fishing port from Peterhead to Great Yarmouth. Many of the 'Scotch fish lassies' settled and married in the east coast ports of England.

The skills which supported the fishing – boat-building, barrel-making, and many others – are, like the fish themselves, long gone. As recently as half a century ago, just about every little harbour around Scotland's coast was still home to a small inshore fishing fleet. All but a few have also gone, their harbours given almost exclusively over to pleasure craft; the cottages that once housed the fishermen and their families turned into holiday homes for city dwellers.

For a time, tourism filled part of the gap left by the fishing – with many of the visitors arriving by train until Dr Beeching closed most of the coastal and branch lines – but in these days of foreign travel, the Scottish seaside holiday itself is much less popular than it once was. Beaches which would have been crowded every summer as recently as the 1960s are now largely deserted, even in the finest of weather, and in the absence of the holiday-maker, many hotels and guest-houses have also put up their shutters.

[right] A small rowing boat lies on a Mull slipway, just across the narrow stretch of water from the island of Ulva.

[opposite page] Once a familiar sight but much rarer today: fishing boats tied up at the jetty in a west-coast sea loch.

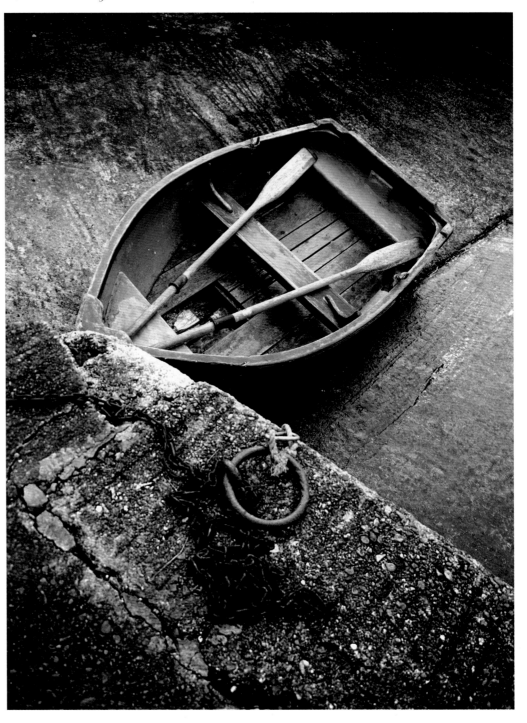

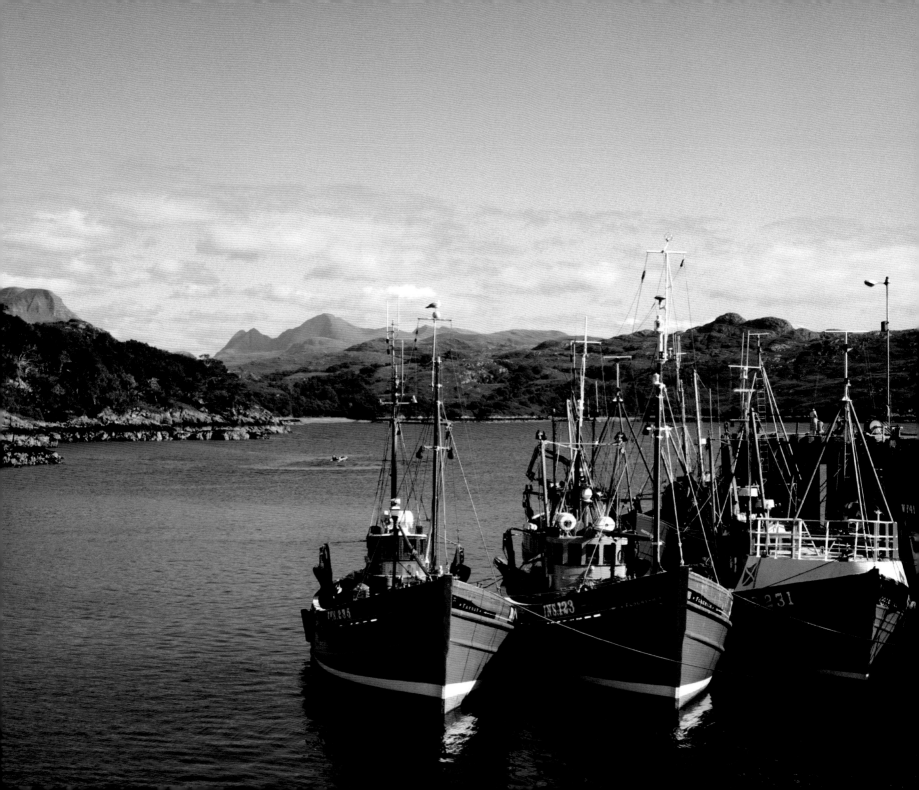

Key for Maps

- ● The Marks left by Men

- ● Land of the Mountain and the Flood

- ○ Great Houses and Humble Dwellings

- ● Churches, Rituals & Monuments

- ● The Land of a Thousand Castles

- ◒ One Thousand Years of Industry

- ● Living and Working by the Sea

The following pages provide schematic maps indicating towns, rivers and the approximate location of many of the sites mentioned in the book. These are not drawn to scale, they are purely to indicate the spread of locations in the various regions of Scotland to assist in the planning of a sightseeing tour or trip.

Maps

Butt of Lewis

Scourie

67 73

67

6 Carloway

134

Stornoway

2 Lewis

Hebrides

The Minch

Ullapool

48 169

140 30

Harris

18

Poolewe

181

Gairloch 54

Ross & Cromarty

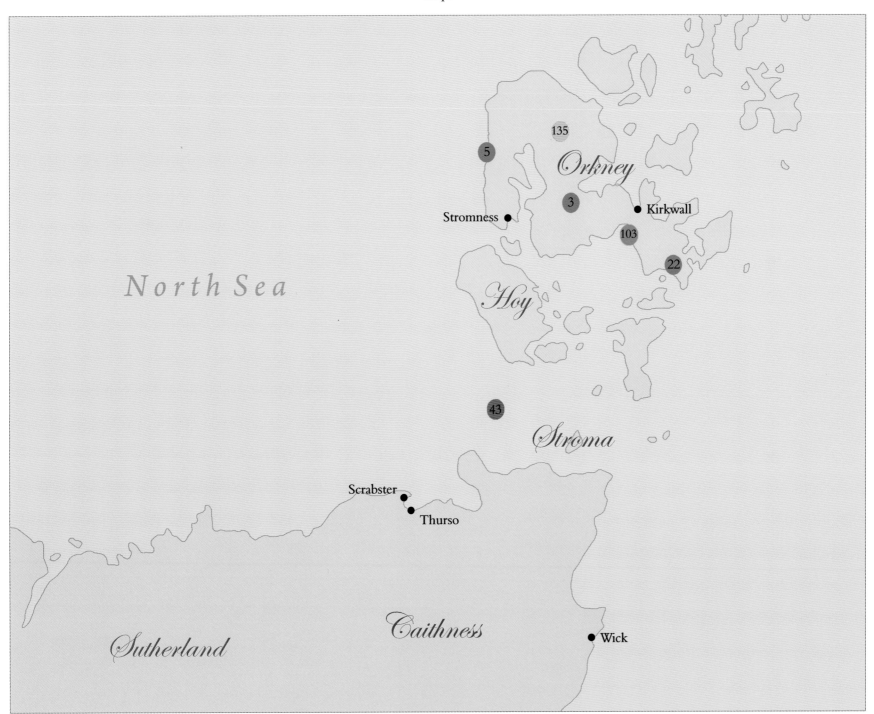

70
42

Portree ●

Skye

135

61

179

Kyle of
Lochalsh ●

128

Broadford ●
40

6

8

Rum

Mallaig ●

Spean
Bridge

25

Glenfinnan ● 25

Fort William ●

127 37

Hebrides

121
Motherwell
160
Duns
82
Lauder
114
Peebles
76
Galashiels
101
10
87
132
102
149
84
Kelso
9
Roxburgh
100
Jedburgh
Hawick
119
Riccarton
England

Islay

17

● Port Ellen

Kintyre

Arran

North Channel

Firth of Clyde

● Kilmarnock

125
130
146 ● Lanark

● Ayr

Dumfries ●

137
99
110

114

Stranraer ●

98

Wigtown ●
1

129
167
172
68

Kirkcudbright ●

65
178
168

*Northern
Ireland*

North
Sea

Montrose

14

90

Forfar *Angus*

86 Arbroath

176 162

Dundee

24 158 Crieff Perth

79

21 17 122 121

St Andrews

91 117

12

158 123

151 90

63

118 *Fife* 169

169

120 104 161

124

Stirling

76

161 23 23

151

Dunfermline

81

66 73 139 94

Falkirk 154 141 161

11 145 106 116 Edinburgh

80 144 111 22 77

129 24 174

97 78 Musselburgh

Lothian 85 77

89 152

109

Firth of Forth

177

119 115

35 Dunbar

136

105

102

Index

*Page numbers in italics
signify illustrations.*

A

Abbotsford, *84*
Aberdeen, King's College, *107*
Aberlemno, 14, *15*, 16
Achnacroish, *173*
Adam, John, 79
Adam, Robert, 77, 79, 83, 102
Adam, William, 79, 83, 84
Ahbain Culeig Waterfall, *31*
Altbea Clapper Bridge, *140*
Antonine Wall, vii, 8, 9, 10, 11
Arbroath Abbey, *86*, 87
Ardoch Roman Camp, 8, 9, *12*, 13
Aros Castle, *133*
Arrol, William & Co., *152*, 153
'Atlantic Bridge', *140*, 141-142
Auchencairn, *168*
Auchendowie, *63*
Augustinian Canons, Order of, 90, 101
Augustinian Nuns, Order of, 90

B

Badachro, *170*
Baillie, George, of Jerviswood, 83

Balvaird Castle, *121*
Barclay, Andrew, Sons & Company, 155
Bearsden, 8-9
Beaton, Cardinal, 117
Benedictine Monks, Order of, 93, 95
Blackness Castle, 111, *116*, 117
Blair Castle, 121
Bonawe Iron Furnace, 61, *150*
Bo'ness & Kinneil Railway, *154*
Borthwick Castle, *123*
Boswell, James, ix, 51, 53, 72
Bothans Church, *102*
Bothwell Castle, *121, 132*
Britannia, Royal Yacht, 175, *176*, 177
Broadford Bay, Skye, *40*
Brodgar, Ring of, *3*
Brown, Dan, 89
Brown, John & Co., 177
Bruce, King Robert the, *23*, 117, 133
Bruce, Sir George, 81, 153, 164
Bryce, David, 83
Burleigh Castle, *132*

C

Caerlaverock Castle, *110*, 111-112

Cairnbaan, 1
Cairnholy, *1*, 3
Caledonian Canal, 32, *142*, 143
Caledonian MacBrayne, 169, 171, 179
Caledonian Railway, *155*
Calgary Bay, *38, 57*
Callanish, *2-4*, 7
Camden, William, vii, ix
Campbell, John, of Possil, 83
Carberry Hill, Battle of, 121
Carlyle, Jane Welsh, 104
Carlyle, Thomas, 104
Carter, Howard, 51
Castle Campbell, 109, 121, *124-125*
Castle Coeffin, *132*
Castle Fraser, 109
Castle Kennedy, *ii*
Castle Stalker, *108*
Castle Sween, *133*
Castle Tioram, 125, *126-127*
Charlestown Lime Kilns, *139*
Chiocchetti, Domenico, 20
Churchill Barriers, *22*
Cistercian monks, Order of, 98, 137
Colonsay, *170*
Cook, Thomas, ii, 38, 44
Craig, Sir Thomas, 57
Craigellachie Bridge, *140*
Craigmillar Castle, *111*, 112, 121

Craignethan Castle, *125, 130*
Crail Church, *90*
Crichton Castle, *109,* 112, 117, 121
Crinan Canal, 1, 142, *143*
Crocodile Rock, *24*
Culross, *66, 73, 81,* 153, 164
Cup and ring markings, 1, 3

D

de Baliol, Devorgilla, 95
de Baliol, John, 95
Dallas Dhu Distillery, *159*
Defoe, Daniel, ix, 33, 35, 38, 76-77, 107, 163-165, 169
Denny Brothers Ltd., 157
Dere Street, 10
Dirleton Castle, *119*
Discovery, ship, 162
'Doom' Painting, *90*
Dounby Click Mill, *135*
Doune Castle, 112, *120*
Drummond Castle, *79*
Dryburgh Abbey, 98, *101*
Duart Castle, 41, *112*
Dun Carloway, *6*
Dun Law Wind Farm, *160*
Dun Telve, 7-8
Dun Troddan, *6*, 7-8
Dunblane Cathedral, 91, *104*
Dundrennan Abbey, 95, *98*
Dunfermline Abbey, 95
Dunfermline Palace, *81*

Dunmore Pineapple, 20, *23*
Dunnottar Castle, 121, 125, *126*
Dunstaffnage Castle, 117
Dupplin Cross, 14, *17*

E

Easdale, *56, 74-75*
Eas Fors Waterfall, *31*
Ecgfrith, King of Northumbria, 14
Edinburgh Castle, 109, 111, *123*
Eilean Donan Castle, 112, *128*
Elgin Cathedral, *88,* 95, *98*
Ellenabeich, *170*
Elphinstone, Bishop William, 107

F

Falkirk Wheel, 144, *145*
Falkland Palace, *123*
Fingal's Cave *52*
Finnieston Crane, *167*
Fionnphort, *59*
Forth Bridge, *141*
Forth Road Bridge, *161*
Forth & Clyde Canal, *144,* 149
Fowlis Easter Church, 89, *90*

G

Gearrannan, 67, 69, 72
Glasgow Cathedral, *96*
Glasgow Science Centre, 157, *175*
Glen Nevis, *51*
Glen Ogle, *148*
Glen Turret Distillery, *158*
Glencoe, *26-27*
Glendale Mill, *135*
Glenfinnan Monument, *25*, 31
Glengoyne Distillery, *158*
Glenlee, sailing ship, *164-165*
Glenluce Abbey, *98*
Great Bernera, *67*
Greenknowe Tower, *122*
Greyfriars Bobby, 20, *23*
Greyfriars Church, Edinburgh, 107

H

Haddington *85*, 104
Haddington, St Mary's Church, 104, *105*, 106
Hadrian's Wall, 8, 13
Hamilton, Sir James, 125
Haymarket Station, *154*
Hebrides, ferry, *169*
Hermitage Castle, *119*, 121
Holy Rude Church, Stirling, 91
Holyrood Abbey, 96, *97*, 106
Holyroodhouse, Palace of, *78*, 106
Huntingtower Castle, *122*

I

Inchcolm Abbey, 90
Inchtuthil, 13
Inglis, A & J, 157, 177
Innerpeffray Churchyard, *21*
Inveraray Castle, *84*
Iona Abbey, 90, *92*
Iona Nunnery, 90, *91*
Iona, St Martin's Cross, *iii*
Italian Chapel, Orkney, 20, *22*

J

Jedburgh Abbey, 98, *100*, 101
Johnson, Samuel, ix, 7, 27, 51-3, 58, 69-70, 72

K

Keils, *68*, 69
Kellie Castle, *123*
Kelso Abbey, 98, 101, *102*
Kilcheran Loch, *49*
Kilchurn Castle, *title page*, *131*
Kildalton, Great Cross of, 16, *17*
Kildrummy Castle, 112
Kilmartin Stones, *20*
Kilmodan Stones, *20*
Kirkcudbright, *167*, 165, *178*
Kirkwall Bishop's Palace, *103*
Kirkwall, St Magnus' Cathedral, *103*
Knox, John, 104, 106
Kyles of Bute, *46*

L

Lakeside & Haverthwaite Railway, *155*
Lamb Holm, Orkney, 20, 22
Leaderfoot Viaduct, 9, 10, *149*
Leith, 164, 172, *174*
Linlithgow Palace, *80-81*, 116, 117, 119
Linlithgow, St Michael's Church, *106*
Lismore, 7, *41*, 49, *56*, 57, 132, 172, *173*, *175*
Loch Achray, *42*
Loch Ainort, *61*
Loch Chon, *58*
Loch Crinan, *172*
Loch Etive, *60-61*, 117
Loch Garry, *45*
Loch Katrine, *46*
Loch Leven, Argyll, *28-29*
Loch Leven Castle, 114, *118*, 121
Loch Linnhe, *41*, 57, *174-175*
Loch Lochy, *32*
Loch Lomond, *ii*, *41*, 44, *64*
Loch Moidart, *36*, 125
Loch Scridian, *39*, 62
Loch Suinart, *34*
Loncarty, Battle of, 14
Lorimer, Professor James, 123

M

MacBrayne, David, 143
MacCunn, Hamish, 27
Maid of the Loch, steamer, *157*, 177
Mar's Wark, 76

Martyrs' Monument, 24
Mary, Queen of Scots. 77, 81, 91, 109, 111, 114, 117, 119, 122, 125
Meall a'Ghlas Leothaid, *iii*
Mellerstain 79, *82*
Melrose Abbey, 87, 98, *101*
Mendelssohn, Felix Bartholdy, 27
Methil, 151, *161*, 164, 172
Miller, William, 20, *21*
Mingary Castle, 32, *131*
Morton, Henry Vollam, ix, 51-2, 91, 104, 123, 176, 180
Muir, John, 57
Munro, Neil, 142

N

Na Buirgh beach, *48*
National Covenant, 24, 107
National Monument, 20, *25*
Nechtansmere, Battle of, 14
Necropolis, Glasgow, 16, *21*
Neidpath Castle, 109, *114*
New Abbey Corn Mill, *137-138*, 139
New Lanark, 135, *146-147*
North Berwick, 115, *177*
North Carr Lightship, *176*

O

Orchardton Tower, 109, *129*
Order of Tiron, monks of, 87, 101
Owen, Robert, 146

P

Paps of Jura, *50*
Pennant, Thomas, ix, 7, 9, 14, 31, 33, 38, 51, 53, 90-91, 95, 107, 169
Pennygown Chapel, *19*
Pentland Firth, *43*
Picts, 13-15
Pitmedden, *83*
Pittenweem, *169*
Playfair, William, 20
Pluscarden Abbey, 93, *94-95*
Premonstratensian Canons, Order of, 98
Preston Mill, *35*, *136*, 137
Prinknash Abbey, 95

R

RRS *Discovery*, *162*
Rennie, John, 142-143
Riccio, David, 122
Rodel Church, Harris, 18
Roslin (Rosslyn) Chapel, 89
Royal Yacht, *Britannia*, 175, *176*, 177
Ruthven Barracks, *113*
Ruthven Castle, 122
Ruthven Raid, 122

S

St Andrews Castle, *117*
St Andrews Cathedral, *91*, 95, 101
St Andrews, St Rule's Church, 104
St Fillans, 24
Salen, Mull, 19, 69, 133, *171*

Scalpay, 40, *179*

Scott, Sir Walter, 20, *22*, 27, 84, 98, 121

Scottish Mining Museum, *152-153*

Seil Island,140-142,*170*

Selkirk, Alexander, 20, *169*

Shaw, George Bernard, 27

Shawbost Mill, *134-135*

Sir Walter Scott, steamer, *156*

Skara Brae, *5*, 7

Smailholm Tower, *132*

Soutar, William, 30

Southernness Lighthouse, *172*

Southey, Robert, 141, 151

Spean Bridge, 20, *25*

Springburn Locomotive Works, 155

Staffa, 27, *53*

Stevenson, Robert, 177

Stirling Bridge, *161*

Stirling Castle, 109, 111, *116*

Strathspey Railway, *155*

Strollamus, Skye, *179*

Sueno's Stone, 14,

Sweetheart Abbey, 95, *99*

T

Talbot, William Henry Fox, 41

Tantallon Castle, *viii*, *115*, 121

Telford, Thomas, 32, 140-142, 151

Threave Castle, *114*

Tirefour Broch, 7

Tironensian Monks, 87

Tobermory, 32, *166*, 167

Tormiston Mill, *138*, 139

Torosay Castle, *83*

Traquair House, *76*

Trimontium, 8-10

Tullibardine Distillery, *158*

U

Ulva, *70-71*, 180

Union Canal, *144*, 149

V

Vanbrugh, Sir John, 84

W

Wallace, William, 20, *23*

Watson, George Mackie, 129

Watt, James, 142

Waverley, steamer, *157*

Wee Willie Winkie, 20, *21*

Wilson, George Washington, 44

Wishart, George, 106, 117

Wormit Station, *154*